W9-BOZ-222

The Sculpture of Verrocchio

THE SCULPTURE

OF *Verrocchio*

BY

CHARLES SEYMOUR, JR.

NEW YORK GRAPHIC SOCIETY LTD.

Greenwich, Connecticut

FOR ELIZABETH DOWNER BALL

Standard Book Number 8212-0375-4
Library of Congress Catalog Card Number 77-154326

Published in 1971 by New York Graphic Society Ltd.,
Greenwich, Connecticut

Design by Philip Grushkin

Printed in Japan

PREFACE

THIS BOOK on the sculpture of Andrea del Verrocchio follows upon several well-known recent studies: first, Planiscig's slight but influential monograph of the 1940's; then Pope-Hennessy's section on the artist in his *Introduction to Italian Sculpture* of the 1950's; and Passavant's more ambitious volume on the total oeuvre of Verrocchio, which appeared in the late 1960's.

It is advisable at the outset to underline the different aim of this book. It was written in the first place as a short study designed to bring succinctly some knowledge of Verrocchio to college students and the more general reader, and it was to have been part of a series, since abandoned, on sculptors and sculpture of all periods and places. It is thus directed toward a broadly educational goal rather than to Renaissance specialists, and it cannot be considered in any sense a "complete" study. Instead, it should be thought of as a critique—that is, an up-to-date and, one would hope, a focused view on the main elements, the principal thrusts, of Verrocchio's activity as a sculptor. This book contains no reference footnotes and no full catalogue of accepted and rejected works, as a proper monograph should; it does include, however, a section of critical notes on the principal pieces discussed and a bibliography designed mainly as a handy reference tool. And since no serious work can be done at any level without some knowledge of the historical sources, students will find in an appendix a sampling of the various kinds of original materials upon which the image of Verrocchio as an artist must be based—today as in the past.

The work of examining the archival sources to build a more accurate picture of Verrocchio as a personality and as a practicing artist is being pursued by Dario Covi of the University of Kentucky. What is offered here is based in some important parts on Professor Covi's recently published findings, and it takes into consideration a number of conclusions made even more recently by Dr. Passavant.

What can be done now, at this moment, in studying and writing even briefly on this artist? Three principal points come to mind. First, above all, Verrocchio should be shown to be much more than a transitional figure between Donatello and Leonardo da Vinci, an opinion still held and published in some quarters. Verrocchio was clearly an artist of outstanding stature, not only for the Italian Renaissance but for any age in Western Art. A major objective, then, will be to provide evidence for so high an evaluation.

Secondly, though Verrocchio was a painter of some competence, a distinguished draughtsman, and a practiced worker in precious metals, he excelled primarily as a sculptor, as a modeler in clay, caster in bronze, and carver of marble. In his personal oeuvre, painting appears without serious question to have taken second place to sculpture. Consequently in the study that follows, examples of his painting are shown only to throw light on the relationship of that art to his sculpture; the same policy has been followed for his drawings. Emphasis is deliberately placed on Verrocchio as sculptor.

Finally, it will be shown and emphasized that even though he must in the long run be ranked as an outstanding *individual* in the history of sculpture, Verrocchio was the head of a large enterprise: a shop, or bottega, something much more elaborate and businesslike than the "studio" of a later age. In that shop were trained—among others—Leonardo da Vinci, Domenico Ghirlandaio, Pietro Perugino, and almost certainly Luca Signorelli, as well as Verrocchio's legal artistic heir, Lorenzo di Credi. The output was large in both painting and sculpture, and perhaps in the minor arts. Collaboration was the rule rather than the exception. Sometimes the design appears to be by Verrocchio but the actual execution by a member or members of the shop. Sometimes one can find evidence of responsibility for execution shared between master and assistants. Only occasionally can we say that we are looking at an individual work of art completely carried through by Verrocchio alone. The evaluation of artistic production completed under such corporate responsibility offers problems today, for we are still very much influenced by the nineteenth-century Romantic image of the artist as hyperindividualist.

In preparing this study I am indebted not only to work of the immediate past such as that mentioned above but also to the work of generations of scholars and writers—beginning with Giorgio Vasari—who have written on Andrea del Verrocchio. Though I may not always have followed their lead on specific matters, their stimulus to think and sometimes to question has been always welcome. Some of the still controversial points brought out (in necessarily abridged form) five years ago in my survey of Quattrocento Italian sculpture in the Pelican History of Art are here either enlarged and explained or amended. But, in general, the picture of Verrocchio that I attempted earlier to outline remains much the same.

My thanks go to Mr. Burton Cumming of the New York Graphic Society who first suggested the book; to Mrs. Betty Morrison Childs who has edited the text and seen it through the press, and to Mr. Philip Grushkin who designed the volume; to Professors J. J. Pollitt and Ross Kilpatrick for assistance in rendering difficult Renaissance Latin into English; to Mrs. Wendy Stedman Sheard, who has helped with photographs and a special study of the base of the Colleoni Monument; to Miss Mary Margaret Collier and Mr. David Brown for photographic help and advice on the drawings; to Mr. Philip Foster for advice on Medici patronage problems; to Miss Helen Chillman for help in the Library at Yale; and to the libraries of the German Institute in Florence and the Harvard Institute for Renaissance Studies at I Tatti. Professor Covi has been generous in his answers to questions and in making some valuable suggestions. Mrs. Robert Schotta has ably made the typescripts of the various drafts. The time for writing the volume was made possible by a Senior Fellowship Grant from Yale University—for this and other help in the past I am most grateful.

C. S., Jr.

New Haven, December 1970

CONTENTS

CHAPTER ONE
THE ARTIST, HIS WORLD, HIS WORK

Verrocchio's place in the criticism of art; the problem of his
relationship to both Donatello and Leonardo da Vinci. Biographi-
cal legend and fact. Formation of Verrocchio's style: roles played
by Vittorio Ghiberti, Desiderio da Settignano, Bernardo and
Antonio Rossellino, Antonio Pollaiuolo. Patronage patterns in
Florence: public-civic, private, semiprivate. Public and possibly
semipublic commissions for Venice. Verrocchio's important
studio (bottega); participation of younger artists, such as Leonardo,
Domenico Ghirlandaio, Perugino, Lorenzo di Credi. Attribution
problems posed by the bottega system. Verrocchio as painter and
draughtsman as well as sculptor; the question of interplay between
techniques. Vasari's view of Verrocchio as a "realist."

CHAPTER TWO
THE DOCUMENTED SCULPTURE

The first work on record: tomb-slab design for burial marker of
Cosimo de' Medici in S. Lorenzo (*ca.* 1465). Early period: bronze
candelabrum for the Chapel of the Signoria in Palazzo Vecchio
(1468-69); funeral monument of Piero and Giovanni de' Medici in

S. Lorenzo (*ca.* 1469-72; bronze Eros with a Dolphin, fountain figure for the Medici Villa of Careggi (*ca.* 1465-70?); bronze David now in the Bargello (before 1476). Mature period (after 1475): S. Thomas group for Or S. Michele (commissioned 1466, completed by 1483); Forteguerri Cenotaph in Pistoia (commissioned 1476, left unfinished); silver relief for the Baptistry altar frontal (commissioned 1477, finished by 1480); Colleoni monument in Venice (1479, announcement of competition; left unfinished, cast by Leopardi). Lost documented work: a partial listing.

CHAPTER THREE
ATTRIBUTED SCULPTURE

1. The question of Verrocchio's beginnings as a sculptor, undocumented and undated. Hypothetical activity of Verrocchio in the studios of Desiderio da Settignano and Bernardo and Antonio Rossellino: the Altar of the Sacrament in S. Lorenzo (*ca.* 1460-64); the Chellini Monument in S. Miniato al Tedesco. The problematic Lavabo of the Old Sacristy in S. Lorenzo. Portraits in marble: the mysterious "Lady with Flowers" of the Bargello; other portrait-busts in Washington and Paris in relation to Desiderio's and Verrocchio's documented styles. Madonna reliefs: the terracotta Virgin and Child for S. Maria Nuova, now Bargello; the smaller so-called Diblee-Oberlin Relief type. The Careggi Ascension relief, now Bargello. Other work in terracotta: Portrait of Giuliano de' Medici and the Running Putto on a Globe, in Washington; the bust of a deacon-saint of S. Lorenzo, now in the Old Sacristy, S. Lorenzo. Entombment sketch, formerly in Berlin. Remnants of the Monument of Francesca (Pitti) Tornabuoni done for S. Maria sopra Minerva, Rome (Bargello, and, very possibly, Paris).

2. The periphery of the artist's oeuvre: remoter attributions, bottega work, imitations and influence. An example of the genre of small bronze statuettes: the Judith, now in Detroit. "Decorative sculpture": the putto now in San Francisco. Reliefs connected with the Matthias Corvinus reliefs mentioned by Vasari: the "Alexander" now in Washington, the Scipio now in Paris. The

portrait of Lorenzo de' Medici, now in Washington. Verrocchio's influence: primarily on Francesco di Simone, Matteo Civitali, Rustici. Influence beyond Tuscany.

LIST OF ILLUSTRATIONS

143. *Desiderio da Settignano. Christ and St. John the Baptist. Louvre, Paris. Marble.*

144. *Desiderio da Settignano. Christ Child. National Gallery of Art (Kress Collection), Washington, D.C. Marble.*

145. *Attributed to Verrocchio. Resurrection from Careggi. Museo Nazionale (Bargello), Florence. Terracotta.*

146. *Luca della Robbia. Resurrection. Duomo, Florence. Glazed terracotta.*

147. *Attributed to Verrocchio. Resurrection from Careggi. Detail, Christ.*

148. *Detail of Resurrection from Careggi, Angel to left.*

149. *. . . Angel to right.*

150. *. . . Soldiers to left.*

151. *. . . Soldiers to right.*

152. *Attributed to Verrocchio. Portrait of Giuliano de' Medici, detail. National Gallery of Art (Mellon Collection), Washington, D.C. Terracotta.*

153. *Verrocchio (?). Bust of a Deacon Saint, detail. S. Lorenzo, Florence. Terracotta.*

154. *. . . Bust of a Deacon Saint, from back.*

155. *. . . Bust of a Deacon Saint. Detail, head, face on.*

156. *Design attributed to Verrocchio. Madonna and Child. Allen Memorial Art Museum, Ohio. Stucco.*

157. *After Verrocchio. Madonna and Child. Rijksmuseum, Amsterdam. Stucco.*

158. *Detail of Fig. 156, head of Madonna.*

159. *Attributed to Verrocchio. Madonna from S. Maria Nuova. Museo Nazionale (Bargello), Florence. Terracotta, partially polychromed.*

160. *Attributed to Verrocchio. Running Putto on a Globe. National Gallery of Art (Mellon Collection), Washington, D.C. Terracotta.*

161. *. . . Back view.*

162. *After Verrocchio. Version of Running Putto on a Globe. Art Market, Paris (as of 1970). Bronze.*

163. *Verrocchio Shop. Detail of pupil's study sheet with record of a running putto on a globe. Cabinet des Dessins, Louvre, Paris. Pen and ink on paper.*

164. *Attributed to Verrocchio. Entombment. Formerly Kaiser Friedrich Museum, Berlin. Terracotta.*

165. *Shop of Verrocchio. Relief from Monument of Francesca Tornabuoni. Museo Nazionale (Bargello), Florence. Marble. Detail, death of the mother.*

166. *. . . Detail, the dead child shown to the father.*

167. *Attributed to Verrocchio. Flying Angel. Louvre, Paris. Terracotta.*

168. *Attributed to Verrocchio Shop. Companion Angel. Louvre, Paris. Terracotta.*

169. *Verrocchio (?). Judith. Detroit Institute of Arts, Detroit. Bronze.*

170. *. . . Detail of Judith, in profile.*

171. *Verrocchio Shop (?). Relief of "Alexander." National Gallery of Art, Washington, D.C. Marble.*

172. *After Verrocchio (?). Relief of Scipio. Louvre, Paris. Marble.*

173. *Attributed to Verrocchio. Reclining Putto. De Young Museum, San Francisco. Marble.*

174. *Albrecht Dürer. Madonna and Child. Kunsthistorisches Museum, Vienna. Oil on panel.*

175. *Influence of Verrocchio, c. 1490. Tabernacle. S. Maria, Monteluce. Marble.*

CHRONOLOGY OF EVENTS

1435

Birth of Andrea di Michele Cioni in Florence. Son of Michele di Francesco Cioni and his first wife, Gemma.

1441

Birth of Andrea's younger brother Tommaso (see below).

1452

Death of Andrea's father.

1453

Andrea charged with homicide following the death of one Antonio di Domenico in a scuffle outside the city walls. He is absolved.

1457

First declaration of property to the *Catasto*. Andrea is living with his stepmother, Nannina, and younger brother Tommaso in his father's house in the parish of S. Ambrogio, quarter of S. Croce. He describes his profession as that of goldsmith and indicates he is doing poorly financially.

1461

Andrea enters a competition, along with Desiderio da Settignano, the sculptor, for the design of an altar (*cappella*) for the Duomo of Orvieto. He fails

to obtain the commission, which goes to a Sienese.

1466-67, January 19

Decision of Florentine Duomo authorities to commission *Palla* for cupola. No artist selected until the following year.

1467, October 22

Body of Cosimo il Vecchio de' Medici placed in tomb in S. Lorenzo for which Andrea had designed the marker, perhaps finished some months before the entombment. Cosimo died August 1, 1464.

1467, November 4

Andrea is paid for metal transferred to Michelozzo and Luca della Robbia for casting their final panels of the bronze doors of the North Sacristy of the Duomo, Florence.

1467-68, February 7

Tournament (*Giostra*) of Lorenzo de' Medici, for which Andrea supplied Lorenzo's standard and evidently some of his parade armor (lost).

1468, March 30

Andrea to be paid a monthly sum of 25 lire on account for the Mercanzia group for Or S. Michele.

1468, June 29
First payment to Andrea for a bronze candelabrum for the chapel of the Signoria. Subsequent payments in September, 1469, and in April, 1480.

1468, September 10
Andrea commissioned to cast the great bronze *Palla*, or globe, surmounted by a cross for the Duomo cupola. The bronze had been bought by the Duomo authorities on June 30, 1468.

1469, March 29
Piero de' Medici "and company" to act as agent in making payments to Andrea for the *Palla* of the cupola of the Duomo.

1469, December 2
Death of Piero de' Medici. The joint tomb of Piero and his brother Giovanni begun by Verrocchio in 1470-71.

1470
Andrea's second declaration of property to the *Catasto*. Andrea is living alone in the family house in the parish of S. Ambrogio. He has sold some land in Certaldo, a center a few miles west of Florence.

1470, August 2
Bronze for figures for Mercanzia Niche to be weighed out.

1471, May 27
Palla is placed in position on cupola of Duomo. On June 6, it is recorded that the technique of making the *Palla* had been altered by decision some time after September, 1468.

1471, September 22
Andrea commissioned to redecorate (with sculpture of bronze or marble) exterior of the choir of the Florentine Duomo. Apparently nothing was ever done by Andrea in this matter.

1472
Completion of Tomb of Piero and Giovanni de' Medici in S. Lorenzo (according to inscription).

1473
Andrea estimates value of marble pulpit in Prato for payment to Mino da Fiesole and Antonio Rossellino.

1474, January 2
Council of Pistoia first discusses memorial cenotaph for Cardinal Niccolò Forteguerri. Five artists later submit modelli in competition, among them Andrea.

1474
Andrea casts bell for Convent of Monte Scalari (believed lost by later recasting).

1474-75, January
Tournament of Giuliano de' Medici, for which Andrea makes a standard.

1476, May 10
Florentine Signoria acquires from Lorenzo and Giuliano de' Medici the Bronze David for the sum of 150 florins (*fiorini larghi*).

1476, May 15
Andrea's modello for the Forteguerri commission barely wins approval by a vote of 43 to 35 in the Council of Pistoia. On March 7, 1477-78, the committee for the monument authorizes all possible means to get the memorial finished within two years' time. Meanwhile Piero Pollaiuolo has submitted a modello on request.

1477, July 24
The decision is taken to complete the frontal of the Silver Altar of the Baptistry. Andrea is asked to submit modelli.

1477, August 2
Andrea is paid for two modelli, evidently of historiated reliefs for the Silver Altar.

1477, September 22
Death of Francesca Tornabuoni in Rome. Monument, in Rome, to be done by Andrea.

1477-78, January 13
Andrea assigned the scene of the Beheading of the Baptist for the Silver Altar.

1477-78, March 1
Lorenzo de' Medici asked by Forteguerri monument committee to arbitrate the matter of commissioning Andrea or Piero Pollaiulo to execute the monument. Before the month is up Lorenzo has replied, evidently in favor of Andrea. Final commission follows.

1479

Rather than 1476, as erroneously given by Milanesi (see Passavant). The Christ of the Mercanzia Niche group has already been cast and preparations are evidently being made to cast the St. Thomas.

1479, July 30

The Venetian Senate deliberates on the erection of a bronze equestrian statue to the condottiere Bartolommeo Colleoni of Bergamo (who had died February 1, 1475-76). Andrea and two other masters of bronze, Bartolommeo Bellano of Padua and Alessandro Leopardi of Venice, are subsequently invited to submit models in competition.

1480

Payments to Andrea for finished Silver Altar relief, Beheading of the Baptist.

1480

Andrea's last declaration of property to the *Catasto*. He has bought, and moved into, Donatello's old quarters close by the Opera del Duomo and is supporting three orphaned nieces.

1481, July 12

The Ferrarese Ambassador in Florence writes back to Ferrara to obtain a *laissez-passer* permitting Andrea's life-size ("*naturale*") modello of a horse for the Colleoni commission to go through to Venice. It is possible that Andrea traveled with the model, though doubtful that he stayed in Venice for long at this time.

1483, *evidently May*

Andrea's newly finished modello of the Colleoni Monument horse is seen in Venice by Frater Felix Faber, with the modelli by his rivals. Faber clearly indicates that the winning modello (i.e., Verrocchio's) is of wax.

1483, June 21

The Christ and St. Thomas group, now finished, is set in place in the Mercanzia Niche on Or S. Michele. This unveiling is on the Feast of St. John the Baptist, Patron of Florence.

1485

Altarpiece for the Cappella della Piazza of the Pistoia Duomo, for which Andrea had contracted some years earlier, described as nearly completed.

1486

By this date Andrea had moved permanently to Venice to complete the Colleoni Monument.

1488, June 25

Andrea makes his will. He appoints as chief executor Lorenzo di Credi, who is to see to the completion of the Colleoni Monument. He leaves his two houses in Florence in trust to his brother Tommaso; the studio property is all to go to his principal assistant, Lorenzo di Credi.

1488, *probably June 30*

Death of Andrea. He is buried not in Venice, as he had directed in his will, but with his family in S. Ambrogio in Florence.

1496, March 21

Unveiling of the Colleoni Monument, on its pedestal in Campo SS. Giovanni e Paolo, the bronze horse and rider having been cast, chased, and gilt under the direction of Alessandro Leopardi.

Chapter One

THE ARTIST, HIS WORLD, HIS WORK

His name was Andrea di Michele di Francesco Cioni. He was called Andrea del Verrocchio, and he was the leading Florentine sculptor of the latter part of the fifteenth century. Given his distinguished place in Florentine art and the central place of Florence in Early Italian Renaissance art, one would expect that his reputation should have taken wings. It may seem strange, therefore, that barely fifty years after his death in 1488 Andrea's ghost had begun to labor, as indeed it does still, under a relentlessly clinging burden . . . his relation to Leonardo. That load might be called today the "Cimabue-Giotto syndrome"; it may be more plainly described as the problem that seems to plague the reputation of the master of a better-known, more successful pupil.

It was Dante, in the *Purgatorio*, who gave that notion to western art history. In a brilliant comment on the course of change in the world and in men's reputations, particularly of those whose character is flawed by arrogance, Dante played wittily on Cimabue's epitaph, which was still to be seen in the old Florentine Duomo at the time he was writing the *Divine Comedy:*

> Once, Cimabue thought to hold the field
> In painting; Giotto's all the rage today.
> The other's fame lies in the dust concealed.
>
> (Translation: Dorothy Sayers)

The first Italian art historian, Giorgio Vasari, picked up Dante's verses for his biography of Cimabue. In Vasari's *Life* of Verrocchio (first version 1550, revised version 1568; see translation pp. 176-81), the Cimabue-Giotto succession pattern recurs—though less overtly expressed than in the *Life* of Cimabue—in the Verrocchio-Leonardo succession. For Vasari, Leonardo opened a new and greater era, whereas Verrocchio closed the older one. Diligence and earnestness characterized Verrocchio, whereas matchless facility and highest inspiration characterized his pupil Leonardo, one of those rarest of beings "so endowed by heaven with beauty, grace and talent that he leaves other men far behind."

Not only is he relegated to the role of prosaic forerunner of genius, Verrocchio is also very often pigeonholed merely as the follower of Donatello. A common opinion today —judging at least from one generally consulted American desk-encyclopedia—is that Andrea del Verrocchio is little more than a hinge between two great ages of art, one introduced by Donatello and the other by Leonardo. As the presumed pupil of the former, and onetime master of the latter, Andrea sometimes seems required to assume the historical role of a hyphen.

The purpose of this book is to enter the lists, to use Dante's metaphor in the passage just recalled, in defense of an opposing thesis: that the historical significance of Verrocchio as an artist is dependent neither on his influence on his pupil, Leonardo, nor on his continuation of the teachings of his so-called master, Donatello. His relationship to both of those undoubted giants was not so simplistic. There was unquestionably some element of competition with Donatello; and who knows precisely the nature of his relationship to Leonardo? He was probably not, in any event, dominated by the younger man's "genius." Andrea also had unique qualities and undoubtedly had genius, too. Like any Florentine of his period, he owed much to the past and just as surely helped mightily to prepare the future. But he was very much his own man. It is time, then, to try to define who he was and what he seems to have been seeking.

First question first: Who was he? This is not easy to answer fully. There is the Andrea del Verrocchio, mostly dependent on Vasari, who has come into popularized art history —a Verrocchio thrown rather haphazardly together, a creation that is in considerable part legendary. There is also the Verrocchio of so-called fact—a mosaic of many little hints and a few larger certainties put together painstakingly from documentary evidence. This type of evidence has been used to make up my CHRONOLOGY OF EVENTS. I hold no particular brief for it as a biography. It is probably no more accurate a picture of the real man than the pseudo-legendary portrait in words we have inherited from Vasari. But such a listing of events does have a purpose in that it suggests the complexity of the period in which Verrocchio lived and some aspects of the intricately interwoven worlds of art and human activity with which he had to deal.

Andrea was a Florentine. He was born in Florence; he was brought up there and worked there for most of his life; and he was buried there, in the family vault under the left aisle of S. Ambrogio, the church of the parish where he was born in 1435 and where he lived until he was about forty-five years old.

His beginnings were modest. His father, Michele di Francesco Cioni, worked for a while as a kiln-tender or tile-maker (*fornaciaio*). The street just behind S. Ambrogio is named for the tile-makers (Via della Mattonaia), and just to the south of S. Ambrogio, in Via de' Macci, a Cioni still owns a shop which sells hunting equipment. Andrea's mother evidently died when he was a young child, and like Leonardo, Andrea was brought up by a stepmother. He was the elder of two sons who survived to manhood. His younger brother, Tommaso, whom we shall hear about in connection with problems of docu-

menting Andrea's work, was at least five years his junior and never amounted to much; he rose only to the status of a cloth-weaver and apparently was a spendthrift. In his will, Andrea left Tommaso his personal property but stipulated that Tommaso could not sell any part of it so that enough would remain for dowries for his two unmarried daughters, Andrea's nieces.

Another source of documentary evidence on Andrea's life is the property declaration for the tax known in Florence as the *Portata al Catasto*. Andrea filled out the city tax forms for the *Catasto* on three occasions: in 1457, 1470, and 1480. Like every Florentine citizen, he listed in these his assets (property owned, debts owed him, and so on); and also like every citizen, he was allowed to declare his losses and received deduction for dependents (called realistically *bocche:* "mouths"). In 1457, he listed his stepmother and younger brother as dependents; in 1470, he listed no dependents; in 1480, he listed three unmarried nieces, daughters of his sister Margherita. Evidently Andrea felt the traditional Florentine family loyalty, and he took care of those members who he thought needed protection. In this, one senses a concern for family security similar to that emerging from the biography of Michelangelo. Like Michelangelo, and possibly for related reasons, Verrocchio never married. However, there is no proof in either the documents or sources that he was an overt homosexual. His inner emotional life remains a closed book.

There is one rather mysterious incident in Andrea's youth—it is in fact the only event recorded for that period of his life. It was picked up and published by the nineteenth-century archivist Gaetano Milanesi, but modern scholars have left it aside. Milanesi found a record of a court case in which an Andrea—who appears to have been our Andrea di Michele Cioni—was arrested for killing a wool-worker with a thrown stone. The incident took place outside the city walls near the Porta S. Ambrogio, thus close to Andrea's home. There was apparently a scuffle in which some apprentices, Andrea among them, flew off the handle. The death was called accidental, and Andrea was absolved. There seems to be no reason to cast out the anecdote from the record, and I suggest it be retained as an index of a sort of vitality, and of physical strength and dexterity sufficient to throw a stone with the force and accuracy to kill a man. Sculpture requires strength of arm and dexterity of hand.

In 1457, Andrea reported that he was employed as a goldsmith and was getting so little work that he was no longer active in his trade. He stated that neither he nor his brother Tommaso was earning enough to "keep them in footwear (*chalsi*)." This type of complaint occurs so frequently in the *Catasto* declarations that a distinguished Florentine archival scholar has recently warned us all to discount this kind of talk as a ploy to obtain a better tax rate for the declarer. Unquestionably in 1457 Andrea could have exaggerated his precarious financial situation to that end; but the fifties of the fifteenth century were not, as far as is known, a high point of Florentine prosperity, and goldsmith work in the last years of the decade might well have been in recession, since it depended on the very metals from which specie was coined. Some time, therefore, after 1457 and perhaps

before 1460, Andrea was probably considering leaving one profession in the arts to enter another.

We know absolutely nothing about the date or circumstances of his becoming a sculptor. Actually, the goldsmith's techniques in Florence were not very different from those required by a sculptor in bronze. Lorenzo Ghiberti was trained both as a painter and as a goldsmith before he became a sculptor; one can ask legitimately whether his famous Baptistry Doors are not as much goldsmith work as sculpture.

Ghiberti left a son, Vittorio, to carry on the family shop in the 1450's, and Vittorio is generally credited with the bronze framing of the south doors of the Baptistry around the earlier valves designed and cast in the preceding century by Andrea Pisano (*Fig. 2*); here in the framing on the south the casting is still bolder and the modeling has even greater sculptural vitality than the work of Lorenzo. The framing of the south door has special interest for us because certain elements suggest a context for Andrea's beginnings in monumental bronze, and the influence can be traced clearly even in his later work in stone (*Fig. 1*). One senses also a kinship of esthetic in small-scale work in metal that Andrea as a goldsmith might have shared with his near contemporary Antonio Pollaiuolo, who was also to become a celebrated sculptor in bronze. Characteristic of those shared interests is the highly ornamented yet still sculptural silver base for the crucifix of the High Altar of the Florentine Baptistry. This commission was given to Antonio Pollaiuolo in 1456, at the time we believe Andrea was still a practicing goldsmith, though possibly already thinking of moving on into sculpture. Later, in the seventies, Andrea and Antonio were commissioned to work in silver for the altar antependium (*Figs. 91, 92*).

Andrea's beginnings in marble carving are harder to ferret out. The technical connection of marble carving with goldsmith work is so tenuous that one must suppose a special apprenticeship in working marble. The usual course in fifteenth-century Florence was to begin with decorative work, then gradually to go on to large-scale relief or statuary. In the 1450's marble-sculptors were having a difficult time in Florence. One of the best, Mino da Fiesole, left the city in the middle of the decade for programs in Rome and Naples. In Florence, the chief marble-sculptor (he is not recorded as ever working in bronze) was Desiderio da Settignano, whose reputation had spread north to Milan and south to Rome, as we know by recent discoveries in the archives. Apparently second only to Desiderio's bottega was the one shared from time to time by the two Gambarelli brothers, who went by the nickname of Rossellino. If Andrea wanted employment and instruction in marble working, these two botteghe were the places to turn to in the late fifties. Donatello, to be sure, had returned to Florence from Padua in 1453, but he had no large program in marble in hand at the time, and indeed spent most of the period of 1453 to 1460 either working in Siena or executing projects for the Sienese. We have no record, in fact no trustworthy indication whatsoever, that Verrocchio ever worked in Donatello's studio as an assistant or pupil. There are stylistic indications that he could have worked—

at least for a time, from about 1460 on—in the shops of Desiderio and the brothers Rossellino. This stylistic evidence will be discussed in its proper place in Chapter Three; for the time being I am interested mainly in sketching the possibilities for his training.

The chances are that Andrea began as a sculptor working for some years as an assistant in a large bottega. As far as one can judge, he did not become his own master, as it were, until fairly late in the sixties. Only in 1469 was he enrolled in the sculptors' guild in Florence; and only in 1472 was he enrolled in the painters' Company of St. Luke. Both enrollments must have been prompted by technicalities arising from large public commissions that involved the formation of a bottega with numerous assistants. Otherwise, as an artist working as part of a bottega other than his own, or even more or less independently on smaller commissions for private patronage, he would not normally have required guild membership as a master painter or sculptor if he were already enrolled in another Florentine guild—and we believe Andrea had been a member of the goldsmith's guild for some time, at least since 1457.

In 1457, Andrea was already in his twenty-third year. For a Florentine of the Renaissance that age was maturity; in the fifteenth century one could reach one's majority as early as the age of eighteen—in some cases fifteen—according to fairly recent computation. It would be inexplicable if Andrea were not active as a productive artist by 1460, at least. Unfortunately our curiosity about these early years remains unsatisfied: Andrea's first documented work can be dated (as completed) only to the year 1467. And we have absolutely no record of his production as a goldsmith, or silversmith, until 1477-80, when, with Antonio and Piero Pollaiuolo and two others, he was asked to contribute the relief in silver for the altar antependium of the Florentine Baptistry that we have noted briefly (p. 21). Vasari retails the tradition of Verrocchio's manufacture of some morses for ecclesiastical use and two "bowls" so cleverly ornamented that other craftsmen had casts of them in their workshops to serve as models for their own designs. The relative anonymity of goldsmith work, even pieces of the fifteenth century, makes most dubious the prospect of identifying Verrocchio's early work in that art—even supposing some of it still survives. Personality and personal style are much easier to distinguish in sculpture, particularly in marble carving, where not only the touch of the chisel but the larger scale of the forms offer the eye a more satisfactory field for critical judgments.

It is necessary to say here that there are few more controversial areas of art history than that which proposes the hypothetical "early," undocumented, work of Verrocchio as a sculptor. No one can seriously maintain today that any sizable Florentine commission in marble is wholly the autograph work of the master to whom it is attributed. Large funeral monuments (for example, Bernardo Rossellino's Tomb of Leonardo Bruni in S. Croce, Desiderio's Tomb of Carlo Marsuppini in the same church, or Antonio Rossellino's Tomb of the Cardinal of Portugal in S. Miniato al Monte) or large altars (like that by Desiderio in S. Lorenzo) are the products of several assistants' "hands" along

with the master's. With a little visual practice, we may pick out with our own eyes the places where one hand stops and another begins; generally speaking, the work of one hand will correspond to the unit of marble worked, whether it is a whole figure or a section of figured or ornamented relief. The real difficulty comes in identifying the hand by name, for an assistant is not normally named in the document of commission or payment that identifies the master. Thus, while we know that Antonio and Bernardo Rossellino were responsible in business partnership (*compagnia*, as it was called in Florence) for the Tomb of the Cardinal of Portugal, we can only surmise, and not always satisfactorily, the identities of the various assistants whose hands can be picked out on the monument today. The Tomb of the Cardinal of Portugal is unusually well documented, more completely than any other Florentine monument of its date and class. If there are uncertainties here, one can imagine what they are in other monuments where we might look for Verrocchio's participation as an assistant or unnamed partner. Yet it is precisely in such circumstances that Verrocchio must have done his first work in marble.

Once he had made that beginning, small but more independent commissions would have come to him. Then, with minor assistance only, he would have a free hand to express his own sculptural ideas. The pavement-tombstone of Fra Giuliano del Verrocchio, still to be seen in the floor of S. Croce (*Fig. 29*), seems to have been such an early commission. The patron would have been a student of Fra Giuliano's, a member of the Medici family, though not of the famous branch of Cosimo and Lorenzo (see NOTES ON THE PRINCIPAL PIECES, pp. 161 ff.). Unfortunately, the inscription on the tombstone does not give its date; it seems to have been made at least twenty years after the subject's death. Moreover, the surface, as it often is in floor-memorials in Florentine churches, is so worn that it is hard to be sure of the style. However, within those limitations there is every indication that the carving was done by Andrea. This S. Croce tombstone is particularly interesting not only because it may be dated as early as 1465 but because it brings together the names of the Verrocchio family and the Medici, two families which were to play a large role in the artist's life and career.

In the sources from 1467 on, Andrea was nicknamed "del Verrocchio." The precise origin of the name is still somewhat uncertain. We are given a choice between two alternatives that today seem to be decidedly unequal in historical probability. The older theory is the weaker. It used to be supposed that Andrea was named "del Verrocchio" after his "first master," a shadowy goldsmith by the name of Giuliano Verrocchio. But the dates of that Giuliano do not fit the historical situation very well; he is now thought to have been twelve years Andrea's junior—and is not known to have been a goldsmith. It is more likely that the nickname "del Verrocchio" was given to Andrea because as a young man he was patronized by the Verrocchio, one of the older patrician families of Florence; the Fra Giuliano for whom Andrea may well have carved the tomb in S. Croce was a distinguished member of that family.

This brings us to the important topic of Verrocchio's patronage, for what he might have hoped to achieve was circumscribed by the then existing conditions of patronage for sculpture. In the fifteenth century, sculpture was far more expensive than painting. It was also much more a part of the actual ambient of city life, in exterior and interior monumental memorials and tangible celebrations of human worth and history. The documented works of Verrocchio are to be classified mainly as public or semipublic monuments, though some had their origin in semiprivate programs, mostly for the Medici. The earliest documented works are Medici commissions: one (the tombstone of Cosimo Pater Patriae) must have come from Piero il Gottoso, Cosimo's eldest son. Piero seems to have inherited his father's expensive taste for fine buildings, for beautiful books, and for precious works of art. He was devoted to his father's larger family projects: the burial place in S. Lorenzo and the villa at Careggi where Cosimo had installed Ficino and the Neoplatonic Academy. It is tempting to ascribe to Piero's patronage, rather than to Lorenzo's, the Winged Boy with Dolphin fountain figure for Careggi (here called Eros with a Dolphin) and quite possibly also the bronze David sold to the Signoria in 1476. Ostensibly, from internal evidence, Piero commissioned the Lavabo of the S. Lorenzo Sacristy. Piero was also on the committee which supervised the commissioning of Verrocchio's only great public monument in Florence, the bronze group of Christ and St. Thomas for the Mercanzia on Or S. Michele.

It was in this group that Verrocchio first openly and directly challenged his predecessor Donatello. In the 1420's, Donatello had designed the niche for the Parte Guelfa on Or S. Michele and executed in bronze gilt the huge figure of St. Louis of Toulouse that so grandly filled this space. Some time before 1463 the Parte Guelfa fell into disfavor; in that year the niche was given over to the merchants' tribunal, the Mercanzia, and the statue of St. Louis was moved to S. Croce. Only late in 1466, or possibly even in 1467, did the committee charged with commissioning new statuary for the niche decide on Verrocchio as the sculptor. When Andrea came to design the sculpture, he broke dramatically with Donatello's example by providing not one large figure, but a group of two smaller and more active ones; the over-all effect is in striking contrast (*Figs. 5, 6*). The same degree of contrast is found in comparing Andrea's David with Donatello's David of about 1435 (*Figs. 7, 8*).

The final chapter in the undeclared competition between Andrea and Donatello was written in the complicated story of the equestrian monument to the memory of the Venetian general Bartolommeo Colleoni of Bergamo. It was Colleoni who instigated that competition by bequeathing to the Venetian Republic funds for an equestrian statue of himself that—in direct analogy to the placement of Donatello's Gattamelata Monument in Padua—would stand in front of the most famous pilgrimage church of the city. In Venice, this was of course S. Marco, just as in Padua it was S. Antonio. By perhaps not entirely justifiable legalistic means, the Venetians worked around the terms of the bequest and finally had the statue erected near the Scuola di S. Marco in the Campo SS. Giovanni

e Paolo. There it was raised on a high base similar in general effect, but different in principle of design, to that of the Gattamelata Monument. The statue is so placed that from one of its principal views (one can not really speak of *one* principal view) it is visually united with the façade of the Scuola di S. Marco—if not with the church of the same name. Comparing the merits of Donatello's and Andrea's bronze equestrian statues (*Figs. 9, 10*) is to this day a favorite exercise among lovers of sculpture, and, alas, one all-too-routinely assigned to students of the history of art. Neither work deserves academic embalming. That surely is one point on which the partisans of Donatello and those of Verrocchio will agree.

It must be evident even from a casual glance at the contrasting Or S. Michele niche figures, the two bronze Davids, and the two monumental equestrian statues, that Verrocchio was far from being a docile pupil of Donatello (a relationship for which we have no written evidence) and was in fact a none-too-respectful rival: what the Renaissance would have called—with a sharpened edge to the word—an *aemulus*. Almost two generations separated them. Donatello's spiritual home was the Florence of sober old Giovanni di Bicci de' Medici and of Cosimo Pater Patriae, the more truly "republican" Florence of Coluccio Salutati and Leonardo Bruni of 1400 to 1440; Verrocchio belonged to the far showier, more brilliant era of Piero and Lorenzo de' Medici and of Poliziano, after 1465. Donatello and Verrocchio shared, each in his own way, enthusiasm for the Antique; this was indeed their heritage as "modern" descendants of the ancient Etruscans. Both worked as well in the spirit of their own times; they were alike inventive and enjoyed innovating—if not in creating something unprecedented, at least in taking a refreshingly novel and eye-opening approach.

Andrea worked for a broad spectrum of patronage which is reflected in the subtly shifting styles apparent in his work: not only for the princely Medici but also for the City Council of Pistoia (the commission, which he never completed, for the Cenotaph of Niccolò Forteguerri); for the Tornabuoni family (the Tomb of Francesca Pitti Tornabuoni in Rome); and for the Venetian Senate (the Colleoni Monument, which he also left uncompleted). There is some evidence that Andrea's quick and lively style in modeling clay appealed to connoisseurs of his day, just as in a later period Lorenzo Bernini's clay sketches, those famous *bozzetti*, appealed to seventeenth-century collectors and patrons in Rome. Vasari speaks of Andrea's work in the related genre of small bronzes as well.

Verrocchio also designed armor and standards for ceremonial "jousts." He seems to have taken death masks and possibly life masks of the prominent. He was by all odds the most sought-after sculptor of his period—*decus Florentiae*, as he is called in a contemporary tribute in Latin: the "glory of Florence." When Lorenzo the Magnificent de' Medici wished to give a present to the King of Hungary, he sent two reliefs by Verrocchio. When the King wished to reciprocate by making a gift to Florence, he chose Verrocchio as sculptor of a fountain, never completed to be sure, but quite possibly intended to stand

in the Piazza della Signoria. A beautiful late-fifteenth-century panel in the Walters Gallery in Baltimore shows the central position to be accorded a fountain within the esthetic economy of the Ideal City of the Renaissance (*Figs. 11, 12*).

There statuary plays the major role of visual accent; architecture is used more generically, to provide a setting rather than a focus of attention. Statues of three Virtues (Temperance, Fortitude, and Justice), with the civic desideratum of Abundance, are placed, in the mode of Roman Antiquity, high above the paving on splendidly carved columns; at the intersection of the imaginary diagonal lines between the columns is a fountain whose water symbolizes both life and purity. Its sculptural apex, the active little genius spouting water, the running putto on a globe, strongly recalls a motif frequently attributed to Verrocchio. Possibly the idea of the uncompleted gift from the King of Hungary lives on in the view of the Ideal City whose geometrical perfection, in the Platonic sense of immaterial ideal form, exists in realms beyond the laws of earthly physics, in the pellucid depths of the intellect.

Vasari called Andrea a student of "visual geometry." By the Vasarian term (*prospettivo*) we may understand an expert in the application of the theory of perspective and proportion rather than a practicing architect. There is, indeed, little that we can ascribe to Andrea's architectural creativity except perhaps part of the Silver Altar of the Baptistry, the beautiful little arcaded interior in which is played the drama of the Beheading of the Baptist (*Fig. 93*). The harmonious design of the marble and bronze base for the Colleoni Monument (*Fig. 9*) bespeaks extremely sophisticated architectural insight, perhaps Leopardi's—more probably another's—but not Andrea's; the design suggests Venetian rather than Florentine taste and training.

There is, however, more evidence for Andrea's skill as a painter and draughtsman. The single extant documented painting by Andrea is a medium-sized altarpiece of the Madonna with Saints in the present Chapel of the Sacrament of the Pistoia Cathedral (*Fig. 14*). The design is almost certainly Andrea's, but the execution is not his, at least in its entirety. The picture attracts relatively few visitors today, but at least in its presence one does not risk being crushed by the onrushes of guided tours, in contradistinction to the more celebrated San Salvi Baptism in the Uffizi. The San Salvi Baptism (*Fig. 13*) contains the angel introduced, according to Vasari's famous statement (in this case quite accurate), into Verrocchio's picture by his pupil Leonardo—the angel that has been aptly called a "visitor from another world." According to Vasari this angel was "the reason why Andrea would never touch colors again, he was so ashamed a boy understood their use better than he did." This last part of the anecdote is not historically sound, for Andrea was indeed active as a painter afterwards, as we have noted above, in the design and perhaps even in some small part in the execution of the Pistoia altarpiece. In any event, the usual collaboration of members of his bottega is brilliantly illustrated by Leonardo's intervention in the San Salvi Baptism.

The Pistoia altarpiece is clearly even more a bottega effort. Collaborating in its painting were Lorenzo di Credi, who seems to have finished it, and Perugino, and very possibly Ghirlandaio as well. Verrocchio's own brushwork most likely appears in the San Salvi Baptism, particularly in the figure of the Baptist. If this is so, one can easily see why Vasari described Andrea's art with the phrase *maniera alquanto dura e crudetta* ("a rather harsh and somewhat coarse style"). What we see today, however, may be only an underpainting that still awaits a softer finish in subtler strokes of the brush.

Probably more characteristic of Andrea's intent is the still earlier painting of the Virgin and Child now in the State Museum in Berlin-Dahlem; its original format is perhaps more closely preserved in an early replica in the National Gallery of Art, Washington (*Fig. 15*). The composition is reduced to three sculptural masses: the Virgin, the Child who reaches toward her, and, behind the Child, an echoing, but inert mass of hill or bluff in the otherwise neutral landscape. Nowhere does one sense the sculptor in the painter more directly than here; the dynamic thrust of the action of the Child's arms and chubby hands is forerunner to the gestures of the St. Thomas and the Christ of the Or S. Michele group, and—though the comparison is less obvious—to the forward thrust of horse and rider of the Colleoni Monument.

If we take the Berlin Madonna as autograph work, an assumption quite generally made today, we must admit that a sense of color was not a strong point of Verrocchio as a painter. In the San Salvi Baptism also it is the drawing, rather than the color, that gives vigor to the wan figure of the Baptist.

Andrea was to all appearances a remarkably fine draughtsman. The sheet of pen drawings of putti in varied poses in the Louvre (*Figs. 17, 18*) may be taken as autograph work not only because of its quality but also because of the roughly contemporaneous inscription on one side that specifically refers to Andrea del Verrocchio by name ("*Varochie*"). The pen rushes across the sheet, as if moving with delight from one active little figure to its neighbor, until the white paper is filled with rounded forms alive with the roll, wriggle, crawl, and stagger of babyhood itself. A likely attribution, of the 1470's, is the even more rapid sketching-in of a baby's pose on the reverse of a sheet in the Uffizi (*Fig. 19*).

We can date more exactly, to 1475-76, a smaller but more finished drawing also in the Uffizi, a Sleeping Nymph and Cupid (*Fig. 21*). The triangular shape of the ground is consistent with the usual Renaissance shape for stiff banners or standards of the fifteenth century; we almost certainly possess here an early drawing for the tournament standard that Andrea is known to have made at the time of the "Giostra" of 1476 that Giuliano de' Medici dedicated to his *inamorata*, Simonetta Cattaneo Vespucci. It would be too good to be true if the design transmitted by the little Uffizi drawing were actually that for the standard carried by Giuliano in the tournament. It shows Love as a "young spirit"—the *spiritello* of a document describing a standard that Andrea actually did make; but according to the testimony of a further document, the *spiritello* banner was borne by a follower,

while Giuliano himself carried a standard with the dignified image of Pallas, an emblem more befitting the Prince on public parade.

In the British Museum (from the Malcolm Collection) is a sheet which carries the design of the standard two steps further. On one side of the paper is the structural laying-in of the head of the nymph at approximately life-size, at the scale of the finished work of art (*Fig. 22*). You can see at the left trace of the hand that supports the languid head in precisely the same pose as in the earlier smaller drawing of the whole figure. The drawing is indeed structural; it is like a scaffolding for a more elaborate encasement in a building; you sense the major abstract planes of the head rather than their surfaces. This is the way a sculptor would start out to model a head in clay or carve it in stone. On the other side of the sheet is the step that takes us to the fully modeled surfaces, the forms with all their delicate transitions from minute plane to even smaller shifts of direction (*Fig. 23*). It is a head that exists in half-light with extremely subtle modulations of shading—luminous, soft, yet also firm and resistant. It is possible here to see where Leonardo found a prime impetus toward his theories of form in subtle contrasts of light and shade in his *chiaroscuro*. This is evidently an idealized head—not of the Madonna, surely, as has been suggested, but, from the wiglike hairdo with its elaborate coiling, more likely of a nymph or a Venus. Simonetta herself? Not even the remotest chance, as we shall see in Chapter Three, when examining a marble portrait possibly of the lady in question. But all the same, it is a magnificent example of Andrea's fully developed sculptural, and also painterly, style of drawing.

There remains one more type of drawing to be associated with our artist (*Fig. 24*). In the Victoria and Albert Museum, London, there is a sketch of a tomb in black chalk, unfortunately marred by later additions by another hand in ink. Above the sarcophagus hover three Virtues, with Justice clearly the central one; at the summit are matching groups of putti at play, while two putti bearing shields sit on the sarcophagus and further putti decorate the console at the base of the composition. The figure of a lion with a book (the usual Venetian symbol of St. Mark) indicates that the tomb design is for a Venetian commission—and for a doge's monument at that, for in fifteenth-century Venice only doges were given such splendid habitations for their corpses. A second study, in the Louvre, is a loose copy of the London sketch by the same hand that went over the original in ink; in the Louvre drawing, heraldic designs on the shields borne by the putti indicate unmistakably that the doge to be buried in the sarcophagus below was a member of the Vendramin family. He would be that Andrea Vendramin whose funerary monument was erected by about 1495 in the Church of the Servi. The exact dating of the Vendramin Monument should be treated cautiously; but the drawing by Verrocchio would seem to show that some time after 1485, when he arrived in Venice, and before 1488, when he died, the Vendramin heirs were already well enough along in their plans to employ the sculptor who had been chosen to execute the most dramatic public monument in all Venice, the memorial to Bartolommeo Colleoni. Andrea died in 1488

before he could cast the Colleoni, and it would seem that death also prevented him from working out final designs for the Vendramin Monument. That task fell to Tullio Lombardi and his bottega, while Alessandro Leopardi cast the Colleoni equestrian statue. Thus Venetians finished the two proudest civic monuments of Venice at that time, commissions granted originally to a Florentine.

Verrocchio was part of the diaspora of Florentine artists who in the last two decades of the fifteenth century left their own city to work in such centers as Milan, Naples, Rome, and Venice. Lorenzo de' Medici did little to halt this trend; he seems even to have encouraged it. Art was an important part of his foreign policy, as is shown by the gift to Matthias Corvinus, and even more clearly (as George Hersey's recent work demonstrates) in the patronage of the Neapolitan king, Alfonso II. In Lorenzo's thinking, Florentine sculptors, painters, and architects were more useful as elements of prestige abroad than as expensive luxuries at home. As soon as Verrocchio had finished the Christ and St. Thomas for the Mercanzia, he was free to go to Venice to finish the models of the Colleoni Monument figures and to cast them there. Exactly when he did leave Florence is not known. Recently found legal testimony by Lorenzo di Credi, Andrea's chief assistant, indicates that he did not move permanently to Venice until some twenty-six months before his death—in other words, not until after the Florentine New Year's Day of 1486 (Julian calendar). However, he had had occasion to go to Venice earlier: in 1483 when he won the competition for the Colleoni Monument, and later, no doubt, to make arrangements for setting up a studio there, though a full foundry may not have been necessary if he had access to the foundries of the Venetian naval arsenal.

While Verrocchio was in Venice, his large and successful bottega in Florence was under the direction of Lorenzo di Credi. As of 1480, Andrea had moved into working and living quarters once occupied by Donatello close by the Opera del Duomo, where he could conveniently receive delivery of marbles needed particularly for the Forteguerri Cenotaph, commissioned in 1478. In the ensuing decade the shop was the busiest and most influential in Florence. Lorenzo di Credi was named heir to the contents of the studios, and to the unfinished commissions, by Verrocchio's will of 1488, but business was so flourishing that Credi personally was able to complete only a fraction of the work for which Verrocchio had contracted.

Evidently the shop was as important for Verrocchio as he was important for the shop. His work must be approached as the product of a system in which several hands, minds, and temperaments might be involved in the making of a work of art. However necessary this approach may seem in the light of history, our experience of the art closest to us, the painting of the nineteenth and twentieth centuries, makes it difficult and incongenial. We want the "master's hand." Unfortunately we will not get it very often in this context of the bottega; we may, however, get the imprint of a personality—often elusive to be sure, but at least subject to discussion and perhaps at times to general recognition.

It was in his capacity as head of a large bottega that Andrea was praised by Ugolino Verino in the contemporary *De Illustratione Urbis Florentiae* as an artist "not unequal to Lysippus—a fountain from whom painters have imbibed whatever [skills] they have, the master of painters whose fame [literally, name] flies through every city of the Tyrrhenian region." In his famous late fifteenth-century rhymed *Chronicle*, Giovanni Santi, father of Raphael, also speaks of Verrocchio using the metaphor of the fountain: "the clear fountain of humanity and inborn gentility which together provide a bridge between the arts of painting and sculpture and over which the noble Verrocchio [*l'alto Andrea di Verrocchio*] passed with such sagacity and skill [*destrezza*]."

The combination of skills which Andrea possessed in several techniques gave his style, or styles, definition and elasticity. Similarly, his ability to work in several techniques, as well as to direct students, must have been the source of much of his popularity as a teacher. His was indeed the most important single bottega both for sculpture and painting in Florence up to about 1485. When he left that city, the slack in painting was taken up by Domenico Ghirlandaio (a former pupil) and by Botticelli. But he had no direct successor as a sculptor in the Florentine area (except perhaps Francesco di Simone), though it is possible to trace the heritage of his style in Florence, in some part through Leonardo, to Rustici in the early sixteenth century.

A painted or drawn likeness of Andrea may have survived to 1550. In that year Vasari published, in connection with his *Life* of the artist, a small woodcut purporting to represent Verrocchio (*Fig. 27*). Of course the shift in scale from a life-size portrait and the linear simplification necessary for the wood-block probably altered the likeness considerably, whether its source was a drawing (which is possible) or a painting. On the drawing of putti in the Louvre (cf. p. 27), Andrea is addressed in Latin by an unknown but evidently admiring and knowledgeable fifteenth-century author with the words "*crasse Varochie*": "fat" or "stout Verrocchio." The Vasarian woodcut shows us a face that is indeed corpulent. Another possible portrait is a fine drawing of a full-faced man in the Uffizi Gabinetto di Disegni (No. 250F), attributed to "Follower of Castagno." Clarence Kennedy at one time proposed this drawing as a possible self-portrait. Berenson classified it as by an "unknown Florentine between Castagno and Botticini," implying a niche which would precisely fit what we know of Andrea's painting and drawing styles. A third possible likeness is a painting now in the Uffizi of a fleshy man holding a small scroll of paper (*Fig. 28*). The picture has most recently been identified by Passavant as perhaps the portrait of the artist painted on a panel mentioned in the inventory of the studio taken after Andrea's death. The Uffizi painting has been from time to time called a self-portrait of Perugino, which it clearly cannot be. (But at least "Perugino" is close geographically—in 1769 the painting was given a dubious attribution to Holbein and, even more fancifully, was identified as Martin Luther.) One would not like to think of our painter-sculptor as this dough-faced, pinch-lipped, cold-eyed individual. But this panel-picture could well be the most "speaking" of the three candidates for Andrea's

likeness. It would show us at least his business side—the merchant-entrepreneur and eminently successful director of the biggest bottega of its period in Florence.

We know very little of Verrocchio's tastes. The same inventory that mentions his portrait, however, lists a number of books that must have been his personal property; they are notably secular in character. He was evidently not what we would call a learned artist, but was sufficiently educated to read and to enjoy owning books. To judge from his tax reports he was far from poor, but not truly much more prosperous than the average property owner or the small-businessman.

In the list of the equipment left in his studios after his death are items which may be casts after nature for study; some twenty "masks"—presumably made after nature, whether in life or death—were listed by his brother Tommaso in the inventory of unpaid Medici commissions that was presented to the heirs of Lorenzo in 1495-6. Evidently study directly after nature interested Andrea a great deal. Toward the end of his *Life*, Vasari returns to the notion of diligence with which he had introduced Verrocchio, tempering his writing now by an evident admiration for his subject's pre-eminent place in the naturalistic movement of his generation. In Verrocchio's bottega painters were taught how to render the folds of drapery by copying meticulously in monochrome— "with the point of the brush," as Vasari says—models draped with cloth which had been dipped in plaster and allowed to harden into the pattern of folds it took as it fell naturally into place. A number of such drawings, some of them optimistically at one time or another attributed to Leonardo or to Verrocchio himself, have survived. Vasari speaks also of accurate molds, not only of faces but of hands and feet, which Andrea took from nature using a special plaster. The *Life* also mentions Verrocchio's connections with a Florentine maker of ultra-realistic images in wax, a man named Orsino. Such wax likenesses were painted and clothes belonging to the owner were placed over a rudimentary armature to suggest the body. These waxworks, for such they were, were placed as *ex-votos*, or thank-offerings, near shrines like those of the famous miracle-working paintings in SS. Annunziata and Or S. Michele. Lorenzo the Magnificent in his own lifetime was represented in this way, and in a later chapter we shall have to consider that fact in dealing with the origin and attribution of the famous bust of Lorenzo now in Washington. What Vasari recounts is an episode in a much larger chapter of Renaissance art: a segment of art history dominated by a virtually obsessive desire to equal if not to outdo nature in portraying reality. It was the period which produced the hyper-realist North Italian Guido Mazzoni, who worked in Naples and in France, satisfying the tastes of kings as well as burghers.

In Florence, the life mask, or more frequently the death mask, was taken, much in the fashion of the later Middle Ages in France, and also as a local Italian continuation of Roman custom. If the "true" features of an individual were to be memorialized, what better, more efficient way? The Renaissance preserved these records of human individuality with a special kind of piety. Occasionally a mask seems gruesomely close to the very

minute of death, and we seem to be present at that moment. Such a mask, of a lady, is in the Louvre (*Fig. 25*); some time after its execution it was given the protection of a wreathed frame. Often a mask from life as well as a death mask was used as the model for the face of the tomb effigy, as, for example, on the tomb of Giovanni Chellini, Donatello's physician. Sometimes, for a member of a prominent family, the mask was encased in molded cloth and the whole was cast directly in bronze by the lost-wax process (*Fig. 26*), as was the commemorative bust at times tentatively identified as that of the widow of Piero de' Medici. In such ways human flesh actually becomes sculptural and sculpture becomes the "thing itself."

Surely the attainment of this haunting ideal of the concrete and the realization of the immediate truth—even, if necessary, the bitter truth of ugliness and sadness—was a major goal of Andrea. We find that goal later transmuted by Leonardo's magic into a kind of poetry of science. But the "real" can mean much, including the ideal "reality" portrayed in Antique art. Behind the immediacy suggested by almost everything Andrea touched, there is an elusive quality of pondered knowledge growing from his taste for the Antique, a quality as characteristic of the Florentines as their sense of the present. The proportion is hard to compute, but both are there for us to rediscover and evaluate for ourselves in a time when past and present are not so easily joined.

1. *Verrocchio.*
Detail of Framing of Tomb of
Piero and Giovanni de' Medici.
S. Lorenzo, Florence. Marble

2. *Vittorio Ghiberti.*
Detail of Framing of the
South Door of the
Baptistry, Florence. Bronze

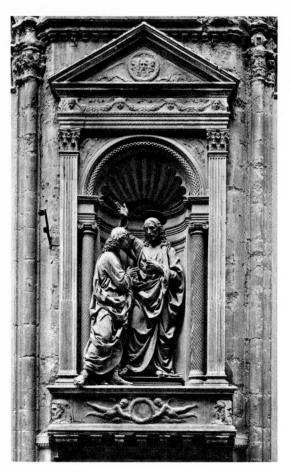

5. *Verrocchio. Christ and St. Thomas.*
Mercanzia Niche, Or S. Michele,
Florence. Bronze

6. *Donatello. St. Louis of Toulouse*
(in original setting). Now Museo,
S. Croce, Florence. Bronze gilt

7. *Verrocchio. David. Museo Nazionale*
(Bargello), Florence. Bronze

8. *Donatello. David. Museo Nazionale*
(Bargello), Florence. Bronze

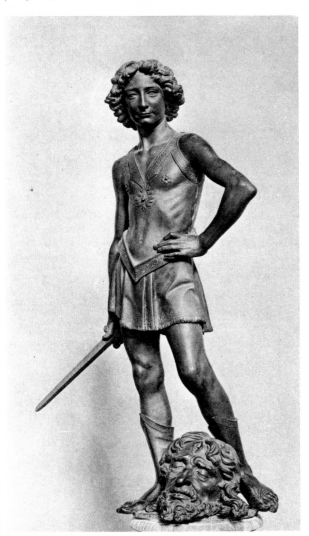

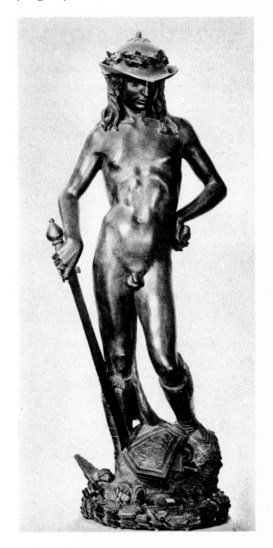

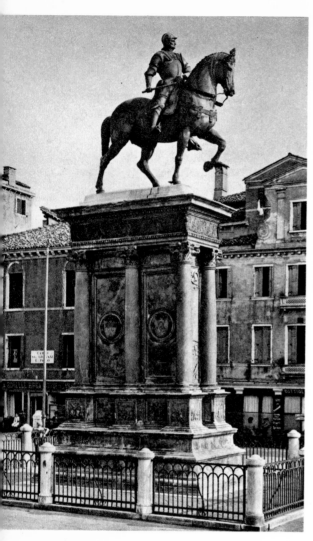

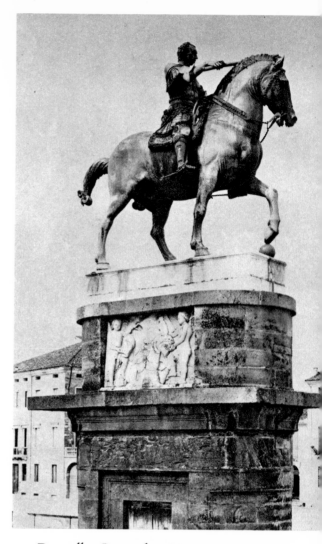

9. *Verrocchio. Colleoni Monument.*
Campo SS. Giovanni e Paolo, Venice.
Bronze; bronze and marble base

10. *Donatello. Gattamelata Monument.*
Il Santo, Padua. Bronze; stone base

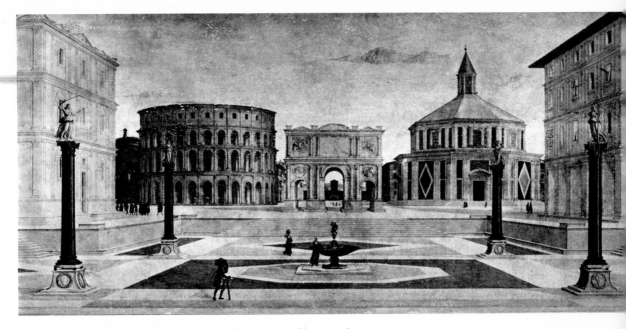

11. *Unknown Painter. Ideal City. Walters Art Gallery, Baltimore*

12. *Detail of Fig. 11*

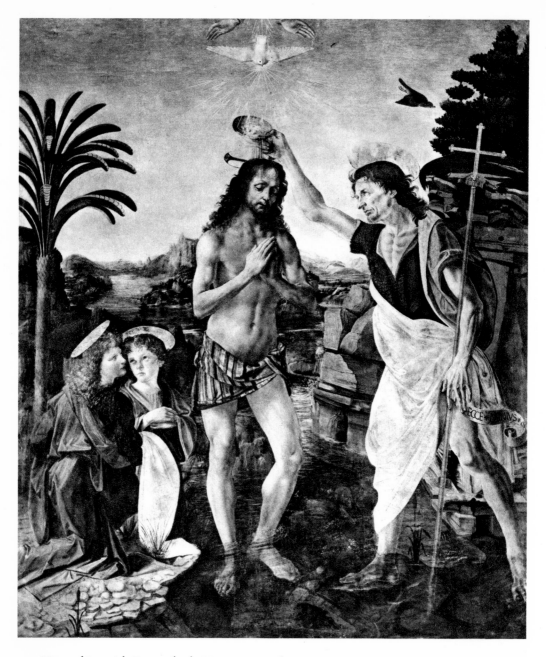

13. *Verrocchio, with Leonardo da Vinci. San Salvi Baptism.*
Uffizi, Florence. Tempera and oil on panel

14. *Verrocchio design; Bottega execution (mainly Credi).*
Medici Altar. Duomo, Pistoia. Oil on panel

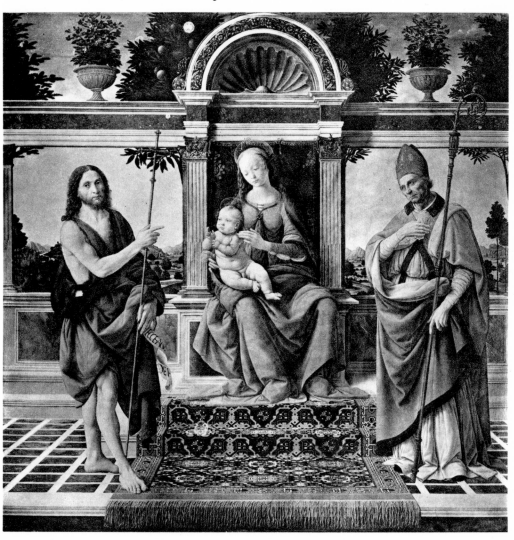

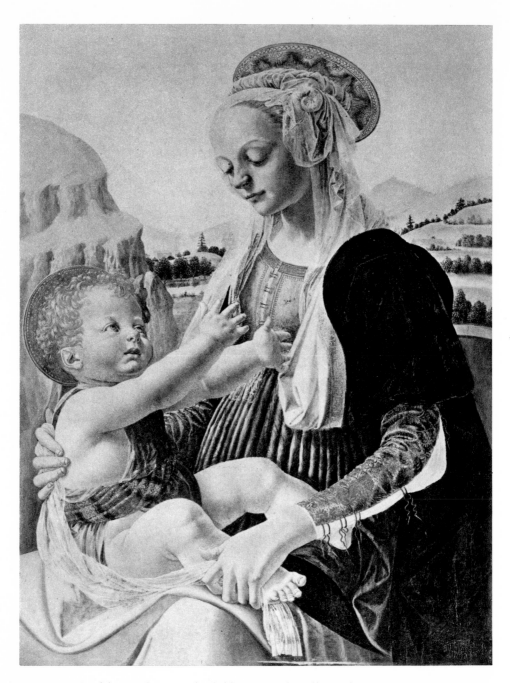

15. *Verrocchio*(?). *Madonna and Child. National Gallery of Art,
Washington, D.C. Tempera and oil (?) on panel*

16. *Domenico Ghirlandaio, following a compositional type of Verrocchio. Madonna and Child. Palazzo della Signoria (Palazzo Vecchio), Florence. Fresco*

17. *Verrocchio. Drawing sheet of Putti (recto). Cabinet des Dessins, Louvre, Paris. Ink on paper*

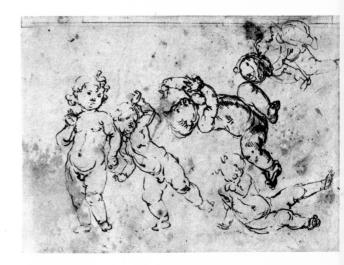

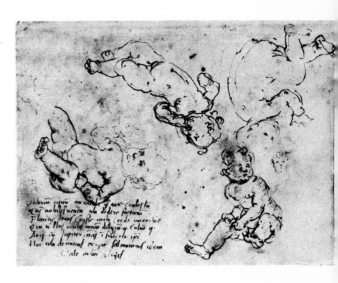

18. *Verrocchio. Drawing sheet of Putti (verso). Cabinet des Dessins, Louvre, Paris. Ink on paper*

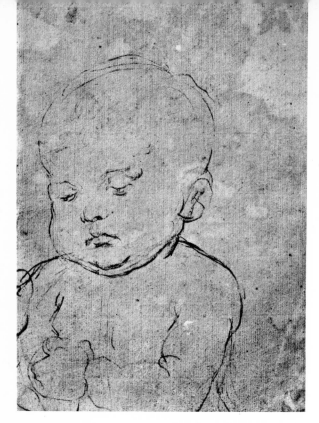

19. *Verrocchio. Sketch of Infant for a Madonna and Child, possibly for the Pistoia Altar. Gabinetto di Disegni e Stampe, Uffizi, Florence. Black chalk on paper*

20. *Verrocchio. Head, pricked for transfer, possibly of an Angel for the San Salvi Baptism. Gabinetto di Disegni e Stampe, Uffizi, Florence. Black chalk reinforced with bistre on paper*

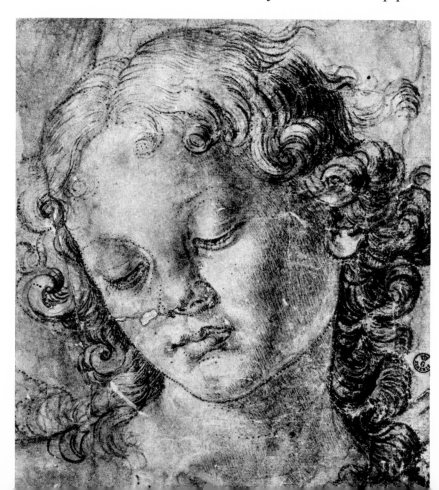

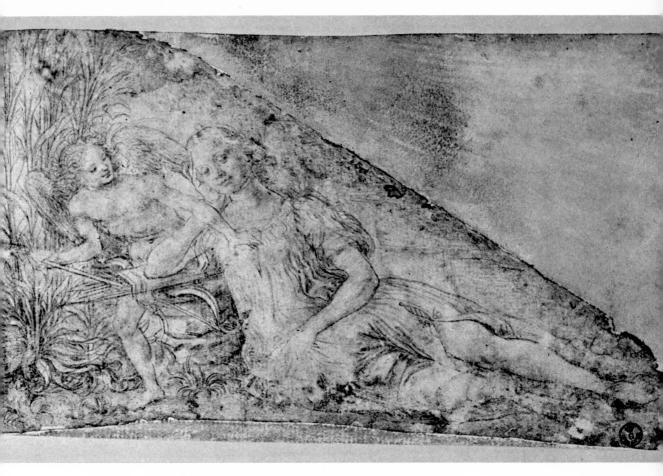

21. *Verrocchio. Sketch for a Standard with figures of Amor and a Sleeping Nymph. Gabinetto di Disegni e Stampe, Uffizi, Florence. Silver point and bistre wash on paper*

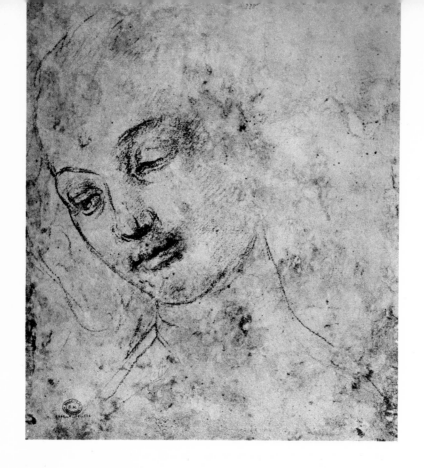

22. Verrocchio.
Drawing of a head of
a Nymph (verso of Fig. 23).
British Museum, London.
Black chalk on paper

23. Verrocchio.
Drawing of a head,
probably of a Nymph
(recto of Fig. 22).
British Museum, London.
Black chalk on paper

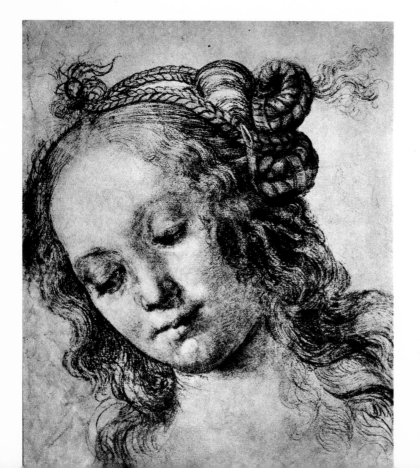

opposite page: 24. Verrocchio,
with overdrawing by another
hand. Sketch for a Venetian
Tomb, probably that intended
for Doge Andrea Vendramin.
Victoria and Albert Museum,
London. Black chalk on paper;
overdrawing in ink

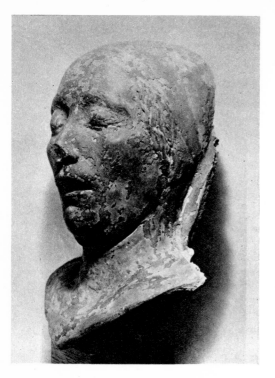

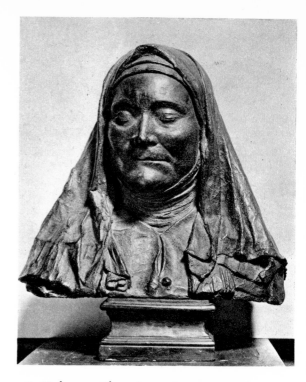

25. *Death mask, probably of Battista Sforza, wife of Federigo da Montefeltro. Louvre, Paris. (Detached from later addition of a wreath-frame.) Gesso or stucco*

26. *Unknown Florentine artist, ca. 1470. Bust of a Lady based on a death mask. Museo Nazionale (Bargello), Florence. Bronze*

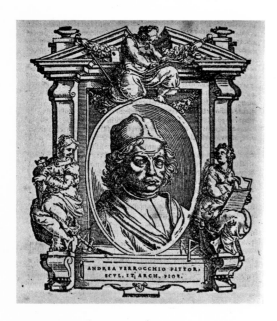

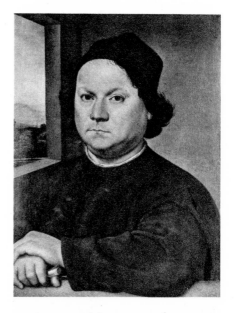

27. *Presumed portrait of Andrea del Verrocchio. From Vasari's* Lives. *Wood-cut*

28. *Perugino (?). Presumed portrait of Andrea del Verrocchio. Uffizi, Florence. Oil on panel*

Chapter Two

THE DOCUMENTED SCULPTURE

THIS CHAPTER will treat the sculpture that fulfills an art historian's definition of "documented"—that is, work that can be identified as by Andrea, alone or assisted by members of his shop, through a neutral written source that is contemporaneous, or nearly so, with the execution of the sculpture. The document is likely to be much closer in time to the event it refers to than is the literary source—closer, for example, than the *Lives* of Vasari, or even than certain autobiographical writings by Renaissance artists. Hence the importance of "contemporaneous, or nearly so," in my definition. Also, a document is essentially unliterary in character, and thus it is less subject to the writer's opinion or bias. Hence, again, the importance of the word "neutral." A document is not in itself a fact, but it purports to come as close as written words can to the factual recording of an event. It may be a terse, undecorated line of a trustworthy diarist. More often it is a notarized statement or the dry minutes of a decision taken by a legal body of some sort, for instance, committees like the overseers (Operai) of the Florentine Duomo, or the consuls of the Calimala guild, both patrons of Verrocchio. Regrettably, the document is rarely in itself a creation of high human quality; but, truly, it offers far greater historical credibility than the more attractive literary source.

The nature of the documentation for most of the sculptures treated in this chapter will be described in the section called NOTES ON PRINCIPAL PIECES DISCUSSED IN THE TEXT (pp. 161 ff.). For Verrocchio, however, there is one type of document that escapes the usual categories: This is a list drawn up by his brother Tommaso in 1495-96, some years after the artist's death, recording works ordered from Andrea by the Medici and not fully paid for. The intent of the list was strictly legalistic; it was the simplest identification of commissions on which it might be proved, in court if necessary, money was owed. Whether Tommaso was acting correctly as his brother's executor, or whether there was really much chance of his collecting on debts incurred so many years before, does not affect the validity of the list as a document. For our purpose it is important that Tommaso could have had access to his brother's business records. Moreover, the list had to have general credibility to be worth the trouble of drawing up—and drawn up it

certainly was, though in the ensuing years the original has disappeared; what survives is a trustworthy Renaissance copy preserved in the library of the Uffizi. A transcript with a rough translation is provided here in APPENDIX I: SELECTED DOCUMENTS AND SOURCES.

Tommaso's "List" gives us a firmer point of departure than Vasari's *Life* (see translation, pp. 176 ff.). The first edition of the *Lives* was printed some sixty-two years after Andrea's death. We have no complete idea of the documentation available to Vasari when he sat down to write about Andrea and his work. Among the written sources it is likely that he had sixteenth-century summaries of Andrea's career or guidebook indications about his work. These, of course, would have been supplemented by commonplaces of artistic lore then current in Florence, anecdotes like that recording Leonardo's part in the San Salvi Baptism, and snippets of oral tradition. The unusual fame of Leonardo would have helped preserve information about his master. There is no reason on earth to suppose Vasari would have had access to documents like Tommaso's "List" or the private records or correspondence of the committees which commissioned the larger Verrocchio monuments, such as the Forteguerri Cenotaph. (The correspondence was sometimes even more revealing than the contract; see the translation of portions of a letter to Lorenzo the Magnificent in SELECTED DOCUMENTS AND SOURCES, p. 176.)

Tommaso's "List" is valuable not only for its inclusion in the oeuvre of items which may be identified as extant today, but also for its record of work which has not survived and of which we might otherwise have no knowledge at all. It provides, finally, our best insight into the important Medici patronage that Andrea received up to about 1480.

The first documented piece we can ascribe to Verrocchio is the tomb-marker of Cosimo Pater Patriae de' Medici, a work of impressive dimensions set into the pavement of S. Lorenzo at the crossing of the transept. It was placed there to indicate the burial shaft below, which in turn was situated just in front of the original emplacement of the High Altar. The marker (*Fig. 30*) is not, properly speaking, sculpture—one might call it a sculptor's interpretation of an abstract two-dimensional "design." It reveals something of Andrea's ability and reputation as of 1465, when we must assume that Cosimo's heir, Piero, approved, and perhaps even instigated, Verrocchio's selection to make the marker. He possibly also supervised the construction of the burial shaft and tomb below (which, incidentally, has its own, less elaborate, identifying inscription: PETRVS. MEDICES./PATRI/ FACIVNDVM. CVRAVIT.). From what we know of Piero de' Medici, he would have employed only a first-rate craftsman, though he might not have insisted on a big name, a superstar of the magnitude of Donatello, for instance. By this time Andrea was already a master in stone—probably also in bronze—and was doubtless an artist of some prominence who would have been a logical candidate for Piero's commission.

We know from written records that there was an appreciable interval after Cosimo's death in 1464 in which discussions took place about the type of memorial that would be most fitting and where it should go. The decision finally made, to bury the greatest

Medici up to that date in S. Lorenzo, implied a special tribute, for S. Lorenzo was the Medici family's parish church and the family had been instrumental in Brunelleschi's rebuilding of the fabric. Cosimo's father and mother had been buried, according to his instructions, in the Sacristy adjoining the left arm of the transept; their tomb was in the center of the Sacristy and that place of honor was therefore pre-empted (*Fig. 3*). The placement of Cosimo's grave before the High Altar of the Church, however, was in most ways even more honorable. It was a more public position, and in a sense the whole church becomes Cosimo's burial chamber and his monument in three dimensions—*Si monumentum requiris, circumspice*. At the same time the memorial would become closely associated—physically and in liturgical geography, as it were—not only with the portions of the mass said at the High Altar (then in the crossing) but also with the pulpits for the reading of the Epistle and the Gospel. These bronze *ambones* by Donatello and his assistants, commissioned by Cosimo around 1460, originally stood nearby, also at the crossing. Today, the intent behind the placement of Cosimo's tomb is no longer obvious: the High Altar has been moved from the crossing back to the liturgical choir, and the *ambones* are strangely placed—on the north and south sides of the nave, resting on stilted columns between the last (westernmost) two nave supports. In fact, the meaning has been all but destroyed.

The tomb-marker of Cosimo is important. It gives some idea of Verrocchio's ability to handle, with originality and confidence, a large geometrical design with handsome Humanist lettering in the ancient Roman style, *all'antica*. The pattern of colored and white marbles in Cosimo's marker turns up without essential change in the decoration of the marble plinth below the sarcophagus of Piero and Giovanni de' Medici, also in S. Lorenzo; it represents a giant step forward in Andrea's development as an artist (*Fig. 38*).

The double-tomb of the brothers Piero and Giovanni de' Medici was ordered, according to the inscription that runs around all four sides of the plinth, by Piero's sons and heirs, Lorenzo and Giuliano. According to the same inscription the tomb was finished and in place by 1472, unless one interprets 1472 as the date of the commission, a highly unlikely supposition in view of surviving written evidence. The inscription identifies Lorenzo and Giuliano as commissioners (the F. F. following their names stands for FECERVNT FARE, "ordered"). On the other side of the sarcophagus in the centrally placed roundel is the unmistakable reference to the memory of "father and uncle" (PATRI PATRVOQVE, indicating the relationship of Piero and Giovanni to Lorenzo and Giuliano.

Though Piero was sickly (*malsano*, as his own father was forced to call him) and for years a sufferer from the Medici family disease, a form of arthritic gout, his death came suddenly and evidently unexpectedly, at the age of fifty-three, before he was able either to make his will or to say confession. A letter from Florence addressed to Niccolò Strozzi, then in Naples, the day after Piero's death (December 2, 1469), contains the gist of the sad news in a short sentence: "*Piero s'è morto più presto non si credeva*"—death took him more rapidly than anyone believed possible. These circumstances do not incline us to

the idea that Piero, as sometimes happened in the fifteenth century, according to the theme of Browning's poem, ordered his own tomb. In his *Riccordi*, Lorenzo noted that immediately after his father's death, Piero "was much mourned by the whole city" of Florence; that he, Lorenzo, and his brother Giuliano, "were greatly consoled by letters and embassies of condolence from the princes of Italy"; and that a tomb was planned for the very near future (*del continuo*) for Piero's remains and those of Giovanni his brother. It would be "the most worthy monument that we know how to erect" (*sepoltura . . . la più degna che sappiamo per mettervi le loro ossa*). It was, according to the same source, already being constructed by 1471.

Tommaso's "List" mentions as items No. 12 and 13 "the tomb of Piero and Giovanni de' Medici" and the cutting of eighty letters of the inscription. (There are seventy-six letters and numerals in the inscriptions of the sarcophagus.) The tomb is, therefore, documented as Verrocchio's work, evidently even to the lettering. It was a task to which he brought not only a highly developed plastic sense of form in three dimensions but also unprecedented mastery of the difficult technique of casting bronze. In this monument bronze plays a role at the very least equal to that of polished marble.

It is necessary here to insert a parenthesis on the question of Andrea's previous experience in the medium of bronze. About a year and a half before he received the commission for the Medici Tomb, Andrea had designed and executed in bronze a splendid candelabrum for the chapel of the Palazzo della Signoria. It could be called the Paschal Candlestick of that chapel. The candelabrum is of nearly monumental proportions, roughly a meter and a half in height; its inscription, referring to the term of office of the still unidentified donor, carries the date of 1468, the year in which the first of three payments was made. This candelabrum has survived and is now in the Rijksmuseum in Amsterdam (*Figs. 31-34*).

Three characteristics of its style should be pointed out: the closeness of the design to an antique Roman formula; the graceful and vertical thrust of the main shaft, terminating in a finely flaring bowl; and the use of a triangular foot, carrying the inscription and so disposed that it is impossible to select one single dominant view of the object. The observer's eye is drawn around the total form. This many-sided concept of form, inviting a visual embrace of the entire design, is as characteristic of what we know of Verrocchio's personal style as is the grace and vigor of the shape itself, thrusting into its spatial environment. It must also be apparent that the decorative and compositional motifs here combined are derived from attentive study of the Antique; there can be no doubt that the artist was at that time thoroughly conversant with the vocabulary and grammar of ancient decorative art. The very sobriety of the decoration has the quality of Roman *gravitas* and is thus fully in accord with the function of the candelabrum—to decorate the chapel of the elected governors of a republic that was felt to be in some measure a lineal successor to that of Ancient Rome.

There are other indications of Andrea's recognized capacity as a bronze-caster before

the commissioning of the Medici Tomb. One is his selection in September, 1468, to cast in bronze the huge ball, or *palla*, that was to surmount the cupola of the Duomo (*Fig. 4*). (It was later decided, probably because of the huge scale, to join plates of bronze to form the globe rather than make a single casting. Verrocchio's selection for the task was in any case testimony to his skill in working with bronze.) We know also that by January, 1466-67, Andrea had been chosen to execute the bronze group for the Niche of the Mercanzia on Or S. Michele, for a payment was then made to him, apparently for that group. In November, 1467, Andrea lent bronze to Michelozzo and Luca della Robbia for casting the last panels of the bronze doors to the Sacristy in the Duomo; he must therefore have had a good supply of high-quality bronze alloy in his possession at that date.

When Andrea was chosen as the master of the Medici Tomb, he had, therefore, considerable experience and evidently also a reputation as a sculptor in bronze. It is no exaggeration to say that, from what we know of the situation in Italy at that moment, there was no one south of the Alps who had a higher reputation in this field. The design of the tomb maximizes not only skill of design and execution but also the unique qualities of form possessed by sculpture cast in bronze as opposed to that carved from stone.

Let us now return to the Tomb of Piero and Giovanni de' Medici (*Figs. 35-45*). As it was a double tomb for two brothers, given by two brothers of the succeeding generation, it was appropriately given a double façade. Its program was striking. An arched opening was let into the wall between the Sacristy and what was then the Chapel of the Sacrament (see *figure*, p. 54); the opening was to contain in its lower portion the ornate sarcophagus on its plinth, and in its upper portion an open screen made of twisted cords of bronze. There is thus in the upper portions visual communication, a sense of a shared light and atmosphere, between the Sacristy and the Chapel. In the lower portions the mirror-images of the sarcophagus façades suggested by other means a feeling of unity between the two important liturgical areas (*Figs. 35, 38*). The Chapel of the Sacrament in S. Lorenzo has since become simply the Chapel of the Madonna; it is normally barred to the general public, and it no longer serves its original function, that of sheltering the elaborate altar which housed the Host for continuous adoration.

It is most difficult to know which is the more important of the two façades of the tomb, and perhaps this ambiguity was intended. However, there is a difference. On the side facing into the Chapel of the Sacrament the names of the two brothers who are memorialized are inscribed on the sarcophagus, and those of the two brothers who were the patrons are on the plinth. On the other hand, on the side facing into the Sacristy, most often photographed and seen, the plinth refers simply to "father and uncle" (PATRI PATRVOQVE), and a garland-enclosed roundel on the sarcophagus gives only the dates of each life commemorated. If this differentiation has meaning, it must mean that of the two conjoined and formally equal façades, the one that opens into the Chapel of the

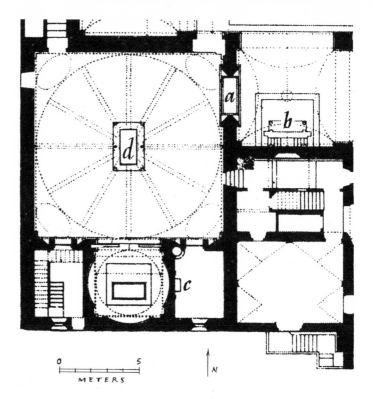

*Ground plan of S. Lorenzo (detail), showing Old Sacristy
and* (a) *Tomb of Piero and Giovanni de' Medici;* (b) *former position of
Altar of the Sacrament;* (c) *present location of lavabo;* (d) *Tomb of
Giovanni di Averardo de' Medici.*

Sacrament is the more weighty from the point of view of identification of the persons
involved. The implication is that those persons, even though not present in life, are none-
theless constantly in worshipful attendance upon the Body of the Saviour here in this
chapel. As He rose from the dead, so will they.

The entombed bodies are close to the Altar of the Sacrament, which almost certainly
was also a Medici commission (probably Cosimo's). It was the final statement of
Desiderio da Settignano, executed by him and his shop in beautifully carved marble. If
we look carefully at the remnants of the decorative pilasters of the original altar, which
has been reassembled on the other side of the church, we could recognize a quite close
relationship with the decorated marble framing of the arch enclosing the Tomb of Piero
and Giovanni (*Figs. 41-44*). There was thus an intent to relate the Tomb to the Altar
formally as well as by location and inference of religious mediation. Piero de' Medici is

known to have been a pious man who would have been concerned about the spiritual significance of the tomb as well as its outward form.

Turning again to the Sacristy façade, we find references to the family relationship of these four Medici and to the burial place close by, in the Sacristy itself, of Giovanni di Averardo Bicci, after whom Piero's brother Giovanni was named. The double monument of Giovanni di Averardo Bicci and his wife, Piccarda, is situated beneath the marble table on which the vestments for the officiating clergy were laid (*Fig. 3*). This table, in turn, is immediately beneath the Sacristy's central cupola, which is surmounted by an edicule (*Fig. 126*) similar, evidently purposely so, to the edicule on representations of the Holy Sepulchre. Such a representation, attributed to Alberti, is in S. Pancrazio in Florence (*Fig. 125*). The Sacristy's references to hoped-for human resurrection, both in its function, through the symbolism of clothing ("to take off mortality and to put on immortality"), and in its architecture, through the parallel to the Holy Sepulchre, are self-explanatory. It is important to recognize that the context created by Brunelleschi's "Old" Sacristy had overtones of meaning for the Medici family over several generations. The influence of that meaning extends to the successors of the generation of Lorenzo and Giuliano and to the program conceived for their tombs in the "New" Sacristy of Michelangelo.

The originality of Verrocchio's monument to Piero and Giovanni de' Medici is hard to overestimate. It is as much a result of the mental images the double tomb evoked as of the imaginative way the program was carried through. Elements of the archeological Roman past are Humanistically revived and put into a different, yet equally consistent and coherent, formal organization. The use of hard, colored stones, such as porphyry and serpentine, is certainly Roman, as opposed to the Florentine choice in tombs up to this time of white marble, used alone, though it was painted and gilded for coloristic effects. Roman also is the dark-greenish bronze with rich acanthus foliage motives and lion's-foot supports (*Figs. 37, 38, 40*). Roman are the shell motives with associated acanthus foliation (*Fig. 40*). Roman, too, are the tortoise supports of the plinth, symbolic of universal life. But entirely characteristic of Verrocchio and of his age in Florence are the extraordinary naturalism of those tortoises (*Fig. 45*) and the vitality of the crisp ornamental shapes, which almost crackle in their exuberance (*Fig. 40*), as well as the tension of the intertwined cord motives (*Fig. 39*). The central pyramidal ornament of the cover is actually the diamond motive of the Medici particularly favored by Piero.

A similarly inventive re-creation of Roman art is the little bronze Eros with a Dolphin that appears as a Medici commission for their villa at Careggi, in item No. 3 of Tommaso's "List" (*Fig. 46*). It has been fairly frequently pointed out that the device of representing a child playfully squeezing a fish can be traced back to Roman types: a little boy with a dolphin in bronze from Pompeii is in the Naples Museum. A Renaissance bronze putto, a wall-fountain figure in the Victoria and Albert Museum (*Fig. 48*), is related to Verrocchio's Eros in the use of the mouth of a dolphin carried on the figure's

shoulders as one of the waterspouts. The style of the Victoria and Albert bronze is hard to pin down (there are echoes of Donatello, Michelozzo, Buggiano, and possibly even of Luca della Robbia). When it was acquired in 1861, the style was interestingly enough thought to be more characteristic of Verrocchio than of Donatello, possibly because of the modeling of the torso. In the museum's most recent catalogue it is called "Workshop of Donatello." Whatever one may ultimately decide about its authorship, the fact remains that its rather passive, classicistic expression is in strong contrast to Andrea's Careggi fountain figure.

What Verrocchio did in the Eros (*Figs. 46, 47, 49*) was to change deliberately the proportions of the child from an Antique canon to more a naturalistic one. The head is larger (and more expressive), the pudgy hands less adult, the feet larger, the little body at once more wreathed in fat and yet more lithe in its suggested twist. The Eros fountain figure, which had been placed in the center of the Palazzo Vecchio courtyard on the order of the Medici Duke Cosimo I, in the mid-sixteenth century, has been removed to a much more protected place inside the palace. It has also been cleaned recently— evidently thoroughly but with his usual discretion—by Bruno Bearzi, the distinguished Florentine expert in the conservation of bronze. We can now see more clearly the quality of the surfaces of the sculpture, which had been partially obscured under the mineral deposits left by the water spouting over them during the past centuries. No trace of the gilding that was evidently present originally is to be seen today.

The casting appears to be very close in delicacy to the bronzes of the Piero and Giovanni de' Medici Tomb. There are some imperfections (see the forehead, *Fig. 47*). These, together with the Desideriesque type of head, suggest a date before 1470, perhaps even as early as about 1465. A running putto, apparently derived from the side view of Verrocchio's figure, is to be seen amid the foliage decoration (finished in 1465) at the top of the bronze grille before the Cappella della Cintola in the Duomo of Prato (*Fig. 50*). I say "apparently derived," but one might put the case more strongly. Surely there are few who would maintain the opposite, that the little figure at Prato is Verrocchio's source, and for only one view, for his Eros with a Dolphin.

It is evident that here, for the first time, Andrea is experimenting in sculpture with movement of several kinds: running; the twisting of the body and limbs around a central axis; and the movement of hair, and above all, of drapery. These are precisely the kinds of movement defined in Leon Battista Alberti's treatise on the art of painting, which became a kind of bible for painters and to some extent for sculptors in Florence between 1435 and 1500. To these types of Albertian movement should be added the even freer movement of water spouting from the mouth of the fish and the heads of lions that we believe decorated the original fountain bowl; there one would have sensed the constantly shifting presence of flowing form in nature that was to fascinate Leonardo.

The original base for this fountain figure is almost certainly the marble double-bowled fountain which stands today in the Pitti (Pinacoteca Palatina), at the top of the

stairs, by the photograph rack (*Fig. 51*). A sixteenth-century putto, in marble and on an Antique model, surmounts the fountain today; it is usually attributed to the sculptor Tribolo, together with the upper bowl. The scale of the little marble Cinquecento figure is very close to that of the Eros with a Dolphin. The fifteenth-century parts, which include the shaft supporting the upper bowl, the lower bowl, and the triangular base, are carved in a marble of different quality than that of the sixteenth-century additions. The ornament of the lower base is clearly Quattrocento in style and executed with great care, though somewhat mechanically. This would indicate that the execution was largely entrusted to a shop assistant (as indeed one would expect). The ornamental motif below the rim of the lower bowl (*Fig. 51*), interestingly enough features dolphins. The Latin inscription (*Fig. 54*), in addition to pointed references to the heraldry of Piero de' Medici, plays wittily on terms for air and flight and so, with the reference to the "golden god" (of Love), would aptly fit the characterization of the Eros by Verrocchio. Finally, the base is decorated by the diamond and the motto "*Semper*," used habitually by Piero de' Medici (*Fig. 53*).

Therefore, though doubts have recently been expressed, we evidently still possess most of the original elements of the fountain base for the piece listed by Tommaso as commissioned for the garden of the Medici villa at Careggi. From there it must have been transplanted in a remodeled state to the sixteenth-century Medici Villa of Castello (whence it came to Florence and the Pitti). The remodeling took place evidently at the time Verrocchio's little bronze figure was brought into town by Duke Cosimo I de' Medici to decorate (on a newly designed base) the fountain of the central court of the Palazzo Vecchio. The original base, to be identified as that in the Pitti, gives us a valuable additional index to the dating of the bronze figure, since the base is decorated with the emblem and motto of Piero de' Medici, who died in 1469.

More difficult to date is the somewhat larger bronze David, item No. 1 on Tommaso's "List" (*Figs. 55-61*). For a time it was believed that the piece was intended for Careggi, but recent checking on the text of the document shows that this was not the case. We can securely identify the piece as one sold to the Signoria for their palace by the Medici in 1476; whether it was ordered, as some have thought, just before that time (say 1473-75) is an open question today. It could, of course, have been ordered and designed earlier. The casting of the bronze is not so adroit as that of the Eros with a Dolphin. The forms were chiseled, showing much reworking after the metal had cooled (*Fig. 58*)—a trait of the Donatello workshop of the sixties. Moreover, the head of Goliath was cast separately (*Fig. 61*), thus facilitating considerably the technical problem. The surfaces were given a dark lacquer patina that is unevenly preserved and therefore makes esthetic and critical judgment difficult. Yet while one finds the evidence of the casting in some ways favoring an early date (say 1465), some of the shapes—corkscrew locks of hair similar to those of the Christ of the Or S. Michele group, for example—seem to point to the style of around 1470, perhaps even of a few years later.

Andrea was given the Or S. Michele commission at the latest by 1467. Before so important a decision was reached, there must surely have been some evidence of his ability to design and cast monumentally scaled bronze statuary. Quite possibly the evidence was the jaunty David, which by its combination of naturalism and abstraction —in the ornament of the armor—provided just such a criterion of ability. And possibly some of the stylistic devices, such as the corkscrew locks, were carried over into the model for the Christ, which we believe preceded by some years the model for the St. Thomas.

The Christ and St. Thomas group for the Niche of the Mercanzia on Or S. Michele represents a new development in Andrea's progress as a sculptor. Here he stepped into maturity. As we have seen in the previous chapter, the niche and the space it offered remained unchanged from the design given it some forty years earlier by Donatello. The sculptural problem, however, had changed enormously, for instead of one large simple figure—the St. Louis of Toulouse by Donatello (*Fig. 6*)—Andrea was faced with installing in the empty niche (*Fig. 62*) a group of two figures. It is not known when the decision was taken to use as a subject the figures of Christ and St. Thomas. It could have come relatively soon after the decision to hand over the niche itself to the Mercanzia. Since the institution acted as the Merchants' Tribunal, the subject of doubt and proof as exemplified by the story of Thomas is clearly apposite. However, the inscriptions on the borders of the garments, both taken from the Gospel of John, do not emphasize physical evidence, things felt and seen, so much as faith, "the evidence of things unseen." The sculptor was thus faced with a double problem: to preserve intact the drama of the story of incredulity and its corollary of Christian faith; and to fit two figures into a space originally designed for one figure only.

Andrea's solution of design was ingenious. Against the dark background of the shadowed niche he first imagined the standing figure of Christ with right arm upraised, permitting the wound in the right side to open up. The left hand then moves in against the body to hold back the opening of the robe (*Fig. 64*). Everything in this pose focuses, as far as gesture is concerned, on the wound in the side. Toward this central point of attention, then, is correlated the pose of the figure of St. Thomas (*Fig. 65*), which seems to be moving inwards from the light of the city street toward the mysterious darkness of the niche, out of which the noble head and upright arm of Christ emerge with impressive yet by no means aggressive power. This is the way one actually sees the group *in situ*, from below, with the drama of gesture reinforced by the contrast of light and shade.

If one compares the two figures, one can easily make out differences of style that confirm the data of the documents (*Figs. 66, 67*). The documents (see p. 163) indicate not only that the Christ was the first to be modeled and cast, but also that Andrea did not begin the St. Thomas until 1479. That figure was not finished, nor were the two figures placed in the niche, until 1483, when they were seen by the public on the Feast of S. Giovanni, late in June.

The drapery of the Christ is more angular in its folds than that of the St. Thomas. The head of Christ (*Figs. 68, 69*), one of the noblest of its kind in all of Western art, is more sparingly modeled than that of St. Thomas (*Figs. 72, 73*). There is one interesting detail that might escape casual notice: The foot of St. Thomas is given an archeologically correct Antique Roman sandal. Apparently Andrea's interest in classical Antiquity had grown during the course of the seventies, and it may also be reflected in the shift toward fuller, less angular forms in the drapery and in the broader facial type of the saint.

The group was intended to be seen only in the formal context of the niche. The artist and patron made a considerable saving in bronze not only by casting the figures hollow, as one might expect, but also by casting only those portions to be seen from the street. Thus the seemingly complete figure of Christ is actually only a partially finished half-shell supported by rough interior armature (*Figs. 70, 71*). The same is true of the St. Thomas. Donatello had used much the same system the figure of St. Louis of Toulouse, hanging, as it were, a shell of bronze plates on an armature. Possibly Andrea was influenced by that predecessor; but it must also be conceded that the partial-shell cast is characteristic of earlier goldsmith technique in Florence.

The visually important hands of Christ and St. Thomas are finished only on the sides visible to the observer in the street (*Figs. 74, 76*). In the finished parts of the hands of Christ one can make out the wound that a nail of the period, precisely rectangular in section, would leave. Vasari wrote that the figures were cast and finished in the round. That so practiced an observer of technique could be fooled is testimony to Andrea's extraordinary power of suggesting weight and fullness through the character of the visible surfaces of his forms.

Under any aspect, the Or S. Michele group represents a tremendous achievement: a turning point not only in Andrea's career, but also in Florentine art. In the valves of the bronze doors of the Sacristy of S. Lorenzo, Donatello had earlier presented the relationship of two equally scaled figures as a series of confrontations, in conflict, sometimes in alienation. Antonio Pollaiuolo brought two equal figures together in his well-known group of Hercules and Antaeus, but they are locked face to face in such a way that they seem to come to a standstill; one action seems almost to cancel out the other. Verrocchio's treatment of the two-figure theme was to some extent influenced by a traditional iconographic scheme exemplified in a painting of Christ and St. Thomas in the Florentine Duomo (*Fig. 79*). But working in real space and with real forms, he was able to put his two figures together on a diagonal, thus creating a relationship of more subtle possibilities; of closeness and yet of separateness in action, of question and answer, of doubt and certainty, of disciple and master, of the living flesh and the living spirit in the guise of flesh.

This new possibility was in part seized upon by Verrocchio's own student, Perugino, in the fresco of the *Handing over of the Keys* in the Sistine Chapel, where the St. Thomas figure reappears in a new context (*Fig. 80*). Later, also in Rome, Perugino's disciple

Raphael further adapted the device in the so-called School of Athens, grouping two figures—more dramatically than Verrocchio—to lead diagonally into space. But the future of the diagonal grouping was less in the High Renaissance than in the Baroque.

Andrea's work of the 1470's was also marked by two even more complex compositions, involving up to seven, possibly nine, figures. They differed radically in scale as well as in visual and programmatic function. Let us approach them singly.

The larger of the two was the monumental cenotaph of marble dedicated to the memory of Cardinal Niccolò Forteguerri for the Duomo in Pistoia (*Fig. 81*). There was a good deal of sparring between the artist and the local committee responsible for erecting the monument. Before a contract could be agreed upon and a design finally ideated and accepted, Verrocchio was first selected as the artist, at least on a temporary basis, then put on a waiting list while the committee considered another design submitted by Piero Pollaiuolo (with help expected from his more gifted brother, Antonio?). Finally, after consulting with Lorenzo de' Medici and after guaranteeing more money than originally offered to cover expenses, the committee settled on Andrea as the artist in 1478 (not 1477, as sometimes given: for this point see the DOCUMENTS AND SOURCES in APPENDIX I).

The design agreed upon may well have been that which survives in a terracotta sketch in the Victoria and Albert Museum (*Fig. 82*). The quality of the sketch is frankly somewhat disappointing. Critics have in the past gone so far as to doubt its authenticity, even as a fifteenth-century object; but that is going too far. Though the most recent catalogue of the museum gives it to Verrocchio himself, it could also be the product of the bottega; and whether or not it really is the final presentation sketch made for the competition is still in question. But the terracotta relief has undoubted value as the best available indication of the over-all design Verrocchio had in mind.

From the evidence of style, the sculpture for the monument was begun by Andrea with the help of at least three assistants and was left unfinished at his death. Two more figures were added in the early sixteenth century, possibly done in a general way after sketches left by Verrocchio. Only in the eighteenth century was the present portrait-bust of the cardinal finally carved and the whole put together in the oppressive architectural frame that one sees today. It is therefore unfair to Andrea to look at the design as it stands. From the whole design, as we can reconstruct it from the evidence of the Victoria and Albert terracotta, it is evident that the monument was first thought of as large-scale relief dominated by the figure of Christ in a mandorla supported by flying angels, much along the lines of the earlier and memorable relief for the frontispiece of the Porta della Mandorla of the Florentine Duomo by Nanni di Banco (*Fig. 83*). The kneeling figure of St. Thomas in the Duomo relief could have been the prototype for the kneeling figure of the cardinal.

Of the Christ, four angels, and two Virtues of the Forteguerri Cenotaph (*Figs. 84-89*), only the Christ and the Virtue at the left (Faith) can be safely given to the master's hand.

The intervention of assistants' hands is to be found everywhere else. However, what we find in the Christ and in the Virtue identified as Faith (*Fig. 85*) is of splendid quality. Here, it should be emphasized, are the only documented examples of Verrocchio's skill as a carver. We tend to think of him almost exclusively as a modeler in clay or a caster of metals, but it is abundantly evident that he should be ranked among the most skillful of the marble-workers of the Italian Quattrocento—and they were on the whole indeed a most skillful group. The forms of these two figures are given a remarkably consistent finish, neither too polished nor too dull; they are handled sensitively, broadly, and with confidence. One senses, as sometimes in the work of Desiderio only, a quality of glowing whiteness and purity that transmutes the hardness and density of the material into a new substance. It is, of course, known that Andrea never completed the commission. We do not know whether he considered those parts he chose to work on himself fully finished. Nor do we know precisely when he worked on them; the time span might amount to as much as five years, from roughly 1480 to perhaps as late as 1485.

Shortly before Andrea began to work in earnest on the full-scale figures for the Forteguerri monument, he completed a much smaller work in relief: the Beheading of the Baptist for one of the sides of the antependium of the silver altar of the Baptistry. This altar has been moved from the Baptistry to the Museo dell'Opera del Duomo, behind the cathedral, where it can be studied at close vantage and usually under excellent light. The relief (*Fig. 91*) was commissioned in 1477; at the same time Antonio Pollaiuolo was commissioned to execute a companion relief of the Birth of the Baptist (*Fig. 92*). The latter looks as if it were done by Piero Pollaiuolo rather than by the more gifted Antonio, whose hand is apparent in much of the Monumental Crucifix (executed in the fifties) which stands on the altar *mensa*. The Pollaiuolo relief of roughly 1477 has a certain spatial unity, but the figures lack the vigor and definition, the visual weight, of Andrea's.

During World War II the altar was dismantled and the various reliefs studied carefully and photographed in their constituent parts. Whereas the Pollaiuolo relief was found to be all of one piece, the relief documented as by Andrea was found to consist of a number of parts cast separately, chased separately, and then assembled by means of doweling into a wood support. This method of "assemblage" is interesting. It continues in some ways the traditional Trecento methods that can be found in the older pieces that decorate the front (not the sides) of the antependium. However, Andrea now acted as painter and sculptor, as well as goldsmith. He first of all made a perspective setting for the drama (*Fig. 93*); the construction of this stage-like environment follows the general procedure advocated by Alberti in his treatise on painting. Then, like a sculptor, Andrea cast the figurines of the action: the kneeling saint, the soldiers in attendance, and the executioner (*Figs. 94, 95*). The modeling of the unseen surfaces attached to the core was left unfinished, but full plasticity of the figures, particularly those closest to the front plane, was retained by actual volume and mass. In the finished work of art we find ourselves looking at something between painting and sculpture—at a dramatically presented "scene," or

istoria, as Alberti would have called it, with its own fictive space, fictive but nonetheless plastically existent in the world of physical space and light. Once again we find Andrea's personal solution to the artistic problem lay in his originality and his vigor.

The last documented work by Andrea may be assigned to the eighties of the fifteenth century. It was not finished by him. Early in 1488, after completing the full-scale *modelli* of horse and rider of the Colleoni equestrian monument in Venice, death overtook him; the task of casting the two elements of the sculptural group fell to a Venetian rival, Alessandro Leopardi, who a few years earlier had competed unsuccessfully for the commission (as had the better-known Paduan Bartolommeo Bellano). Vasari states that Andrea died from a cold, the result of becoming overheated during supervision of the casting. This statement conflicts with the documentary evidence, and it is likely that Andrea died within a week of making his will at the end of June, 1488, before the casting had begun. Very possibly he died of the plague that was endemic in the port city of Venice during the entire Renaissance.

For a time Leopardi was given sole credit for the statuary, design and all. This pro-Venetian, anti-Florentine bit of propaganda can easily be countered by the roughly contemporary lines in the form of an epitaph on the Louvre drawing we looked at briefly earlier (see p. 27 and *Fig. 18*). There we find a reference to our sculptor as the "glory [ornament] of Florence" to whom the "noble Venetians" had entrusted the making of "the horse . . . of wondrous skill." We would like to know more of the origin and purpose of those lines, but they seem to indicate that at the time of his death, or shortly after, Andrea was considered the artist of the Colleoni Monument—the most impressive equestrian statue of the Italian Renaissance, or very close to it, one that may have a peer but no superior.

Donatello's Gattamelata Monument in Padua invokes power through restraint and nobility, a kind of Augustan magnanimity. Verrocchio's Colleoni Monument in Venice suggests power through force (*Figs. 100, 102*). Donatello conjures up the Italic past, the Rome of the military Caesars; Verrocchio sets forth the spirit of a new age, his own time. The head of the rider in Donatello's monument is conceivably modeled on a head of Julius Caesar (*Fig. 110*); the head of the Colleoni rider is a fierce leonine mask, based on an archetype of belligerency, not on any individual source (*Figs. 106, 107*). The armor and gear of Donatello's rider is a fanciful Humanist reconstruction of the Antique, alive with little decorative *genii* and ornamental motives *all'antica* (*Fig. 110*). The armor and gear of the Verrocchio's rider is ornate, but fundamentally stark and businesslike, very much of its time—it might have come from one of the famous Renaissance armor shops of Milan (*Fig. 107*). Gattamelata rides peacefully in triumph after the battle. Colleoni, standing high in the stirrups, hurls a curse and disdainful challenge as he turns imperiously from a review of his own troops to advance against the enemy. There is no turning back. The forward motion of horse and rider seems irresistible.

In order to gauge the emotional impact of Verrocchio's monument on early viewers, it is necessary to turn to the equestrian monument that was erected above Colleoni's tomb in his birthplace in Bergamo (*Fig. 109*) shortly after his death in 1475. Possibly Andrea felt he was in competition with the Milanese style of the marble parts of the monument in Bergamo (*Fig. 108*), as well as with the stiffly wooden horse and rider that surmount the tomb proper. It has often been pointed out that he may have taken the idea of the forward push of his horse from the painted Monument to Niccolò da Tolentino by Castagno in the Florentine Duomo. By 1480, however, there were other models for equestrian figures; the presentation of a military hero in contemporary armor was becoming quite widespread. There are handsome equestrian reliefs of the so-called modern type of members of the Bentivoglio and Malatesta families in S. Giacomo Maggiore, Bologna, and in the Louvre. Another monument, interesting because of the way the armored shoulder is thrust forward in the same pose as Colleoni's, is in Rome (*Fig. 111*). One cannot therefore speak of Andrea's invention of a type here, as sometimes has been claimed erroneously in the past. What he created was a masterpiece which raised an earlier existing type to a completely new level of intensity and expression. Rider and horse seem still to smolder with white heat, as if the molten bronze had never quite cooled. The Colleoni was the main inspiration for Leonardo's Sforza Monument, which never, tragically, reached the stage of metal-casting.

The signature of Leopardi on the harness of Colleoni's charger is ambiguous (*Fig. 112*). In the words "LEOPARDVS V.F.," the "F." could mean, and for a time actually was interpreted as, "made" (FECIT) rather than "cast" (FVDIT). It is barely possible, but not likely, that Leopardi played a role in the design and execution of the base, a splendid architectural creation in its own right. The upper frieze in bronze (much restored) could conceivably be by him (*Fig. 114*), but there is no indication in the records or in what we know of his career, insofar as it can be pieced together, that he had the architectural genius to design the pedestal as a whole; this is particularly unlikely in view of the strict mathematical relationship of the pedestal to the sculpture it supports (see APPENDIX II with accompanying diagram). One thinks instead of a known architect like Coducci, or perhaps even more of Tullio Lombardi (whose tomb of Andrea Vendramin, which used to be given to Leopardi, is based on a similar system of proportions).

The harmony of the Colleoni base and the façade of the Scuola is interesting in this connection. Tullio may have designed and in large part executed the lower part of the façade of the Scuola, which stands at right angles to the church of SS. Giovanni e Paolo before which the Colleoni Monument was placed. This façade in marble, rather than the church in brick, makes the best background for the Colleoni Monument as a whole. A good approach to the monument is by way of the appropriately named Calle del Cavallo, opposite the façade of the Scuola; here one senses first the push and thrust of the powerful hind quarters of the horse. The architectural detail of the base finds its perfected counter-part on monumental scale in the facade of the Scuola, which blocks off the piazza to the

north (*Fig. 113*). On the other hand, the view as one comes down the steps of the bridge over the canal to enter the *campo* is just as striking and projects even more powerfully the sense of forward motion (*Fig. 100*).

Though the group was cast in bronze by 1492, there still remained a great deal of work in the meticulous chasing of detail and gilding. Presumably at this time (i.e., about 1492), the architectural base was designed and work was begun on its constituent parts, including the bronze frieze (*Fig. 114*). Only in 1496, some eight years after the death of Andrea, was the monument as a whole completed: *equum mira arte confectum*. Early in the nineteenth century, the monument was "restored," and we no longer see it entirely as was intended. Originally, it seems a kind of regular courtyard-like podium was created for the monument in the flooring of the Campo SS. Giovanni e Paolo (*Figs. 96, 97*). Its placement was thus more formal, more in the Renaissance taste, than appears today.

There remains a word or two to be said, as an *addendum*, about those documented works by Andrea that have not survived, or if they have survived are still unrecognized. W. R. Valentiner was the art historian who concentrated most notably on the challenge of locating lost works of art by Verrocchio to be matched up with the records. Only in one case, that of the bronze candelabrum now in Rijksmuseum, was he successful. Subsequent writers have rejected or disregarded his identification of a small marble fountain figure in the Louvre with No. 4 of Tommaso's "List," and of the restored Marsyas in the Uffizi with No. 2 of the "List" (*lo gnudo rosso*). None of the standards, helmets, and so on, done for the Medici Tournaments or for the visit of Galeazzo Sforza to Florence have survived. The great *palla* for the Duomo was destroyed by lightning in the sixteenth century. The bell cast for the Convent of Monte Scalari is reported to have been melted down in the eighteenth century. Vasari spoke of a "head of St. Jerome" and of a mechanical putto that "struck the hour" on the clock of the Mercato Nuovo; neither is known today. On the other hand, it is barely possible that Tommaso's "List" No. 5 (*una storia di rilievo con più fighure*) may be still identified, and this hypothesis will be discussed in the next chapter. The survival of elements which may be connected with the commissioned but unexecuted fountain for King Matthias Corvinus of Hungary will also be discussed.

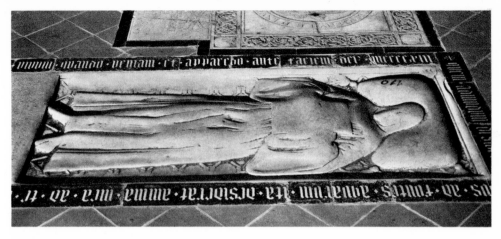

29. *Attributed to Verrocchio. Tomb-marker for
Fra Giuliano del Verrocchio. S. Croce, Florence. Marble*

30. *Verrocchio. Tomb-marker for Cosimo de' Medici.
S. Lorenzo, Florence. Marble, porphyry, serpentine, bronze or brass*

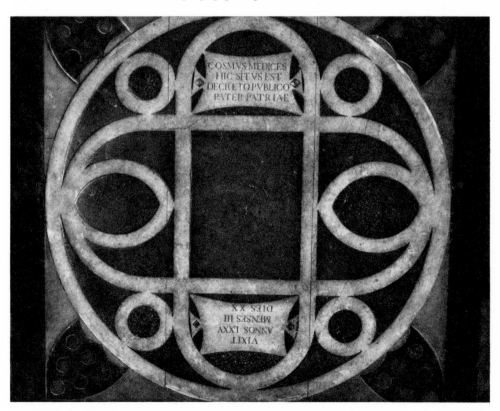

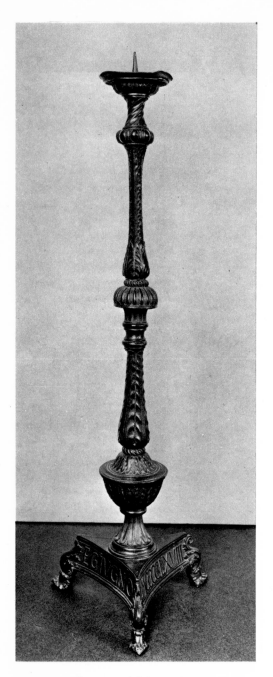
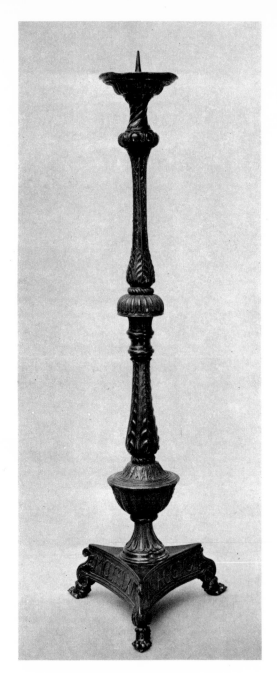

31. *Verrocchio. Candelabrum for the*
Chapel of the Palazzo della Signoria
(Palazzo Vecchio), Florence.
Rijksmuseum, Amsterdam. Bronze

32. *Candelabrum for the Chapel*
of the Palazzo della Signoria.
View showing date.

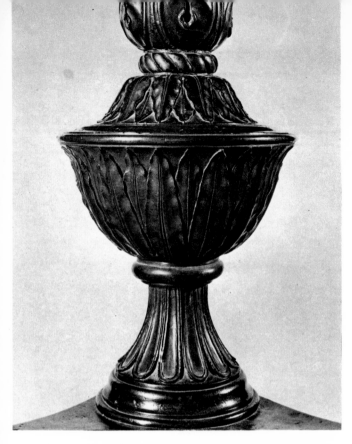

33. *Verrocchio. Hasp of Candelabrum, detail of Fig. 31*

34. *Verrocchio. Base of Candelabrum, detail of Fig. 31*

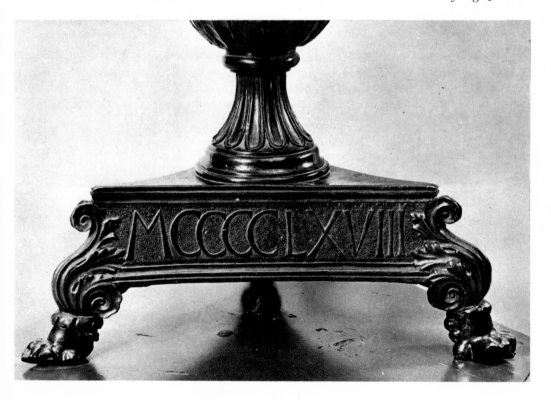

LAVRENTI ET IVLI PETRI F

opposite page: 35. Verrocchio. Tomb of Piero and Giovanni de' Medici.
S. Lorenzo, Florence. Bronze, marble, porphyry, serpentine

36. *Sarcophagus, seen from former Chapel of the Sacrament*

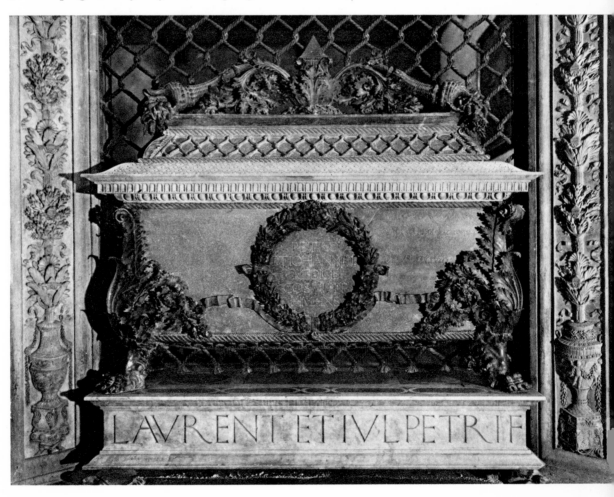

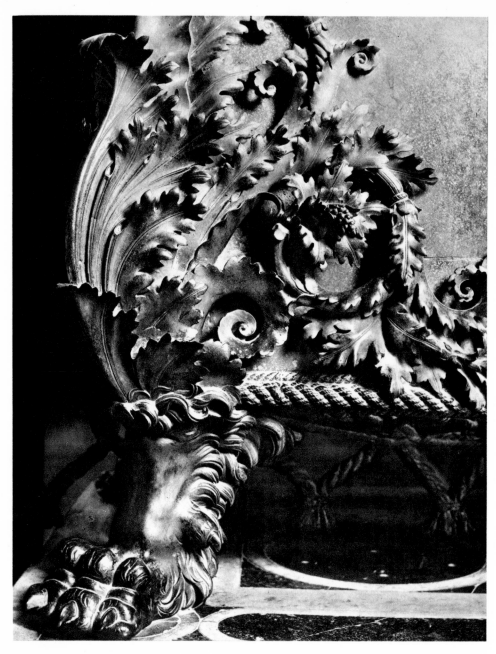

37. *Sarcophagus. Detail, left leg, Sacristy side*

opposite page: 38. Sarcophagus. Detail, oblique view from right, Sacristy side

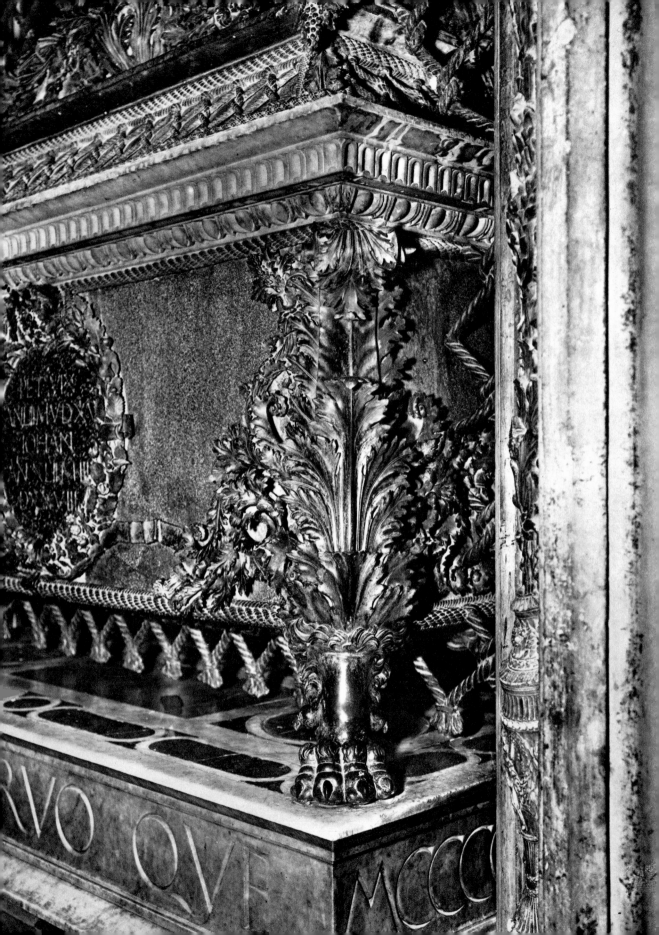

39. *Detail, net above Sarcophagus. Bronze*

40. *Summit of Sarcophagus. Detail, Sacristy side. Bronze*

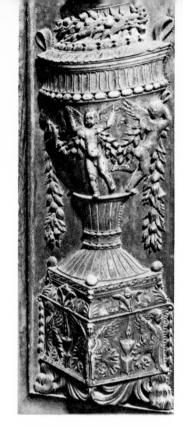

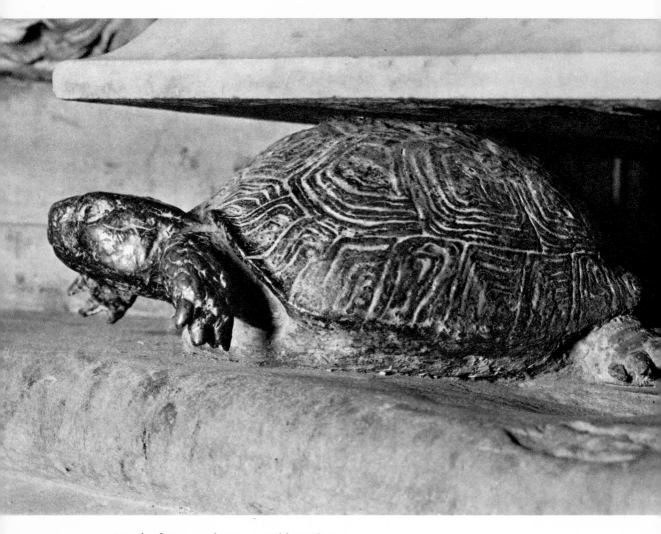

45. *Tomb of Piero and Giovanni de' Medici.*
Tortoise under Sarcophagus, Sacristy side. Bronze

opposite page: 46. Verrocchio. Eros with a Dolphin. Front view (cleaned).
Palazzo della Signoria (Palazzo Vecchio), Florence. Bronze

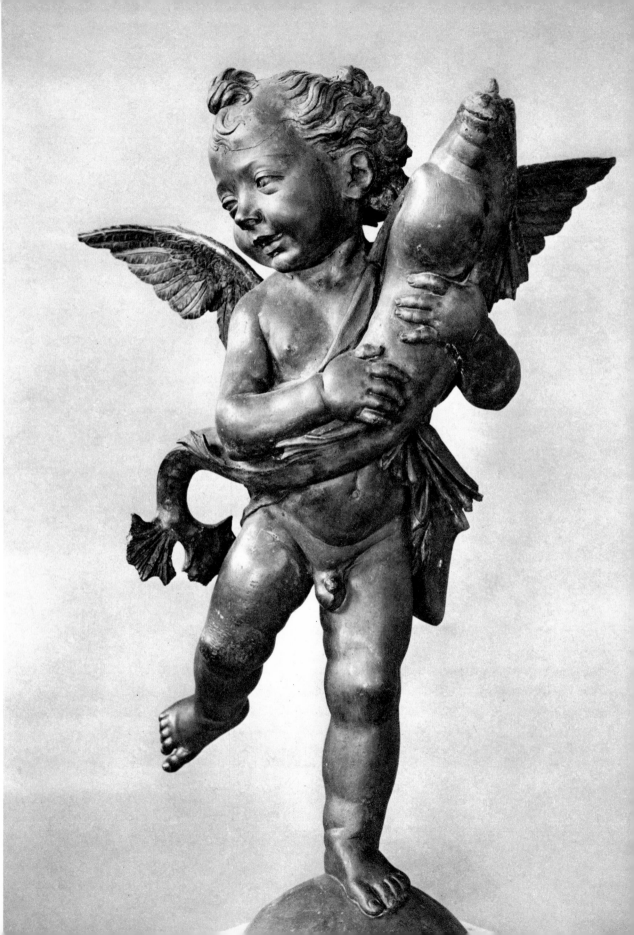

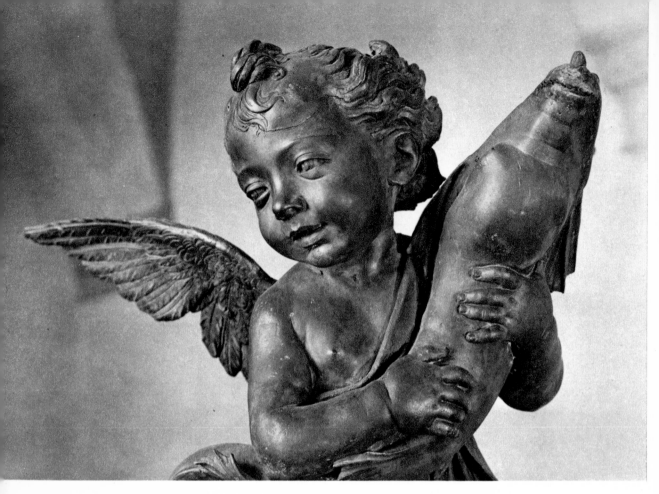

47. *Verrocchio.*
Eros with a Dolphin,
detail (cleaned).
Palazzo della Signoria
(Palazzo Vecchio),
Florence

48. *Attributed to Shop*
of Donatello. Putto
with a Dolphin, detail.
Victoria and Albert Museum,
London. Bronze

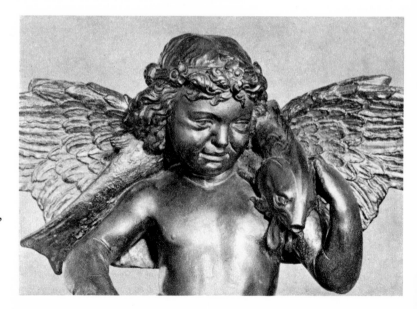

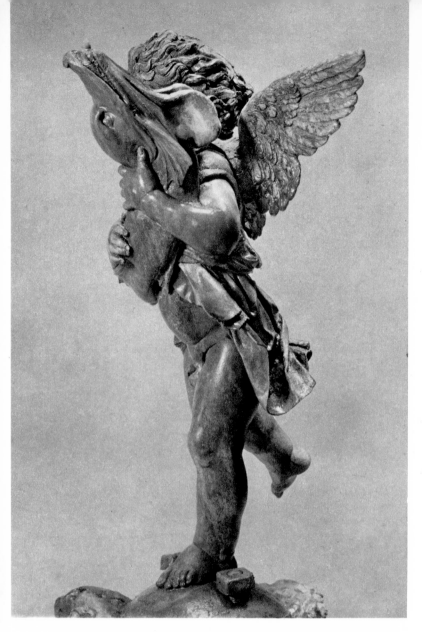

49. *Verrocchio.*
Eros with a Dolphin.
From side (uncleaned).
Palazzo della Signoria
(Palazzo Vecchio), Florence

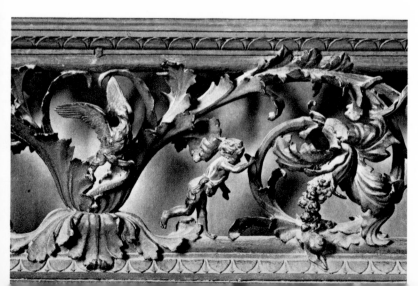

50. *Maso di Bartolommeo.*
Screen for Cappella
della Cintola. Detail.
Duomo, Pistoia. Bronze

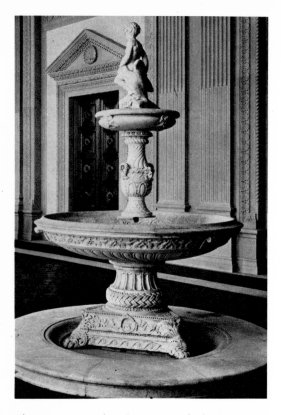

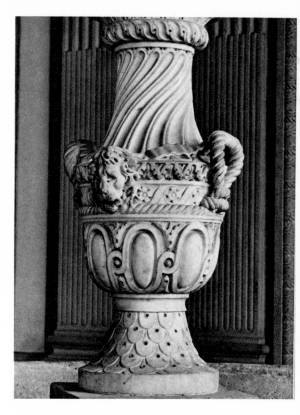

above: 51. Attributed to Verrocchio's design and partial execution. Presumed fountain base for the Eros with a Dolphin. Formerly Medici Villa, Castello. Now Pitti, Florence. Marble

above right: 52. Detail of Fig. 51

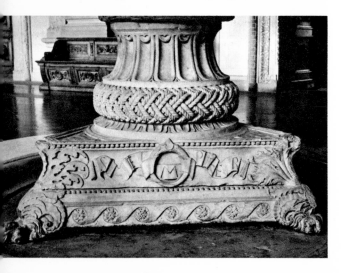

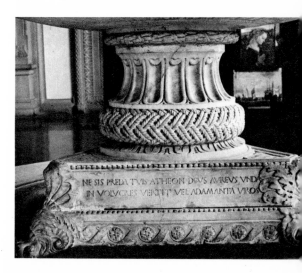

53. Detail of Fig. 51,
with device of Piero de' Medici

54. Detail of Fig. 51,
with inscription

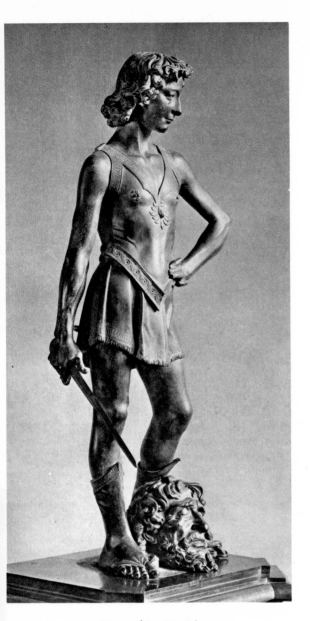

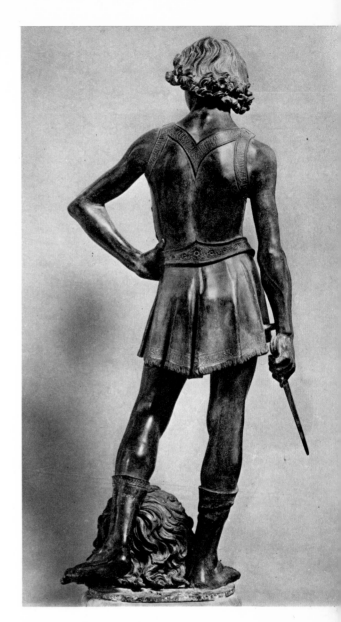

55. Verrocchio. David.
*Side view. Museo Nazionale
(Bargello), Florence. Bronze*

56. Verrocchio. David.
Rear view

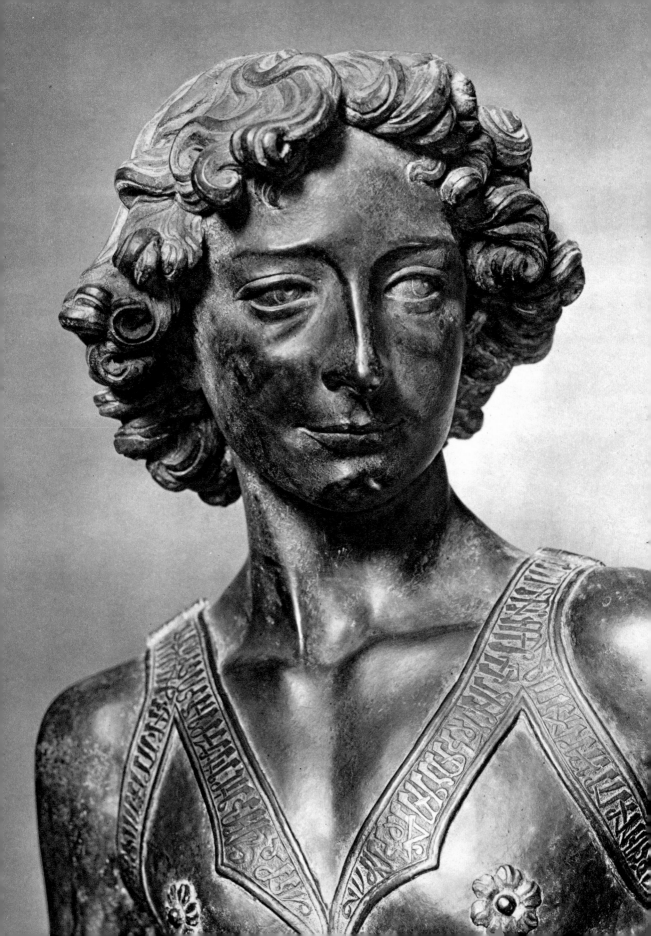

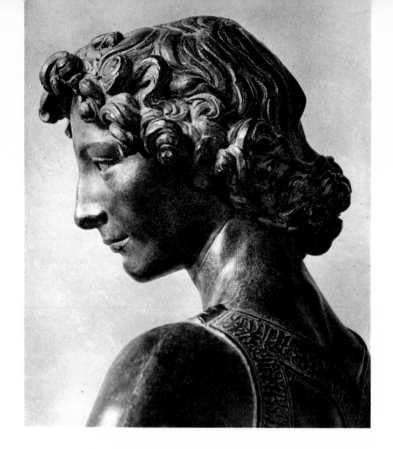

58. Head, left side

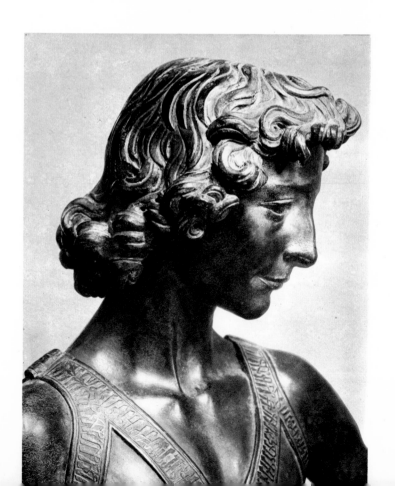

59. Head, right side

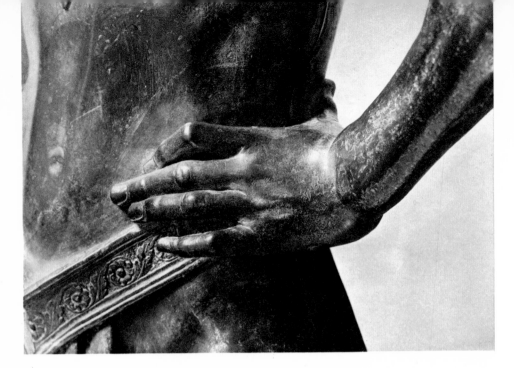

60. *Verrocchio. David. Left hand*

61. *Verrocchio. David. Head of Goliath*

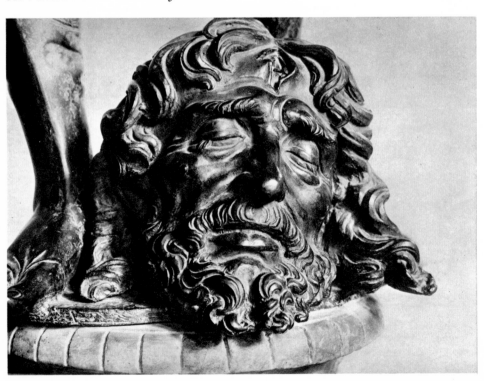

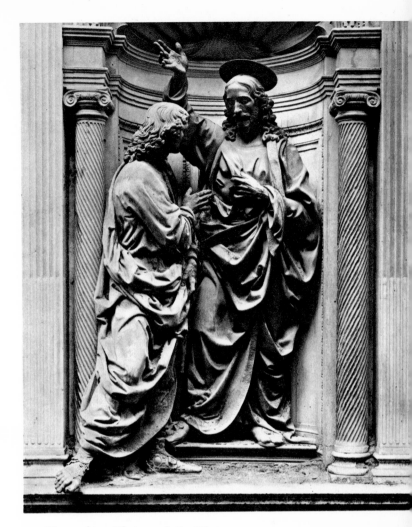

63. *Verrocchio. Christ and St. Thomas.*
Niche of Mercanzia, Or S. Michele, Florence. Bronze

62. *Donatello. Niche*
originally for Parte Guelfa,
later given to Mercanzia.
Or S. Michele, Florence. Marble

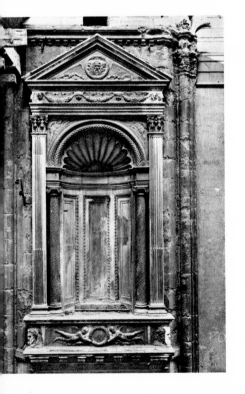

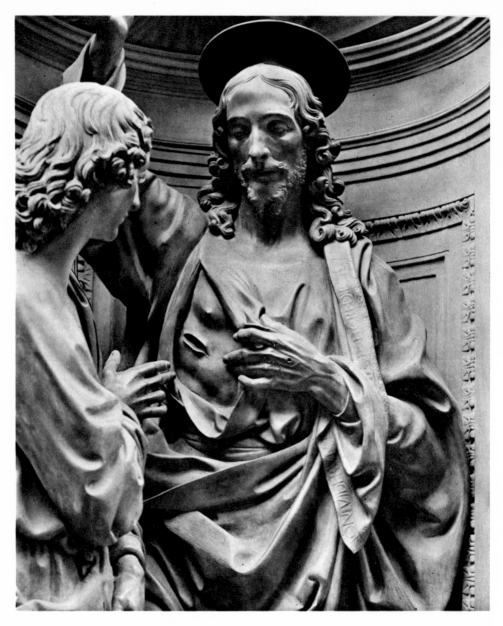

64. *Verrocchio. Detail of Christ and St. Thomas.*
Niche of Mercanzia, Or S. Michele, Florence. Bronze

opposite page: 65. Detail of St. Thomas

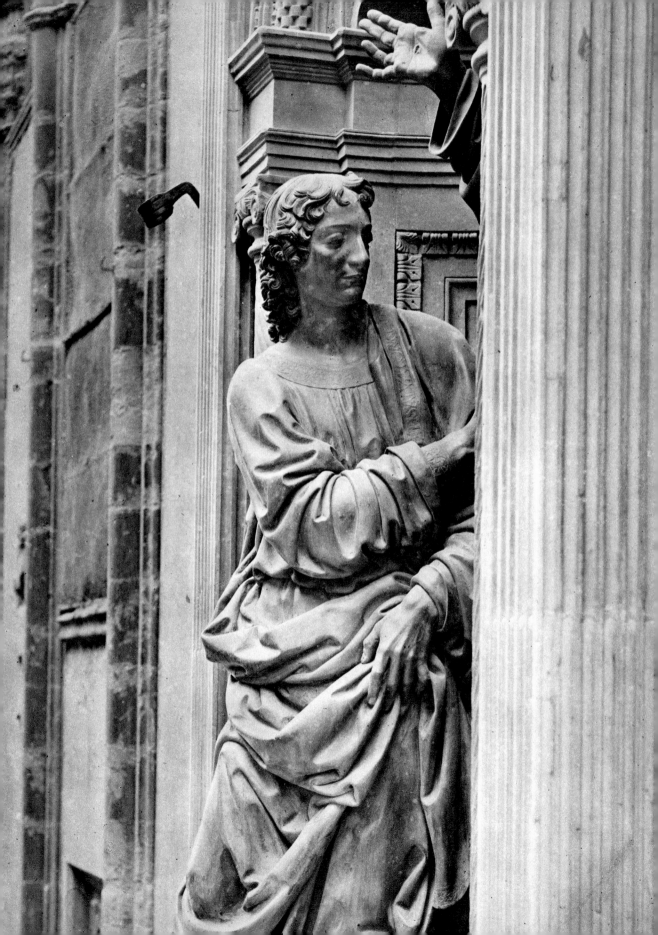

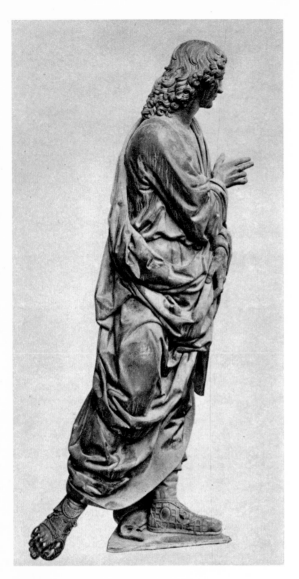

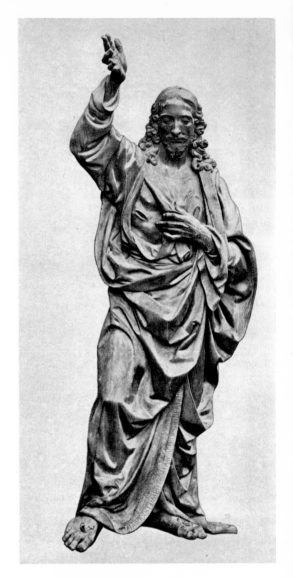

66. *Verrocchio. St. Thomas.*
Niche of Mercanzia,
Or S. Michele, Florence. Bronze

67. *Verrocchio. Christ.*
Niche of Mercanzia,
Or S. Michele, Florence. Bronze

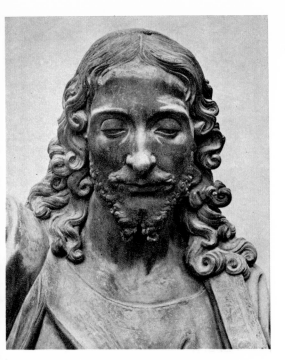

68. *Head of Christ, face on*

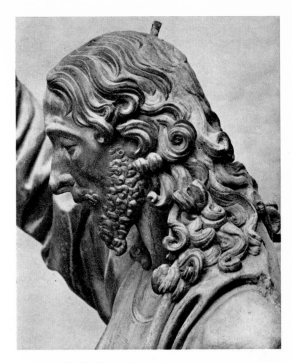

69. *Head of Christ, left side*

70. *Head of Christ, from rear*

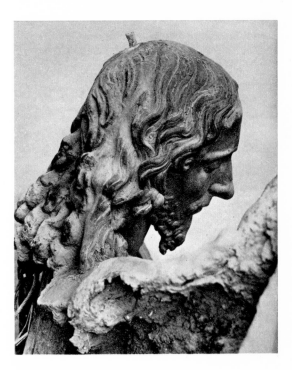

71. *Head of Christ, obliquely from rear*

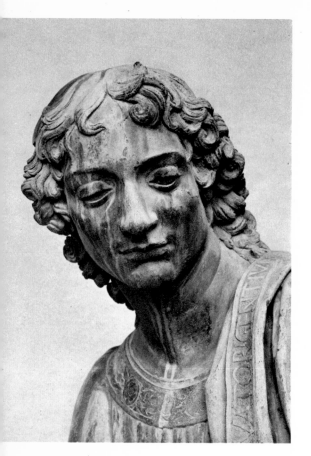

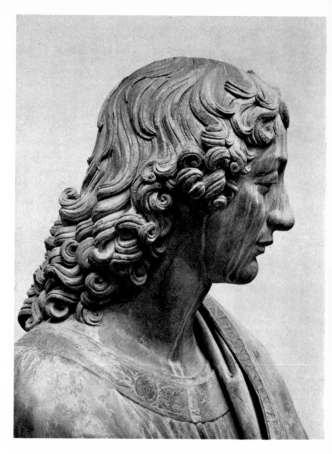

72. *Verrocchio. Head of St. Thomas,*
face on. Niche of Mercanzia,
Or S. Michele, Florence. Bronze

73. *Head of St. Thomas, right profile*

74. *Left hand of Christ*

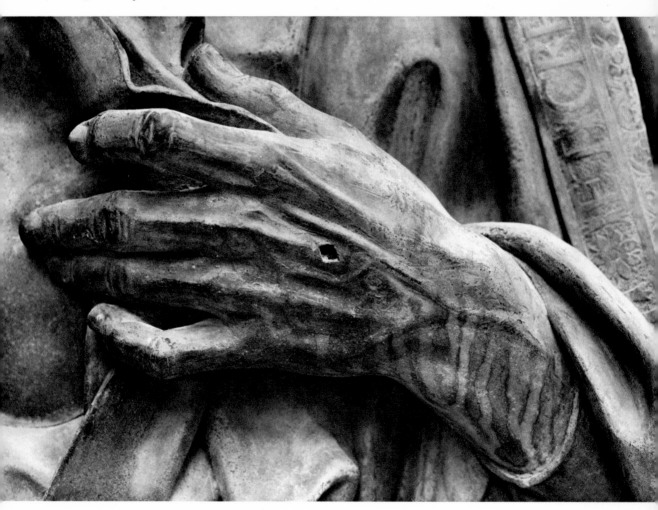

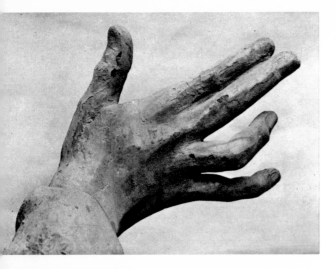

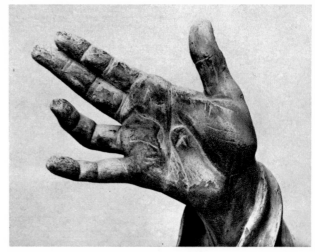

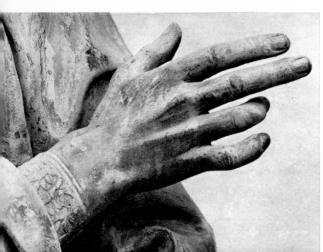

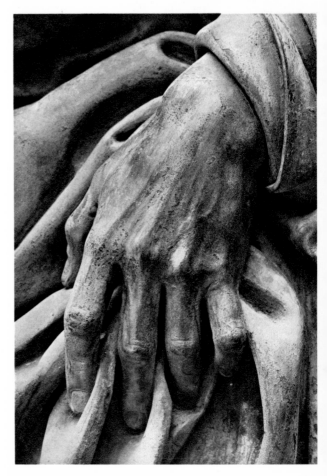

*above: 75. Verrocchio. Upper hand
of Christ, from rear. Niche of Mercanzia,
Or S. Michele, Florence. Bronze*

above right: 76. Upper hand of Christ, from front

above: 77. Right hand of St. Thomas

right: 78. Left hand of St. Thomas

79. *Bicci di Lorenzo.*
Christ and St. Thomas. Detail.
Florence, Duomo. Fresco

80. *Perugino.*
Handing over of the Keys. Detail.
Sistine Chapel, Rome. Fresco

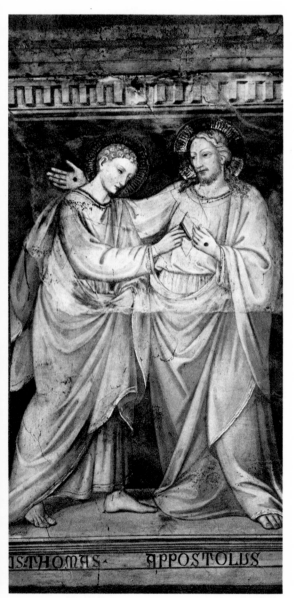

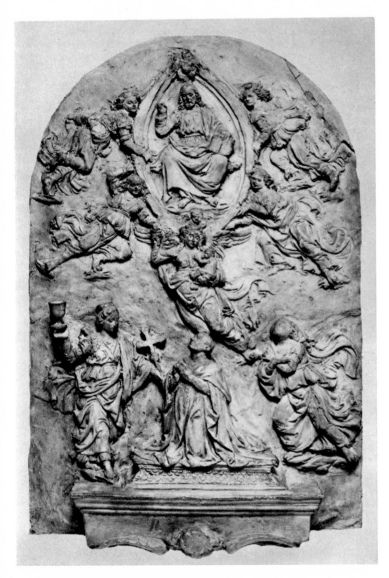

83. Nanni di Banco.
Frontispiece of the
Porta della Mandorla.
Detail. Duomo,
Florence. Marble

82. Verrocchio or Bottega (?).
Sketch-model of the Cenotaph of Cardinal Forteguerri.
Victoria and Albert Museum, London.
Terracotta

below: 84. *Verrocchio. Christ, detail of Fig. 81.*
Cenotaph of Cardinal Forteguerri. Duomo, Pistoia. Marble

opposite page: 85. *Faith, detail of Fig. 81*

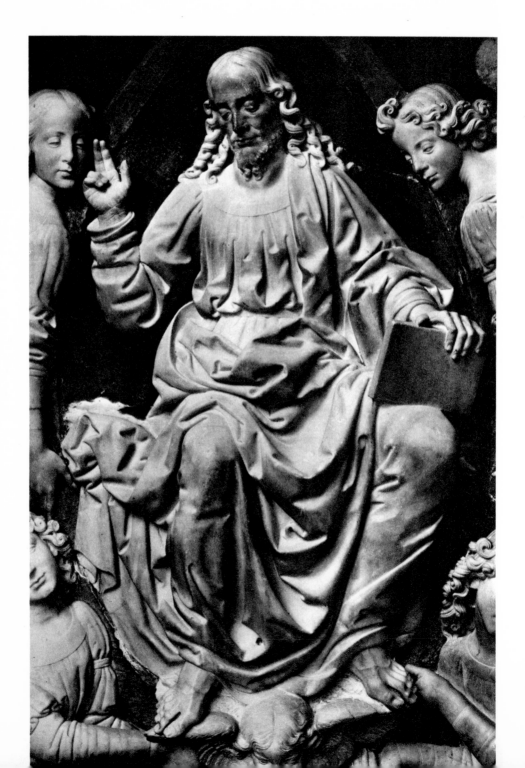

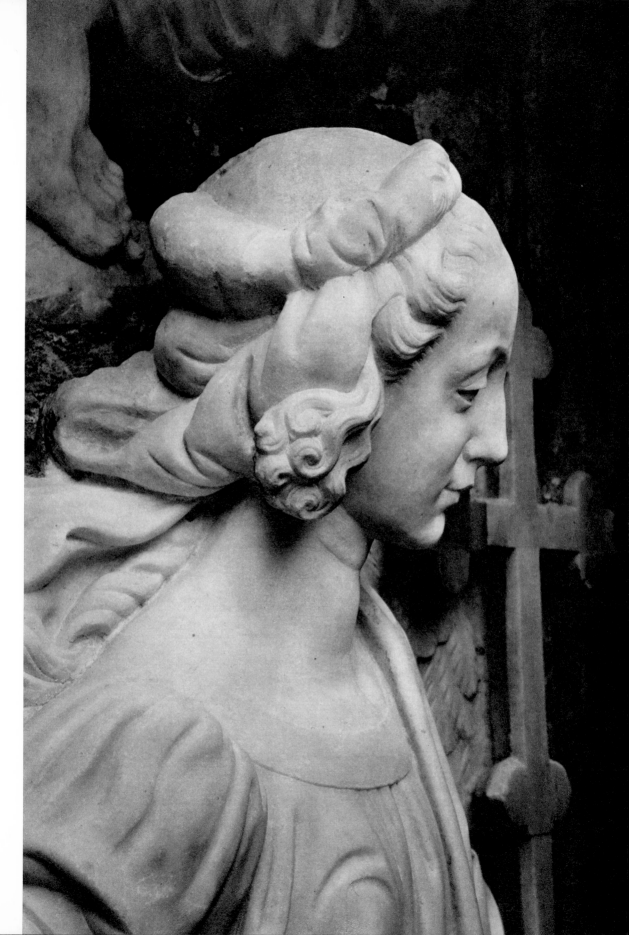

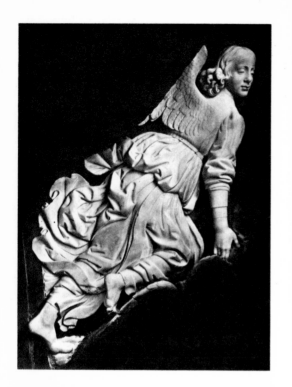
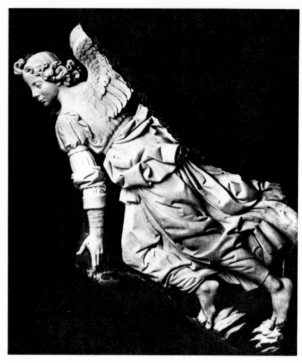
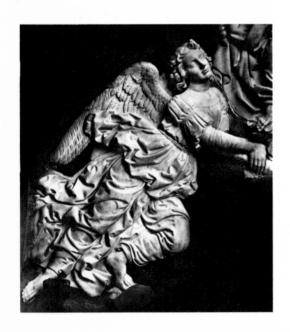
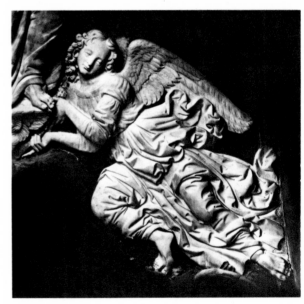

86-89. *Verrocchio Bottega. Angels, details of Fig. 81.*
Cenotaph of Cardinal Forteguerri. Duomo, Pistoia. Marble

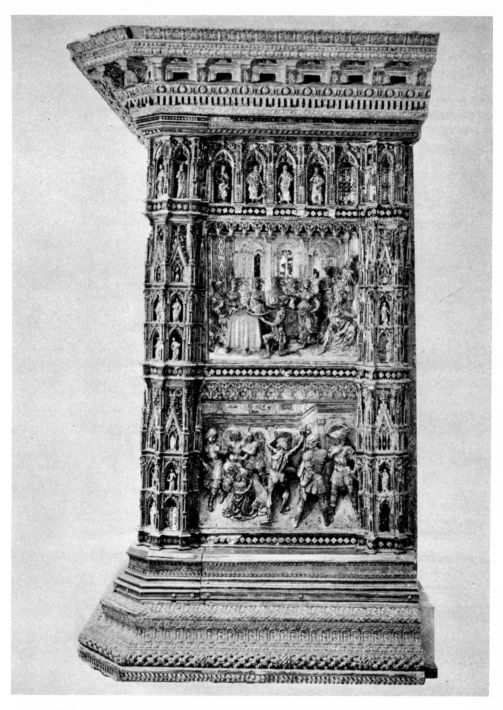

90. *Right lateral portion of the Antependium of the*
Baptistry Altar, right side (including Verrocchio's relief in place).
Museo dell'Opera del Duomo, Florence. Silver

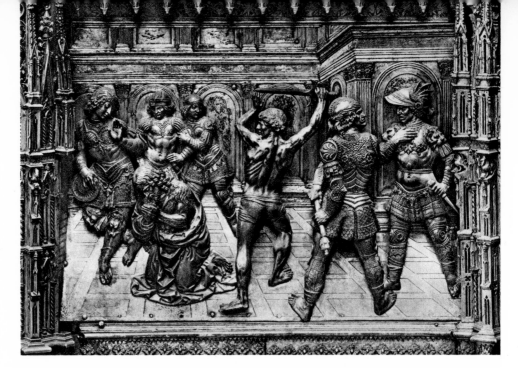

91. *Verrocchio. Beheading of the Baptist. Altar of the Baptistry.*
Museo dell'Opera del Duomo, Florence. Silver

92. *Antonio or Piero Pollaiuolo. Birth of the Baptist, Altar*
of the Baptistry. Museo dell'Opera del Duomo, Florence. Silver

93. *Verrocchio. Setting without figures for Beheading of the Baptist.*
Altar of the Baptistry. Museo dell'Opera del Duomo, Florence

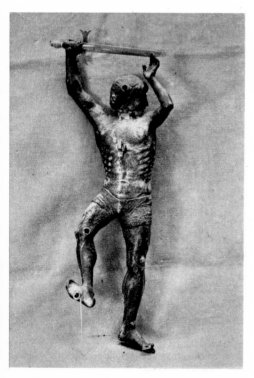

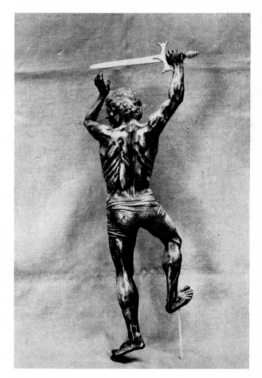

94. *Executioner, front*

95. *Executioner, back*

96. Jacopo de' Barbari.
Plan of Venice.
Detail of Campo
SS. Giovanni e Paolo,
ca. 1500. Engraving

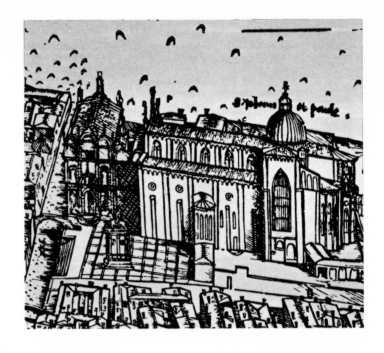

97. Visentini after Canaletto.
View of Campo
SS. Giovanni e Paolo
in the 18th century.
Etching

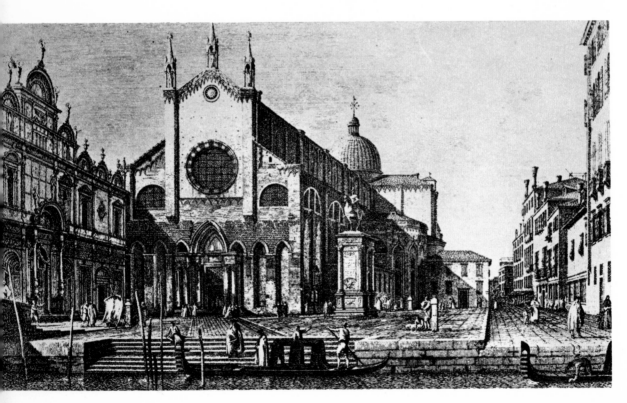

*opposite page: 98. Verrocchio. Colleoni Monument. Campo SS. Giovanni e Paolo,
Venice, looking toward Scuola di S. Marco. Marble and bronze*

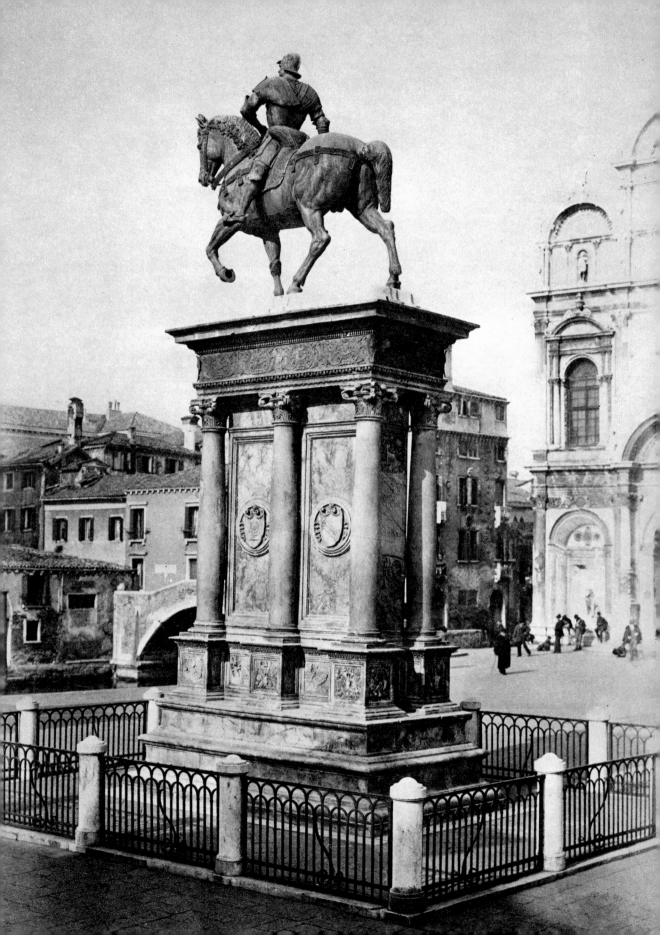

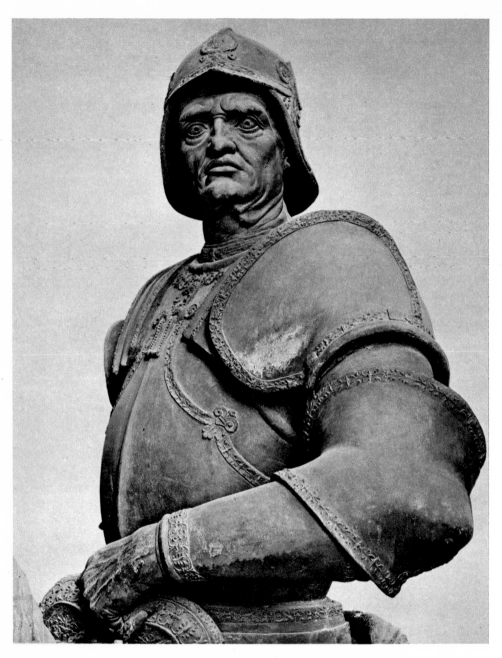

99. *Verrocchio. Colleoni Monument. Rider, oblique view*

opposite page: 100. *Verrocchio. Colleoni Monument.*
Horse and Rider, from right front

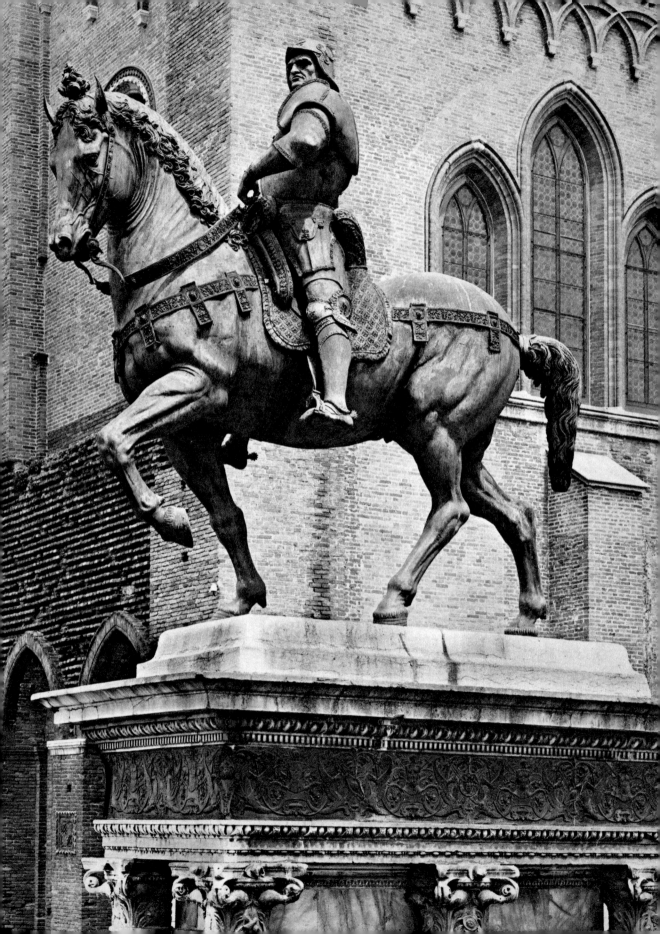

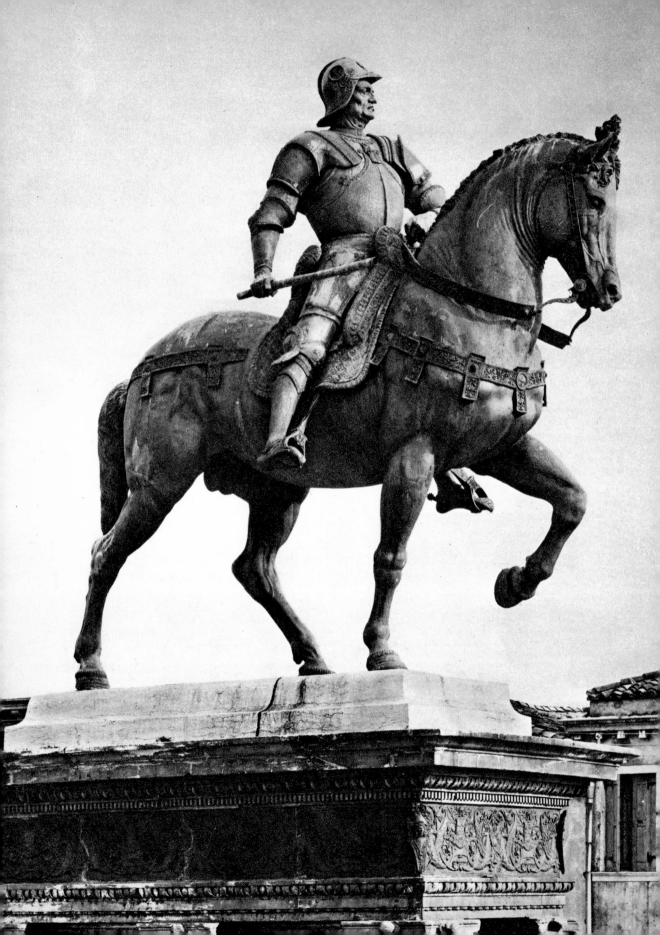

opposite page: 101. *Verrocchio. Colleoni Monument. Horse and Rider, from left front*

102. *Horse and Rider, from left rear*

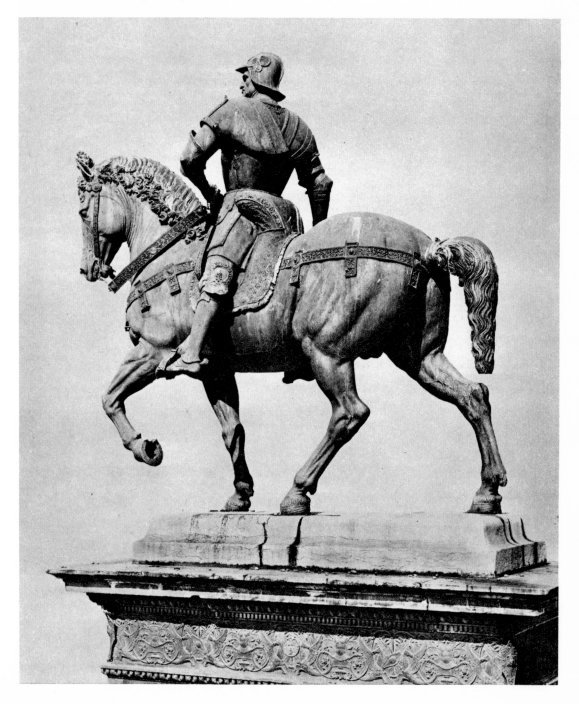

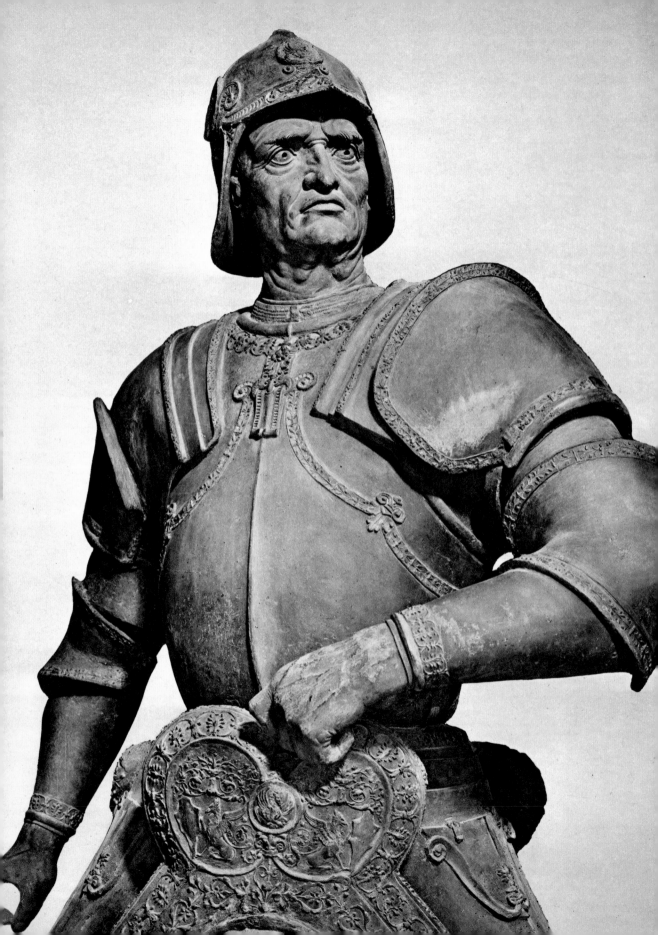

104. *Rider. Detail*

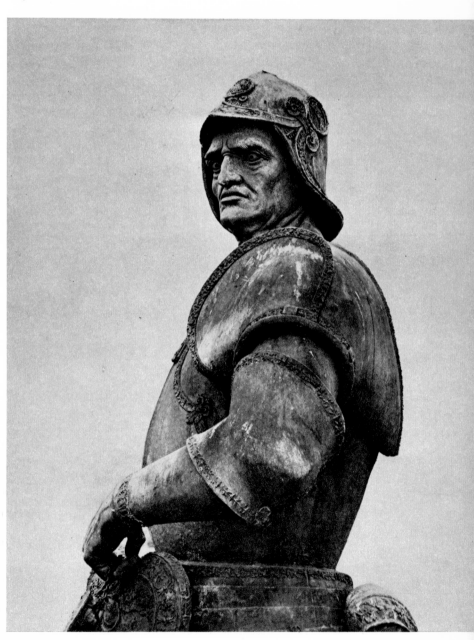

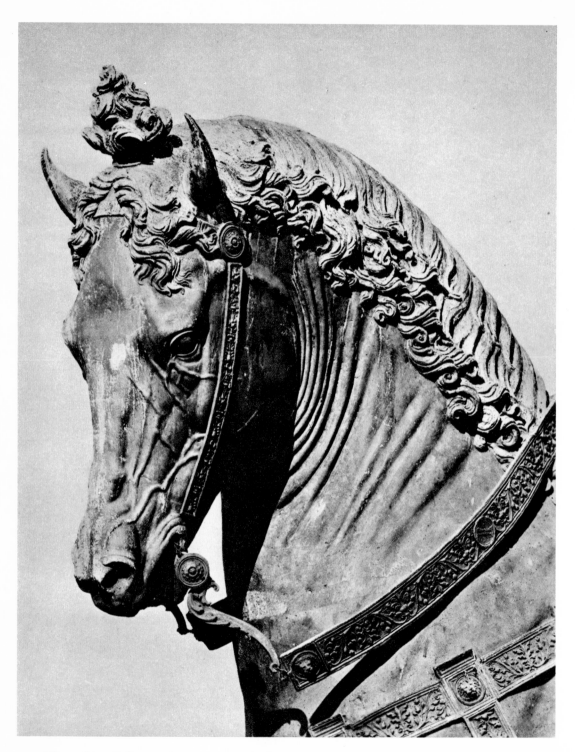

105. *Verrocchio. Colleoni Monument. Head of Horse*

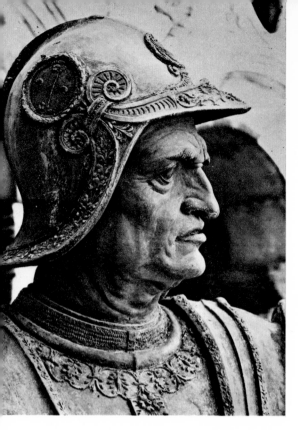

106. *Head of Rider, profile*

107. *Head of Rider,*
oblique view

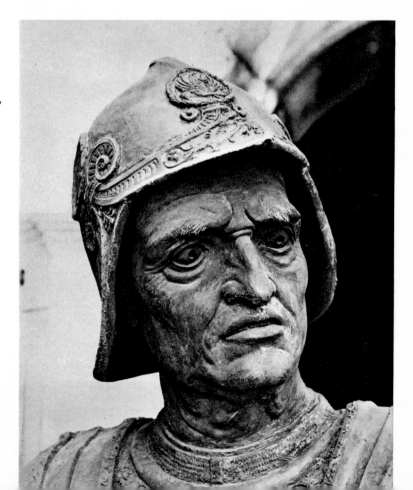

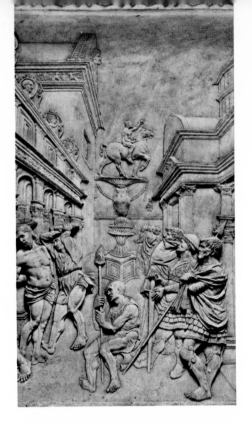

108. *Amadeo. Detail of Fig. 109, showing equestrian statue in the Antique manner. Marble*

109. *Amadeo. Colleoni Monument. Bergamo. Wood and marble*

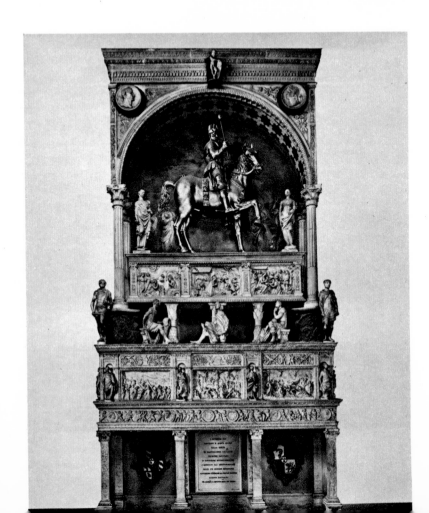

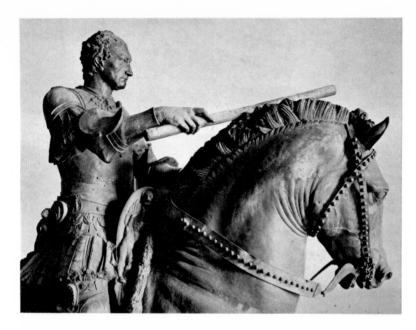

110. *Donatello.*
Gattamelata Monument.
Padua. Rider. Bronze

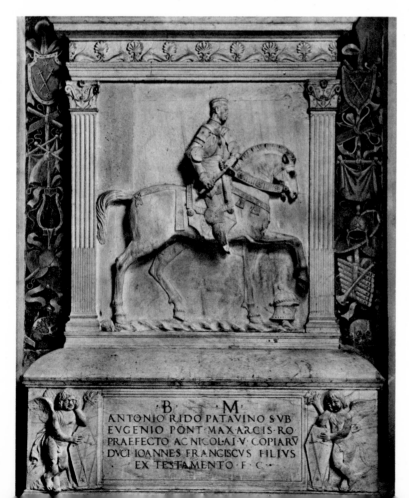

111. *Roman School.*
Rido Monument.
S. Francesca, Rome.
Marble

112. *Verrocchio. Colleoni
Monument. Horse from below, with
signature of Leopardi*

113. *Base of Colleoni Monument.
Detail in relation to architecture
of façade of Scuola di S. Marco*

114. *Base of Colleoni
Monument. Frieze. Bronze*

Chapter Three
ATTRIBUTED SCULPTURE

1. Likely Attributions
in Marble, Terracotta, and Bronze

THIS CHAPTER treats far more problematic material than did the preceding one. But with the documented work in mind, both reader and writer can feel a certain confidence in discussing attributions. We know Verrocchio's style of the seventies and the eighties, and we can surmise fairly well what his work might have looked like between 1465 and 1470. For nearly a decade, however—the period between 1457 and 1465, when Andrea made the momentous shift from the craft of the goldsmith to the art of the painter and sculptor—we have nothing to steer by except suppositions of varying credibility. Judgments based primarily on style now become the rule. We must use our eyes as well as our minds. It is only fair to say that many questions will remain open.

As explained in Chapter One, there is no escape from two basic hypotheses: 1) Andrea had to have specific training in the difficult technique of marble-sculpture; and 2) the best place for such training would have been in one of the two leading marble-working shops in Florence, those of Desiderio da Settignano and the brothers Rossellino—or perhaps in both. We believe today that master-sculptors of the Early Renaissance depended heavily on assistants for the hard, slow work of blocking out and for the even more tedious finishing of their larger compositions. Assistants were apparently employed regularly for the carving of ornament. They might, however, go beyond the execution of the purely ornamental sections of a given project and work on its units of figure-carving.

The sketch-model, or modello, would, we think, be made up by the master or by one of his best-trained assistants under the master's personal direction. In executing the piece in marble at the final scale, the next assistant would be held to following as closely as possible the forms of the modello. But in matters of art a mechanical following out of directions—a literal transcription of the forms of the modello into the final forms of marble—is not to be expected in the period of Verrocchio. The individual's own style

inevitably emerges. Though we may not always be able to attach a name to a given personal style, we can always sense the shift in touch and conceivably in personality when a different executant takes up the chisel; we feel that up to a point we can isolate, and later classify, his handiwork.

Thus the modello will give us the master's ideas expressed in terms of a specific creation at a specific point in time, his usual habits of proportioning his figures, and perhaps some new and original twist: in short, the larger, more basic elements of a given design. The hand of the assistant will usually make itself felt in details of the execution: in the articulation of a wrist, for example; in the surfaces representing flesh or cloth; in the shape of a nostril or a lip; in the feather of a wing. The hand of the assistant was not necessarily inferior in quality to that of the master—one has only to remember Leonardo's angel in the San Salvi Baptism. But it was a different hand, and an observer trained to pick out small variations in a work of art will be able to trace them to a single stylistic source. He will even be able to find them again in a photograph, though the "style" of the photographer may add still another element for interpretation, thus increasing the factor of difficulty and the chance for error. In my experience—contrary to some published opinions—it is always harder to identify the hand of an assistant in a photograph than in the original. But with the photograph one has a constant reference that remains unchanging, exempt from the shifting effects of daylight that seem to alter the original. The photograph may also reveal a normally dimly lit or distant detail with sufficient clarity to provide visual evidence for a decision; then we can talk about it with others who can look at the work with us, under the same conditions of lighting.

This examining of hands is what I propose to do here, with the clear warning that the results can never equal in validity the results obtained from the study of the documented work. What follows, however, is neither pure speculation nor pure theory. There is a factual basis in what the eye can see and the camera can record. After a preliminary look at what may be Andrea's earliest attributable work in marble, I shall present further undocumented work in marble and clay. This later work has been treated more often in the literature, and though it is in some cases no less controversial, it has the greater measure of general acceptance that comes with familiarity.

It is possible that Andrea was a member of Desiderio's bottega during the execution of the Marsuppini Monument. That tomb is usually dated from about 1455, when Carlo Marsuppini died, to about 1460. Quite surely it is a work of collaboration. The figures of the two little shield-bearers in the foreground are by different hands. That to the right, which does not seem to be by Desiderio, is extremely close to work known to have been done by Antonio Rossellino and could be by him. The differences between the two uppermost wreath-bearing boys are still more pronounced, and the style does not in either case seem that of Desiderio himself. Possibly—but only possibly—the figure to the left might be an early work by Verrocchio, although the evidence is still slight for decision.

However, this would be a likely place to look for Andrea's hand, since Desiderio is not known to have been a particularly able sculptor of the nude, or seminude; in addition, assistants were most often given work that would be placed rather far from the eye of the observer, as are the upper portions of this monument. In the Marsuppini Monument, the master's hand seems to be clearly evident in the delicate carving of the effigy and the decorative adjuncts of drapery and ornament on the sarcophagus; typically, these are central elements, close to the observer's eye. They are consistent with what one knows of Desiderio's style. It is a gentle style, one that seems to caress the marble rather than to hew out forms from it; it is a delicate style, full of suggestions of atmosphere enveloping the forms and of transitory expression—a smile, for example. A portrait-bust of an unknown lady in the Bargello seems to represent his style well (*Fig. 138*).

Desiderio's masterpiece—at least apparently in his own mind—was an altar in S. Lorenzo, the Altar of the Sacrament. A record of 1461 indicates that work on it was progressing but was not completed. In 1464, Desiderio died, still in his thirties. Evidently he did not leave the Altar of the Sacrament incomplete, but there is abundant evidence in the remnants of the sculpture of the altar that he received considerable assistance in the carving of its elements. The angels in relief on the two sides of the ciborium to hold the Host are by two different hands. The same is true of the standing boys who hold candelabra. The boy now placed on the right falls neatly and clearly into Desiderio's known style; gentle smile, languid curvilinear pose, delicately modulated details of hair and drapery, a sense of atmospheric envelope (*Fig. 115*). The boy on the left is quite different: a more serious type; in pose, straighter; in structure (both in the drapery and in anatomy suggested beneath), more definite (*Figs. 116, 117*). The features of the face are carved to represent distinctly shaped elements—eyelid and cheekbone, upper and lower lip clearly differentiated; hair definitely bunched in curvilinear ripples at the temples (*Fig. 118*). The wrist is bonier, the hand more nervous (*Fig. 119*), and the feet more prehensile in their firmer contact with the supporting base.

Particularly interesting is the closeness of the shapes of the candelabrum supported by the boy at left and the candelabrum in bronze that Andrea designed and cast in 1468 (*Fig. 31*). All these elements are more than merely reminiscent of what we have learned of Andrea's more mature style. They still, to be sure, show the strong spell of Desiderio—as indeed they should. If we are to search for evidence of his work with Desiderio, it is surely here that we should look. The active, strongly accented little winged putti in the upper parts of the altar show something of the vigor of light and shade that we shall later find in what may be Andrea's modeling, particularly in clay. We see a similarly bold treatment of light and shade in the soldiers of the terracotta Careggi Resurrection (*Figs. 150, 151*).

It has been noted in the literature that if Andrea had been a member of Desiderio's shop as of 1460-61, he would not have competed *against* Desiderio for the commission for an altar in the Cathedral of Orvieto (see CHRONOLOGY OF EVENTS). This is a matter we

cannot decide today in an offhand way. The recorded notice of the competition gives few details, not enough to establish direct opposition between the two men, such as an analogy with the competition in 1401-03 for the Florentine Baptistry Doors would suggest. To compete in 1461 might not have meant conflicting botteghe; Andrea might have been at the time so important a member of the Desiderio organization that he was permitted, or even encouraged, to enter the competition as an individual.

Possibly Andrea worked for a time, also in the early 1460's, in the shop of Antonio and Bernardo Rossellino. The funeral monument of Giovanni Chellini (Donatello's physician) in the church of S. Domenico, in the town of S. Miniato al Tedesco near Florence, has recently been restudied. The visual evidence, from style alone, has been interpreted as indicating that the effigy, which in design follows closely Michelozzo, was carved neither by Antonio nor Bernardo, but by another. The extraordinary vigor of the carving of the head and also of parts of the drapery—to say nothing of the carving of the strong hands—suggests that an artist very like Andrea could have been the sculptor-executant. The lettering of the pillow on which the head rests corresponds to similar details in work by Verrocchio (*Figs. 120, 121*). The cushion itself, with the fluid naturalism of the carving of the attached tassel, finds close echoes in works by or attributed to Andrea (*Fig. 122*).

The first work in marble that we can attribute with some confidence to Andrea, in his own right as a successful master, may be the lavabo, or ornamented washing basin, in the Quattrocento Sacristy of S. Lorenzo (*Fig. 123*). Vasari, in the middle of the sixteenth century, recorded the tradition that it was a work shared by Donatello and Verrocchio. Earlier, in 1510, Albertini gave a conflicting report that the lavabo was by Antonio Rossellino; this, however, can be discounted immediately in view of the style of the major portions of the work as we see it today; it is interesting as part of a tradition that Verrocchio and the Rossellino were at one time connected. Although the lavabo was a Medici commission, Tommaso does not include it in his "List," presumably because it had been completely paid for. Perhaps this rather indeterminate picture given by the written evidence has prejudiced modern views about the authorship of the lavabo.

The lavabo of S. Lorenzo admittedly contains some sculpture that is far from moving, particularly in the lunette relief. It also contains some extremely vital and exciting sculpture. The modern critic (see NOTES ON THE PRINCIPAL PIECES DISCUSSED, p. 165) who would deny the lavabo to Verrocchio notes correctly that the work as a whole evidently was moved from an earlier emplacement to its present unfortunate position in a small chamber adjoining the altar of the Sacristy. He leaves unresolved the question that matters a great deal: Where was the lavabo originally placed? The heraldic evidence is inescapable—this was a Medici commission, and in particular a commission from Piero de' Medici. As a lavabo for religious function or even a fountain for secular function, it is unusually elaborate for its period. Where does one find earlier the design of two super-imposed basins? It was never intended as a free-standing fountain, for the carving of the

main basin indicates that it must have been planned from the beginning for installation against a wall. That wall would most likely have been in the Old Sacristy itself. Such an elaborate wall-lavabo would not have been unwanted in the 1460's: a little earlier Buggiano had provided a rather grand wall-lavabo for the north sacristy of the Duomo. And a lavabo of some sort must have been envisaged for the even more monumental Sacristy of S. Lorenzo. Where would it have been placed? Quite possibly near the door, just as in both Sacristies of the Florentine Duomo. The most likely place for the lavabo, then, is the place where now we find the tomb of Piero and Giovanni de' Medici. (*See figure, p. 54.*)

The hypothesis that follows logically is that the lavabo was displaced because of the urgent priority of the tomb for the sons of Cosimo de' Medici. I think that the arch originally sheltering the lavabo was enlarged and opened up to provide the setting for the double-faced tomb. This would have been done only after the erection of the Altar of the Sacrament, as earlier discussed, and of course after the death of Piero in 1469. What to do with the earlier lavabo? Remove it. Give it a new and smaller arched setting to fit the cramped emplacement in another room, the little room where we see it today. Far-fetched? Probably much less so than any alternative theory.

The sculpture itself now comes to our aid. This emphatically is not all school-work. There is present the hand of a master and those of at least two assistants. The remodeling apparently involved more than the back-relief, which must have originally been higher from the floor than at present. The central cone-shaped motif decorated by dragons, from which the water must have fallen, has been brutally cut down in height both at its summit and base, then squeezed back uncomfortably into the upper basin. Traces of this modification are plainly visible today (*Fig. 129*). Contrary to the most recently published analysis, the lower and larger basin was not recut to modify it from a free-standing monument to a wall-fountain. How is it possible to recut a full-round marble basin to make a wall-type fountain with a flattened inner surface at the rear in which the marble is *continuous* with the marble of the rounded portion? That would require the miracle of adding marble in the supposed recarving.

There must have been, however, a major modification in the supporting base. The present makeshift lump of serpentine that supports the larger basin can hardly represent anything but a restoration or a substitute measure, and a rather poor one at that. We should think of the basin as being originally a good deal higher from the floor, the cone-shaped central motif rising higher than at present, and the back-relief, carved with the device of Piero de' Medici, higher still—of the whole composition as more expansive and free, and above all having sufficient viewing space before it to provide the sensation of monumentality. That space would have been available if the original emplacement was on the wall where the tomb of Piero and Giovanni now stands.

That hypothesis has certain attractive corollaries. It explains the present anomalous position and the modifications of form in the lavabo as we see it today. It also provides

for the presence before 1470 of a lavabo of a monumental type in the Old Sacristy, where one should be expected—and one with Medici heraldry prominently displayed. The patron could have been none other than Piero (see his heraldry of diamond ring, falcon, and his motto, SEMPER); if, as seems most likely, the lavabo was his contribution to the Medici mausoleum while he was head of the family, it can be dated any time from 1464 on—at any rate before 1469, when Piero died and plans for the tomb were begun.

It may be argued that the lavabo's motifs of dragons and harpies with intertwined tails are essentially secular and would be out of place in the Sacristy. The suggestive putti holding water vases in the Sacristy of the Florentine Duomo are hardly less "secular." Actually, in the 1450's, Antonio Pollaiuolo had used winged harpies of this very type as supporting figures for the great silver crucifix of the Florentine Baptistry.

The harpies of the S. Lorenzo lavabo betray two differing styles of treatment. One is rather timidly carved (*Fig. 127*). The other, by what one must call the master's hand, is boldly and freely executed (*Fig. 128*): the eyes stare, the locks of hair flow rhythmically and form a more subtle union with the ornament of the basin. Also by the same hand, which surely can be no other than Andrea's, is the central lion's-head ornament (*Fig. 131*). It is freely and powerfully conceived, far closer to nature than is usual at this date. (Compare the similar motif on Bernardo Rossellino's Bruni Tomb in *Fig. 130*.) It is closer, too, to the spirit of Hellenistic art; certainly, like so much of Andrea's known work, it provides a foretaste of the Baroque. Not conceivably by Andrea, though it most probably follows his design, is the heraldic motif of falcon, ring, and inscribed ribbons in the marble background relief (*Fig. 124*). It must have been carved by a still-unidentified assistant, when the modified composition was set up in its new place some time in the period 1470-75.

Though the tombstone of Fra Giuliano del Verrocchio (see p. 23 and *Fig. 29*) may be the first independent work in marble that we can give to the sculptor Verrocchio, the lavabo of S. Lorenzo seems to be his first elaborate commission allowing imaginative scope. Among his works it would also be the earliest fully three-dimensional Medici commission that has survived, following closely in time the floor-monument of Cosimo Pater Patriae. Even though mutilated, it is not unworthy in quality to stand close to the sculpture of Donatello.

One of the most famous of all the portrait-busts attributed to Verrocchio is the marble half-length of an unknown lady now in Bargello Museum (*Fig. 133*). It is the understandably popular "Lady with Primroses," or more properly titled, according to a recent botanical opinion, simply "Lady with Flowers." There is no record of the portrait's origin. The identity of the lady remains a mystery, though the bust is believed to be traceable to a Medici connection. In the post-Renaissance era there has been talk off and on of linking the subject with Lucrezia Donati, beloved of Lorenzo the Magnificent, or even with Simonetta Vespucci, the mistress of Giuliano. In fact, it is uncertain whether

there was any connection whatsoever between the bust and the Medici family in the fifteenth century, though that is possible.

The costume is one in fashion about 1480: a very delicate lawn undergarment, and over it a light and clinging dress with sleeves to the wrist. Around the waist is a thin scarf, fringed at the visible end. A dress of this kind is worn by the ladies at the banquet table in a painting illustrating part of the Boccaccio's story of Nastagio degli Onesti executed by Botticelli (with assistance) in 1483 (now in the Prado Museum). It is therefore something of a festal costume, whose modishness is echoed by the artfully contrived, tight little curls that frame the lady's temples. The bust is noteworthy not only for including the full arms and hands—an unusual though not unique feature—but also for being carefully finished in the back. It is most effective in profile or viewed obliquely. The directly frontal view is the least successful, though it presents to best advantage the delicately posed and carved hands. These hands have much in common with the hand of the boy on the S. Lorenzo Altar of the Sacrament (see p. 115 and *Fig. 119*), which might well be by Verrocchio in his earliest period as a sculptor. Hands also appear in the bust of Donato de' Medici, a commemorative relief of about 1475-80 in the Cappella della Piazza of the Duomo, Pistoia (*Fig. 132*), where Verrocchio and his shop provided the altarpiece and probably the finely conceived tomb-marker at the chapel's entrance as well. The hands of the Lady with Flowers are far more generally compared with hands by Leonardo, those of the Mona Lisa or those that art historians believe probably graced the missing lower portion of the portrait of Ginevra Benci that is now in the National Gallery of Art in Washington.

Because of the attention to delicate detail and the rather trancelike expression, tinged with melancholy by the faintest trace of a smile, the Lady with Flowers has been attributed often to Leonardo himself, though we have no comparable work from his hand on which to base a judgment. (*Pace* the enigmatic wax bust of Flora, Berlin-Dahlem.) The style of the Bargello Lady admittedly does not have the boldness or breadth of the marble-carving in the Forteguerri Cenotaph, documented as by Andrea. Perhaps the modello for the Lady was Andrea's and the finished marble that we see today at least partly the work of an assistant. (Some have suggested Leonardo also in this role.) It is extremely difficult to tell. The costume, if our analysis of it is correct, would put the work around 1480. But this date creates a difficulty, for it would place the bust in Andrea's maturity, and exactly at the same time that he was working in a very different manner, though also in marble, on the Forteguerri monument. Hence arises, if not concern, at least some reservation as to how and where to classify the work in what we know of Andrea's development.

There is something of the same delicate, trembling, romantic overtone in the design of what appears to be a lost Madonna and Child in marble, which we know through two stucco reliefs that could have been taken from it. One of the stuccos, which came originally from Signa, near Florence, was formerly in the Diblee Collection in England; the other is now in the Allen Memorial Art Museum in Oberlin (*Fig. 156*). We may

provisionally call the hypothetical original the "Diblee-Oberlin Type." Though it has been considered the work of a follower of Verrocchio, and even connected recently with Benedetto da Majano, the quality of its design and its influence on paintings by members of the Verrocchio bottega are so evident (*Fig. 16*) that it is difficult to think of the author as anyone but the master himself—though perhaps before he attained his mature style, since the drapery is more fluid than in the sculpture of the seventies, and the type of the Christ Child approaches Desiderio's.

In Washington, the Mellon Collection of the National Gallery of Art, is a portrait-bust of a child that is one of the most beautiful of its kind of any time or place. Undocumented in any way, it has always been given to Desiderio in the scholarly literature. The subtlety of the modeling, the sensitivity of observation, is truly what we would expect of Desiderio (*Figs. 139-141*). But in many respects it is not in his usual manner. The strong modeling of the eyes and ears, the air of solemnity, the impression of the white solidity of the marble, the tri-dimensionality, all speak against Desiderio's hand. To appreciate this it is necessary only to walk a few yards in the museum to see the indubitably Desideresque Christ Child of the Kress Collection, a piece overflowing with genial good spirits and carved with the lightest of touches (*Fig. 144*)—or to turn to the most famous of Desiderio's reliefs of children, the so-called Arconati-Visconti relief in the Louvre (*Fig. 143*). The Mellon Collection Little Boy could be by Verrocchio, while he was still, of course, very much under Desiderio's influence, if not his direct guidance.

There are other portrait-busts in marble that at one time or another have been associated with Desiderio (and in at least two cases are still officially given to him) but that deserve re-examination. The first of these portraits is of an unknown, and far from attractive, lady in the Louvre, to which she came as a gift from Sir George Donaldson in 1892 (*Fig. 134*). The bust then had no pedigree of interest; it purported, however, to represent Isotta da Rimini, in the nineteenth-century tradition, fostered by Wilhelm von Bode, that attached romantic names to a good number of objects of this kind. The glamorous Isotta, who was first the mistress, then the wife of the dashing condottiere Sigismondo Malatesta, can hardly have been the original model for the rather careworn woman of the Louvre. What is lost in charm is compensated by seriousness and humanity. The style is not far from that of the Little Boy in Washington, or of the finer portions of the Forteguerri Cenotaph.

There is another portrait of a lady in Washington, in the Kress Collection, which also for a time passed as that of Isotta da Rimini—and at least superficially with better reason. It is an extremely fine work, beautifully carved and finished, and of imposing monumentality. It has been remarked that the features are very like those of Simonetta Vespucci in the Vespucci family fresco painted in the Florentine church of Ognissanti by Domenico Ghirlandaio about 1475. This purely visual connection seems convincing. Though the lady in Washington may not be *proved* to be Simonetta Vespucci, mistress of Giuliano de' Medici, the apparent age of the sitter would be consistent with the idea, as

would her features and the sumptuous presentation, which involves a rather elaborate headdress and a heavy brocaded gown (*Fig. 135*). Again, earlier attributions have included not only Desiderio but also Leonardo da Vinci. Neither appears as plausible as the attribution to Verrocchio, particularly Verrocchio of the period of the Forteguerri Cenotaph (*Fig. 85*). If, indeed, this fine marble is the portrait of the same young woman who is represented in the roughly contemporary Vespucci family fresco of 1475, it is worth remembering that the painter, Domenico Ghirlandaio, was for a time, in the seventies, a member of Verrocchio's bottega. Both could have worked from the same drawing or mask.

Also in the National Gallery of Art (Widener Collection) is an extremely beautiful unfinished portrait-bust of a young woman who seems hardly more than a girl (*Fig. 136*). Wilhelm von Bode, director of the Kaiser Friedrich Museum in Berlin before World War I, claimed that the bust came from the Strozzi palace and was none other than Desiderio's "lost" portrait of the attractive and lively Marietta, daughter of Palla Strozzi, celebrated in Florence and prominently mentioned by Vasari. The dilemma here derives not from the sitter's age or presumed personal likeness, but from the style of the object itself. This is an unfinished marble; the problem of attribution is therefore greater than it might normally be. It has also been restored (nose and one lock of hair). But from what we now see, the authentic shapes and the method of blocking them out come very close to the norm of Andrea's marble style. Perhaps comparison with an unfinished drawing of a woman's head (see *Fig. 22*), rather than with a finished marble, might provide the best support for his authorship. Essentially the same method of creating form is used in both. The reason for abandoning the marble in mid-course is not known: perhaps an accidental break or slip of the chisel; perhaps the appearance of an ugly dark streak in the marble, which sometimes occurs in even the best-looking blocks of Pietrasanta or Cararra marble. We shall probably never know. In any case, we can enjoy one of the most attractive sculptural creations of the entire Quattrocento, and savor the unusual opportunity of watching the hand of the sculptor proceed from the rough preliminary forms toward the finished ones. Less monumental, more delicate, daintier in mood, is the slightly smaller bust formerly in the Dreyfus Collection in Paris, where it was fancifully entitled "Medea Colleoni" (*Fig. 137*). It was formerly in the collection of John D. Rockefeller, Jr.

It is time now to turn from attributions in marble to those in clay. Here we are concerned with a far less expensive, and also less risky, medium of sculptural expression. Mistakes in marble can never be erased; in pliable clay they can be redeemed, sometimes in a matter of minutes or seconds. Clay is the rougher medium of the two in the normal technical situation. It may be smoothed but it is not usually polished, though it may be painted or glazed to imitate marble. Clay preserves more readily the direct impact of the sculptor's hand—in the literal sense of the phrase. Marble is shattered somewhat mechanically by

the chisel; clay is molded more directly and more gently by the fingers and thumb. Sometimes the mark of the artist's finger- and thumbprints are preserved virtually intact; a revised Bertillon system might one day be an aid in connoisseurship, and has indeed been recently invoked in the case of Leonardo as a painter.

The earliest work in terracotta usually given to Andrea in art historical literature has most recently been denied to his authorship—I think perhaps unfairly, both to Andrea's memory and to the work of art itself. This is the rather sizable relief of the Resurrection, now in the Bargello (*Fig. 145*). It was made in several sections, of roughly modeled and boldly polychromed terracotta, evidently architectural in original function. The patrons were doubtless the Medici; the relief was found in the Medici villa at Careggi at the end of the nineteenth century, dismounted from its original architectural setting and in a number of fragments.

Ever since its discovery the Careggi relief has excited interest. It has also provoked controversy, particularly as to date and function. Its dependence in general composition upon Luca della Robbia's Resurrection in the arch over the door to the North Sacristy of the Duomo (*Fig. 146*) was at once recognized. The Careggi relief seems to have served a similar function as an over-door decoration, whether at Careggi or near by. The technique of assembling separately fired sections is completely in keeping with that normally used in the Robbia shop, though the joints are not so well disguised or the surface, without covering glazes, so unified. Considerable traces of color and gilding remain, and one should imagine the coarseness of detail in many places as softened by a color-coating. In its freshness and vigor the modeling makes a striking contrast to the more classic surfaces and balance of figures in the Robbia design. This would be what we would expect of Verrocchio. Nonetheless, the Christ in particular (*Fig. 147*) has recently elicited queries about Verrocchio's authorship and also the date. For a time it was thought that the sleeping soldier in the foreground represented the young Lorenzo de' Medici (still, incidentally, a possibility). The identification was based on the fact that the Robbia relief on which the Careggi Resurrection depends was over the door of the Sacristy where Lorenzo had found sanctuary at the time of the Pazzi uprising in 1478. The Careggi relief was thus interpreted as an *ex-voto* of thanks for deliverance and dated about 1478.

It has also been said that the Christ repeats the Christ of Or S. Michele and should therefore be dated in the eighties. None of these arguments for a late dating of the relief seems to this writer convincing. Earlier than 1478, the Robbia relief would have made available an excellent prototype, without any political overtones; and we know that in 1467 Andrea was in touch with Luca della Robbia (see p. 53). Moreover, in 1467 Andrea had in hand the Or S. Michele commission and might well have been working out possibilities, in clay sketches, for the design of the Christ. It could be argued, in fact, that the Careggi Christ is in some ways the model for the Or S. Michele Christ, rather than the other way around. The Careggi drapery, finally, seems to be an experimental interpretation of Antique *figura togata* drapery, which Andrea could have studied from several

sources in Florence, one a sarcophagus that had stood by the Baptistry since Dante's day.

Admittedly, the poor surface, marred by abrasion, breaks, and awkward restorations, detracts from the over-all effect. The angels do not balance very well in style (*Figs. 148, 149*). But the modeling of the soldiers, in groups at the left and right, presents passages of extraordinary bravura (*Figs. 150, 151*). If not Verrocchio, who could possibly be the author? Some have said the young Leonardo. But this suggestion takes us once more into a realm of speculation. Accordingly the plea is made here to recognize the Careggi relief —which could be the "*rilievo com più fighure*" of Tommaso's "List"—as by Verrocchio (probably with assistance) before or around 1470.

One Medici commission that is not recorded by Tommaso, perhaps because it was never completed or was lost in the Medici debacle of the nineties, is a portrait-bust of Giuliano de' Medici. The full-size modello in fired clay for that bust is still extant, at least in large part, in the Mellon Collection of the National Gallery of Art (*Fig. 152*).

The vigor of the modeling of the head, the monumentality of the design, the strong sense of individuality of the personage represented, have assured general acceptance of this portrait as by Andrea's own hand. There are undoubtedly losses, with subsequent repairs to the surface, particularly in the cuirass—it would indeed be remarkable if the terracotta had not been damaged over the centuries. But in its total impression the portrait is one of the grandest of the Italian Renaissance. Its date, one would think, would be closer to 1476, the date of Giuliano's famous *Giostra*, than to 1478, when he was killed in the Pazzi conspiracy. It is a record of triumph, not mortality.

Also in terracotta, possibly a modello in lightly fired clay, is the bust of a deacon-saint at present in the Old Sacristy of S. Lorenzo (*Fig. 153-155*). For long years it was attributed without justification to Donatello; then, for a shorter time, to Desiderio. Its resemblance to Andrea's bronze David in youthful type and to the portrait of Giuliano de' Medici in freedom and power of modeling at once suggests Verrocchio. The profile views (*Figs. 153, 154*) recall particularly the David (*Figs. 58, 59*). The stylistic relationship between Desiderio and Verrocchio, sketched out earlier (see p. 115), would account for the attribution to Desiderio, but it can reasonably be dropped today.

The deacon-saint represented may be either St. Lawrence or St. Leonard. The bust is first mentioned in the church of S. Lorenzo in 1757. There is no mention of its location before that date. A late source cites a record, now unidentifiable, that the bust represents St. Leonard and was installed in the Neroni family's chapel in S. Lorenzo. The bust was stripped of a coating of paint about 1885. This cleaning may account for the rather dry-looking finish, which one might criticize adversely in the presence of the original. Even so, its beauty, combining freedom of handling and sensuous delight in shapes and surfaces of the head, is irresistible.

Andrea's mature treatment of the Madonna and Child theme in sculpture is presented in the terracotta relief, partially polychromed in its present state, from the Hospital of S. Maria Nuova (now in the Bargello; *Fig. 159*). In its original state, apparently, the

figures were painted an ivory tint to suggest marble, whereas the background, as in Robbiaware, was given a darker tint of solid blue. The composition builds up with a good deal of power from a broad base made up of interesting and contrasting shapes of drapery and, at the right, the cushion on which the Child stands. It is evidently later than the Diblee-Oberlin type, which is more planar in its presentation; it also has a greater suggestion of movement than the presumably earlier relief, particularly if one compares the treatments of the Child (*Fig. 156*).

The Child of the S. Maria Nuova relief leads in type directly toward the Running Putto on a Globe of the Mellon Collection in the National Gallery of Art (*Figs. 160, 161*). This terracotta modello, quite possibly for a fountain figure (see again *Fig. 12*), should be compared with the S. Maria Nuova Christ Child rather than with the bronze Eros with a Dolphin (*Fig. 46*), as is usually done. If you can imagine the S. Maria Nuova Child as a slightly bulkier, more classicizing figure, activated into a running position, you would come close to the imaginative process that the artist probably followed. The Running Putto must indeed be later than the S. Maria Nuova relief, probably made between 1475 and 1480. In this writer's judgment, contrary to recently published views that would deny the piece entirely to Verrocchio, the Putto in the National Gallery of Art not only is Andrea's work, but represents the development of his experimental full-round compositional devices at its most complete (except perhaps for the Colleoni Monument). The variety of views and their unfailing interest give the piece a place apart from the earlier Eros with a Dolphin. On the Paris art market is a much later bronze after Verrocchio (*Fig. 162*), a version of the Running Putto. This would indicate that Verrocchio was working toward the kind of movement that the Baroque and Rococo would value and upon which the nineteenth century would capitalize. How else account for the later bronze variant?

A final terracotta, this one seemingly a sketch for a much larger composition representing the Entombment, was formerly preserved in Berlin (*Fig. 164*). It was destroyed, according to all available evidence, in the fire of 1945 that consumed a great deal of the former Kaiser Friedrich Museum's sculpture (ironically believed in safety in one of the antiaircraft towers set up to defend Hitler's Berlin). No one yet has clearly identified the program for which the little relief may have been a sketch. The style looks definitely on the late side. Perhaps, like the Running Putto in Washington, it represents Andrea in the eighties, toward the end of his career.

Of lesser interest is a well-known sketch-model in terracotta of a sleeping youth, also from the Berlin collection and now in Dahlem, that appears frequently in the literature on Verrocchio. Both its history—unknown before 1885—and its subject and program—Endymion (?)—are mysterious. Details, such as the extraordinarily flaccid right arm on which the head rests, seem more characteristic of the naturalism of the nineteenth than of the fifteenth century. For what purpose, what program, was this admittedly able sketch intended? Is it truly Verrocchio's?

There once existed a monument that from an early time was believed to be Verrocchio's work; it has survived only in one fragment and possibly in two related studies. The monument was the tomb of Francesca Pitti Tornabuoni, erected (after her death in 1477) in the Roman church of S. Maria sopra Minerva.

Francesca, the wife of Giovanni Tornabuoni, was also memorialized in the frescos by Ghirlandaio and his bottega of the choir of S. Maria Novella in Florence. Her death in Rome came in childbirth. In the early sixteenth century the Dutch artist Heemskerck, whose visual records of other Roman monuments are apparently trustworthy, made a drawing of a sarcophagus with a double effigy of a woman and a very small child lying on top of her (drawing now in Berlin-Dahlem). This unusual type of double effigy evidently struck the draughtsman; hence the drawing, which can quite reasonably be associated with the monument—now dismantled, and for the most part destroyed— which was then attributed to Verrocchio in the guidebook literature.

In the Bargello is a marble relief representing a death scene: a woman who has just given birth is shown expiring amid her grief-stricken woman attendants; on the left the apparently dead child is brought to the sorrowing father (*Figs. 165, 166*). The style of carving is clearly Verrocchiesque rather than Verrocchio's own. The figures move rather awkwardly, even stiffly, and the details are somewhat crudely cut. The modello, how- ever, could have been by Verrocchio himself, who would have entrusted the execution to an assistant, perhaps Francesco di Simone. From the subject matter and apparent date, about 1480, the fragment in the Bargello would seem to have been part of the monument to Francesca Tornabuoni (probably carved in sections in Florence and then set up in Rome).

The Bargello relief is especially interesting to us today for its clear imitation of Antique Roman relief procedure: the scene takes place on a narrow, stagelike platform; the figures are in two rows, the foreground row with the most eye-catching action and the row behind, in lower relief, with supporting figures and actions. The huddled mourner in the foreground near the deathbed of Francesca may, in 1480, have seemed a particularly appropriate borrowing from Antiquity.

Though they have generally been associated with the Forteguerri Cenotaph, two terracotta modelli, reliefs of angels (now in the Louvre), would appear instead to have been intended as guides for the upper lunette of a tomb, very likely that of Francesca Tornabuoni. The angels (*Figs. 167, 168*) are shown with their feet parallel to the ground line and the base of the reliefs; they are not in suspended flight as are those of the Forteguerri Cenotaph. Moreover, the Louvre angels support a relatively smaller mandorla, in which the Madonna and Child would have been shown in glory, a motif used particularly in the lunettes of tombs produced in Mino da Fiesole's Roman work- shop in the seventies. This too would have been appropriate to the subject—or better, subjects—of the memorial. The Louvre angels are, at least in part, by different hands and are considerably restored, as is evident from the unretouched areas shown in old photo- graphs. The finer one is that to the left, and it may well be Verrocchio's own work entirely.

2. The Periphery. Workshop Attributions; Echoes and Reverberations.

As we have now had ample opportunity to see, the dividing line between the activity of the master and that of the shop is easy to draw in theory but very difficult to establish in practice. We cannot separate Verrocchio's name completely from the production of the bottega without doing him a grave injustice, for his leadership and inspiration are represented there. By the same token, it is equally unfair to his memory as an artist of the first rank to attribute to him pieces that are inferior, or at least are disturbingly different stylistically from his own work, pieces in which his hand seems to have had little or no part in the final execution. To outline precisely all the known or suggested workshop activity and to define the role the artist may have played in each would be far too great a task for this small volume. This would be a challenge of connoisseurship on a grand scale, one this writer is glad not to have to face—at least at this time.

However, this chapter can hardly be called finished until some idea is given of what may be called the periphery of Andrea's oeuvre. There are aspects of his activity that deserve mention, even if the attributions may not seem, for one reason or another, as well founded as those we have already looked at. For example, Vasari mentions modelli in clay, which we know from a source much closer in time than Vasari were highly valued by some of Andrea's contemporaries; but he also speaks of small bronzes, for which we have absolutely no documentary reference. But it would seem strange if so great a modeler and caster of bronze did not actually produce some small-scale work, like that, for example, of his contemporaries Bertoldo and Antonio Pollaiuolo. A particularly fine statuette of Judith in the Detroit Institute of Arts (*Figs. 169, 170*) has been attributed to Antonio Pollaiuolo, but the action of the pose, the swing of the drapery, and the physical type seem to be sufficiently close to the work of our sculptor to warrant its attribution to him—or at least to his bottega, though I think the quality is too high for a purely workshop piece. The statuette is based to some extent on the great Florentine Judith, Donatello's large-scale bronze group, which now stands in front of the Palazzo Vecchio; but in the main it represents a new, original, and more dynamic concept, in line with what we know of Verrocchio's habit of work and turn of thought.

The commission given to Andrea toward the end of his life for a fountain to be presented to the city of Florence by King Matthias Corvinus of Hungary was mentioned earlier (see p. 25). The project never was finished, but we know that marble for it was ordered. There used to be in Berlin two modelli-type terracottas of reclining putti, evidently destroyed in World War II. A fascinating marble related to those terracottas is in the

De Young Museum in San Francisco (*Fig. 173*). Could it not be the product of Verrocchio's art, and might it not have been part of the decorative sculpture for the fountain? The answer to both questions might well be in the affirmative. The putto's history is not known, but the style offers considerable support—even though the surface has suffered from weathering and cleaning, and perhaps, in some places, recutting. Evidently the design was well known by 1500, either in Venice or Florence, for the Child of Dürer's well-known Madonna and Child in Vienna is clearly derived from it (*Fig. 174*).

Now one can well ask what may have survived of the gift King Matthias Corvinus was reciprocating, the two reliefs of Alexander and Darius that Lorenzo de' Medici presented to him. Vasari, who did not know the reliefs at first hand, specified that they were of bronze. Perhaps this was so. But most scholars, in searching for one or both of the reliefs, have thought rather of marble as the material. They may have been wrong. The Darius survives only as a design, in at least two examples of latish Robbia-ware. The Alexander has most recently been speculatively recognized in a piece showing a young helmeted warrior in profile, which, it was claimed in 1922, was found in Hungary. The relief came to the National Gallery of Art through the Herbert Straus Collection in New York. In conception, the design is handsome, even beautiful; but the execution does not seem up to Verrocchio's known work in marble (*Fig. 171*). The breakage, to be expected in an old relief, is somewhat suspect in position and character. At present writing, one must be cautious in making any firm statement. A related profile, entitled SCIPIO, is in the Louvre (*Fig. 172*), and for a time it was identified as Verrocchio's own work. Clearly it must be a shop work, sufficiently well known in the Renaissance, however, for a stucco squeeze to have been made from it; the squeeze is now across the Channel, in the Victoria and Albert Museum in London.

Recently rejected as having any connection with Andrea is an impressive portrait-bust of Lorenzo de' Medici in the National Gallery of Art in Washington (Kress Collection). The sculpture is of terracotta, naturalistically painted (*Fig. 176*). A reversed drawing of one profile attributed to Leonardo in the Royal Library at Windsor would indicate that the type, at least, antedates 1481, and that the most likely source is without question Verrocchio's workshop. It has been argued that the likeness is derived from a death mask, which would make the death date of Lorenzo, 1492, the earliest possible date—and that, of course, is four years after Verrocchio's death. However, the evidence for the use of a death mask is not conclusive; an old cast from the death-mask mold exists in Florence, and in a general way it resembles the features shown here—but only in a general way. There remains the strong possibility that the Washington bust is based on a life mask. This gains weight from the tradition that Verrocchio took life masks and may even have been connected with "Orsino" (see p. 31) in the manufacture of three effigies of Lorenzo; these were made after his escape from death in the Pazzi conspiracy in 1478, to be placed as *ex-votos* at famous shrines. The features of the Lorenzo in Washington have a grim

expression appropriate to a post-Pazzi conspiracy monument—as much a warning as a memorial. It is likely that the original, or originals, if more than one such bust was made, did not survive the Medici overthrow in 1495. However, when the Medici returned to power in 1513, a bust such as this might well have been manufactured on Verrocchio's model. The large scale and type of modeling seem to suggest an early-sixteenth-century date.

If this hypothesis is reasonable, it might indicate how Verrocchio's influence could have been perpetuated well beyond his own lifetime. Perhaps his greatest legacy was to Leonardo, whose sculpture today does not exist in securely attested examples. But even during Andrea's life one could have found striking echoes of his style and compositional inventions, as in the fairly sizable marble tabernacle in S. Maria, Monteluce, not far from Perugia (*Fig. 175*). About 1478 his manner was used to great effect by his follower Francesco di Simone in the elaborate Monument of Alessandro Tartagni in S. Domenico, Bologna (*Fig. 177*). Another follower, probably not Francesco di Simone, did the related set of four Virtues, doubtless for a now-dismantled tomb, that is preserved in the Jacquemart-André Museum in Paris.

Some of Andrea's inventions were repeated, at times virtually without change, and adapted to new functions. The Christ of the Forteguerri Monument, for example, is repeated in the bust of Christ now in the Museo Civico of Pistoia (*Fig. 178*). A partial adaptation from much the same source, the half-figure of a Eucharistic Christ now in the church of S. Maria delle Rose, Lucca, of about 1500 (*Fig. 179*), shows greater changes. The Forteguerri type was given a more tortured, expressionist form in the marble bust of Christ attributed to Matteo Civitale in the Villa Guinigi Museum, also in Lucca.

As the fifteenth century drew to its close, Verrocchio's influence travelled as far afield as the Abruzzi, where, in two churches of the city of Aquila, we find echoes of his gentler (*Fig. 181*), and also his more expressionistic, side (*Fig. 180*). The latter appears to have survived through his direct artistic lineage well into the sixteenth century in Florence itself, in the work of the remarkably talented sculptor Francesco Rustici. A striking terracotta Magdalen attributed to Rustici, now in the Victoria and Albert Museum, must represent here the much larger chapter which could be devoted to the stylistic reverberations of Andrea's energetic style.

It is mainly in the documented works, which seem to require the designation of masterpiece in almost every case, that the measure of his achievement must be taken. Even so, the attributable work is not to be neglected. Only by considering it too may we ever accord to Verrocchio recognition of the full dimensions of his vigorous humanity and experimental variety of mood and form. This would be only his due.

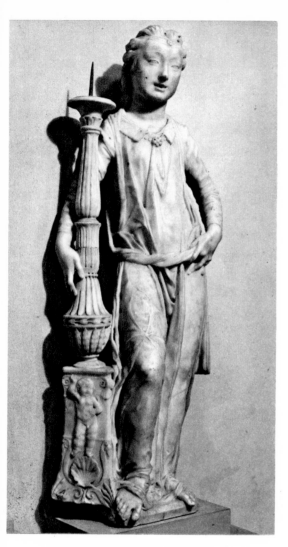

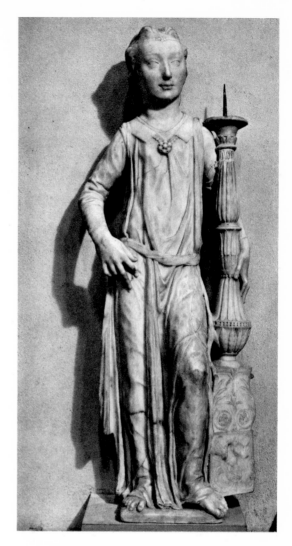

115. *Desiderio da Settignano.*
Altar of the Sacrament. S. Lorenzo,
Florence. Candelabrum bearer

116. *Assistant of Desiderio (Verrocchio?).*
Altar of the Sacrament. S. Lorenzo,
Florence. Candelabrum bearer

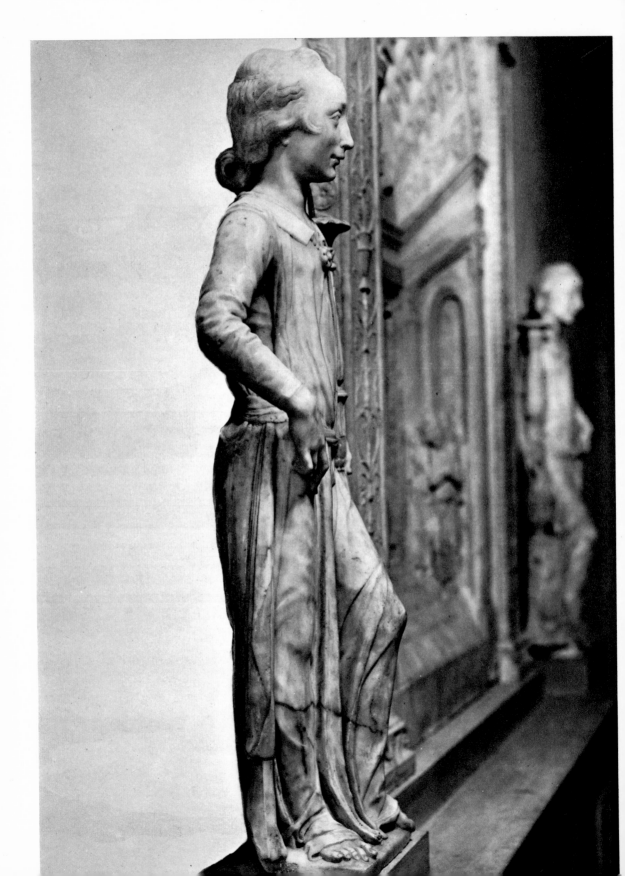

opposite page: 117. *Assistant of Desiderio (Verrocchio?).*
Altar of the Sacrament. S. Lorenzo, Florence. Candelabrum bearer, from the side

118. *Candelabrum bearer, head*

119. *Candelabrum bearer, hand*

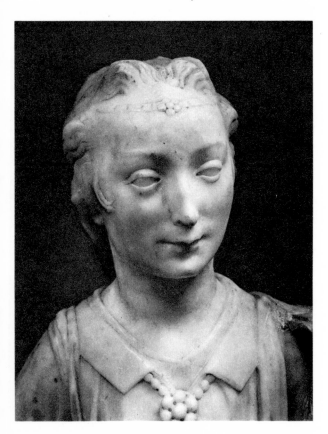

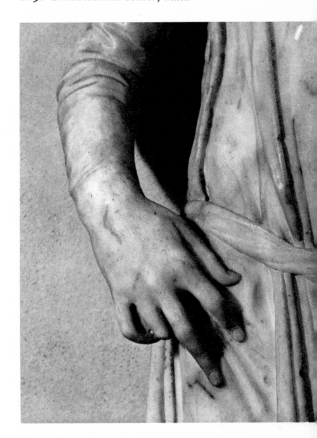

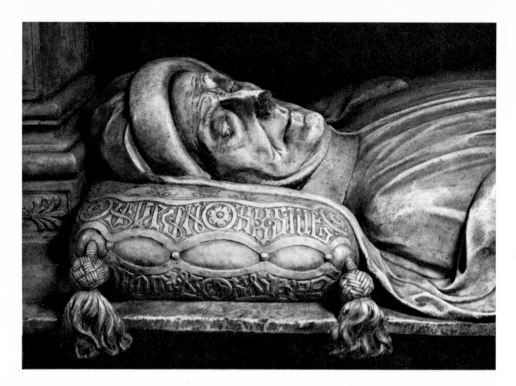

above: 120. Assistant of Bernardo and Antonio Rossellino (possibly Verrocchio?). Giovanni Chellini Monument. Detail of head and cushion. S. Miniato al Tedesco, S. Domenico. Marble

below, left: 121. Verrocchio. David. Detail of lettering on armor (see Fig. 7). Museo Nazionale (Bargello), Florence. Bronze

below, right: 122. Verrocchio. Tomb of Piero and Giovanni de' Medici. Detail of tassels under sarcophagus (see Fig. 39). S. Lorenzo, Florence. Bronze

123. *Attributed to Verrocchio, with Bottega. Lavabo.*
S. Lorenzo, Florence. Marble, porphyry, serpentine

124. *Detail of Fig. 123,*
upper portion, lunette.
Executed presumably
by an assistant

125. *Alberti. Edicule, Rucellai*
Chapel of the Holy Sepulchre.
S. Pancrazio, Florence

126. *Brunelleschi. Edicule, Old Sacristy*
(replica of original, which is now in cloister).
S. Lorenzo, Florence

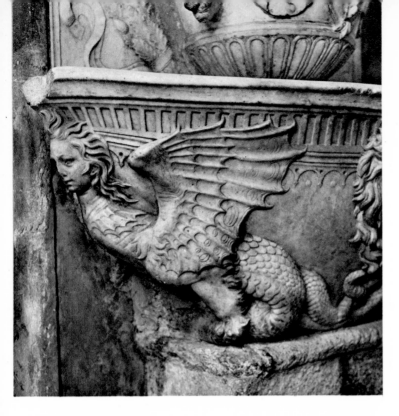

127. *Attributed to Verrocchio with Bottega. Lavabo. S. Lorenzo, Florence. Lower basin, detail of harpy to left. (Detail of Fig. 123)*

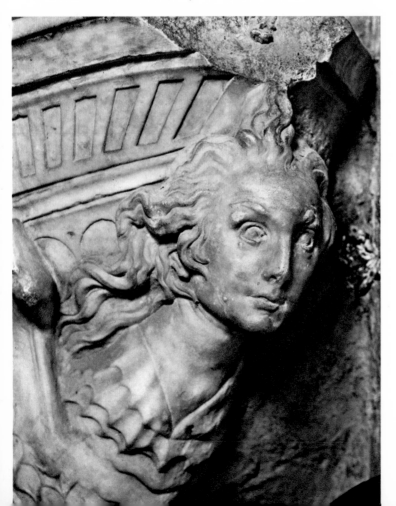

128. *Attributed to Verrocchio with Bottega. Lavabo. Harpy to right. (Detail of Fig. 123)*

right: 129. *Attributed to Verrocchio with Bottega. Lavabo.*
S. Lorenzo, Florence. Upper basin, detail of upper portion

below: 130. *Shop of Bernardo Rossellino. Monument of Leonardo Bruni. S. Croce, Florence. Detail of lion's head on base. Marble*

below right: 131. *Attributed to Verrocchio with Bottega. Lavabo. Lower basin, detail of lion's head. Marble*

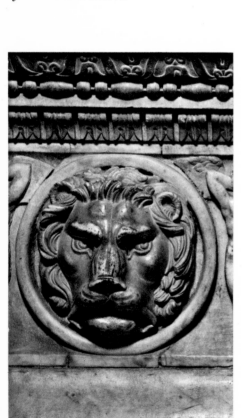

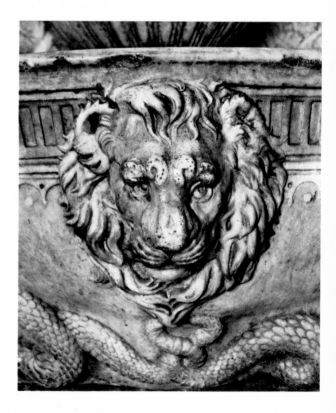

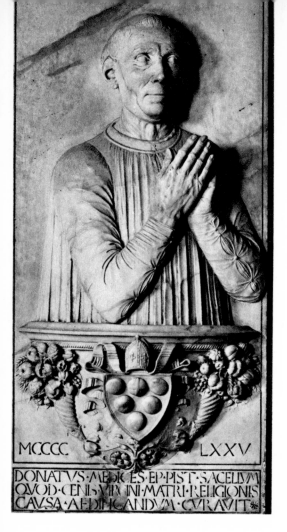

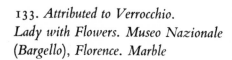

132. *Artist at present uncertain. Memorial portrait of Bishop Donato de' Medici. Duomo, Pistoia. Marble*

133. *Attributed to Verrocchio. Lady with Flowers. Museo Nazionale (Bargello), Florence. Marble*

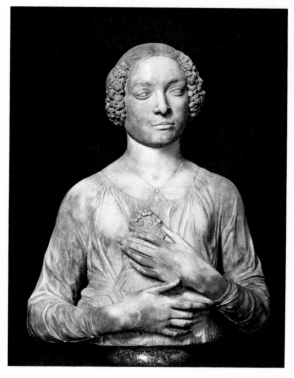

134. *Verrocchio (?). Bust of a Lady.*
Louvre, Paris. Marble

135. *Verrocchio(?). Bust of a Lady*
(Simonetta Vespucci?). Detail.
National Gallery of Art (Kress Collection),
Washington, D.C. Marble

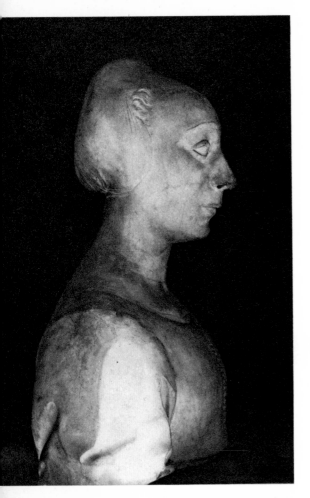

opposite page: 136. *Verrocchio(?). Bust of a Lady (Marietta Strozzi?). Detail.*
National Gallery of Art (Widener Collection), Washington,D.C. Marble

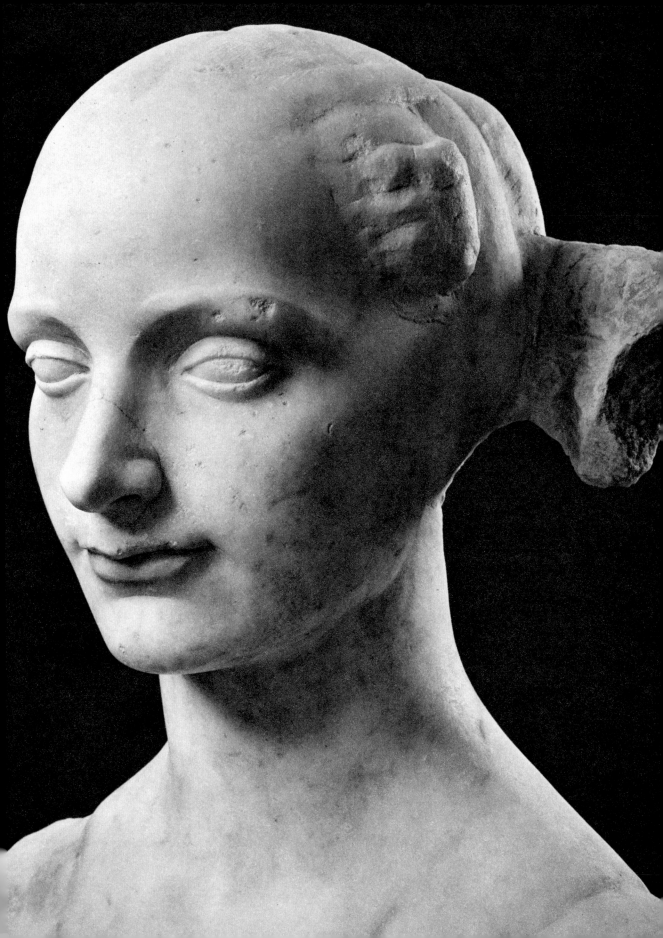

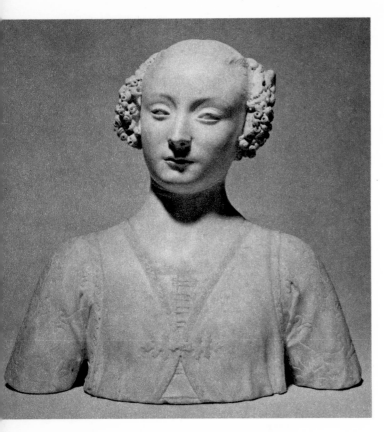

137. *Verrocchio (?). Bust of a Lady.*
Formerly in the collection of John D. Rockefeller, Jr.
(Copyright The Frick Collection, New York). Marble

138. *Desiderio da Settignano.*
Portrait of a Lady. Museo Nazionale.
(Bargello), Florence. Marble

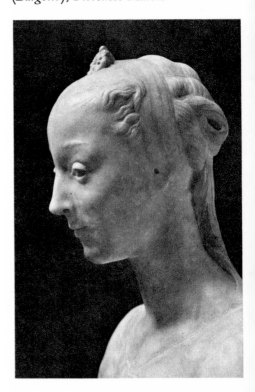

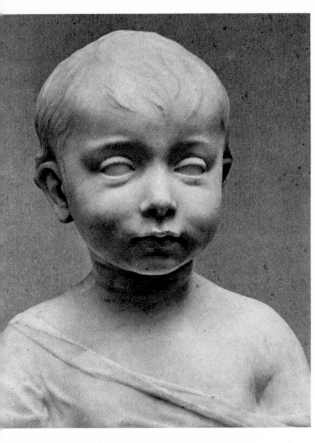

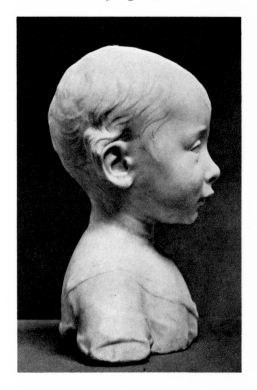

140. Side view of Fig. 139

139. Desiderio–Verrocchio(?).
Bust of a Little Boy.
National Gallery of Art (Mellon Collection),
Washington, D.C. Marble

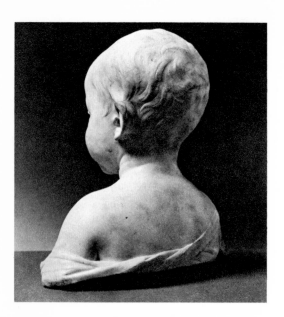

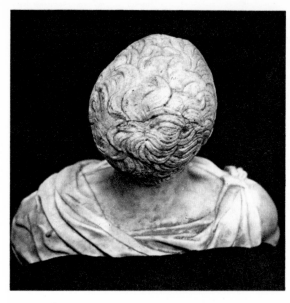

141. *Rear view of Fig. 139*

142. *Roman Imperial period. Head of a Boy. Uffizi, Florence. Marble*

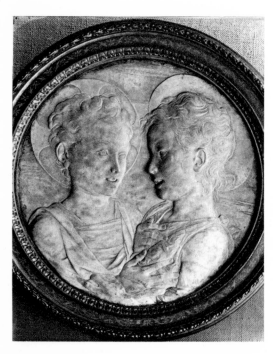

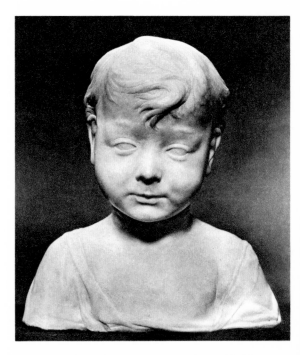

143. *Desiderio da Settignano. Christ and St. John the Baptist. Louvre, Paris. Marble*

144. *Desiderio da Settignano. Christ Child. National Gallery of Art (Kress Collection), Washington, D.C. Marble*

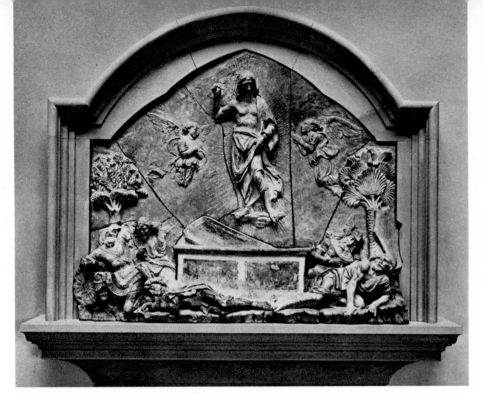

145. *Attributed to Verrocchio. Resurrection from Careggi.*
Museo Nazionale (Bargello), Florence. Terracotta

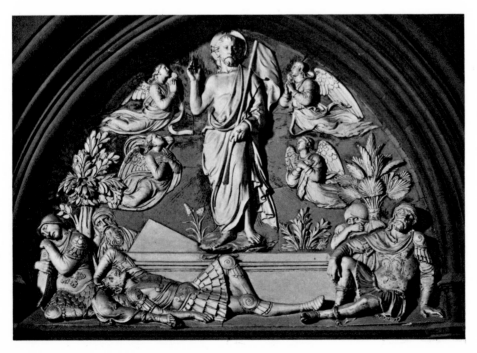

146. *Luca della Robbia. Resurrection.*
Duomo, Florence. Glazed terracotta.

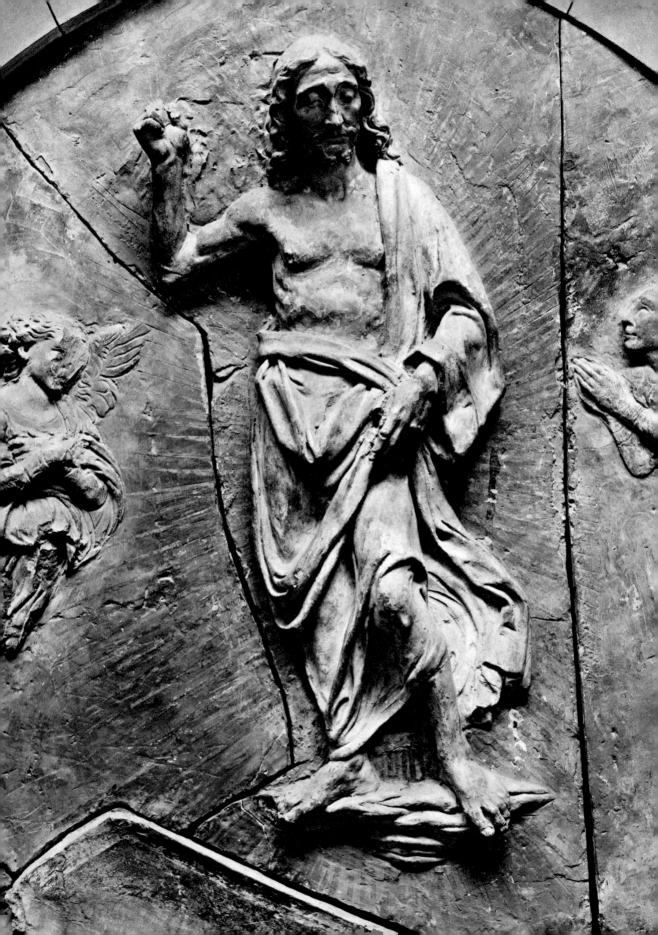

opposite page:
147. Attributed to Verrocchio.
Resurrection from Careggi.
Detail, Christ

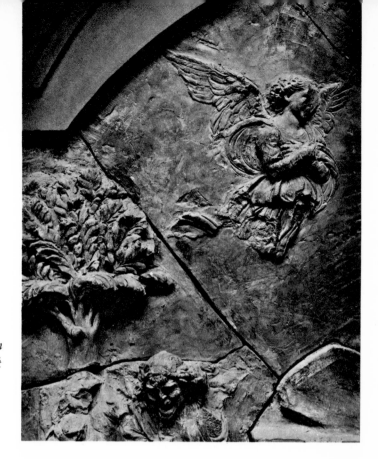

148. Detail of Resurrection
from Careggi, Angel to left

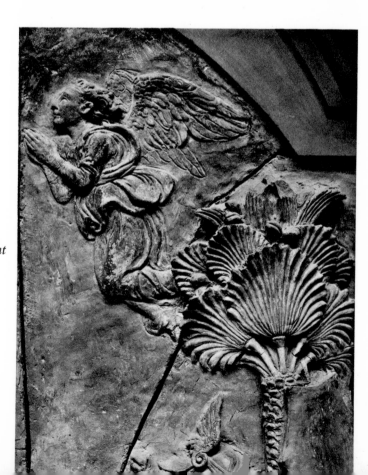

149. Detail of Resurrection
from Careggi, Angel to right

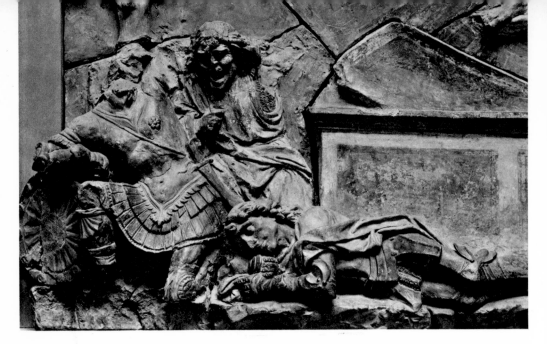

150. *Detail of Resurrection from Careggi, Soldiers to left*

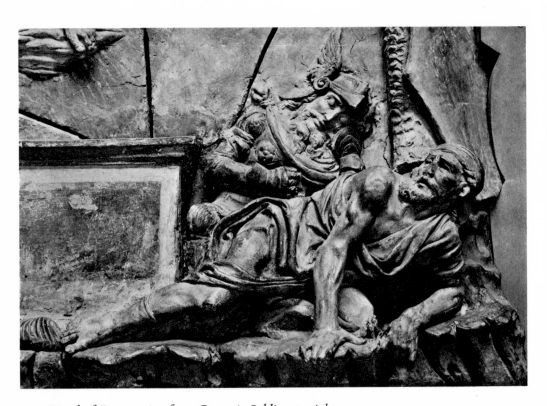

151. *Detail of Resurrection from Careggi, Soldiers to right*

opposite page: 152. *Attributed to Verrocchio. Portrait of Giuliano de' Medici, detail.*
National Gallery of Art (Mellon Collection), Washington, D.C. Terracotta

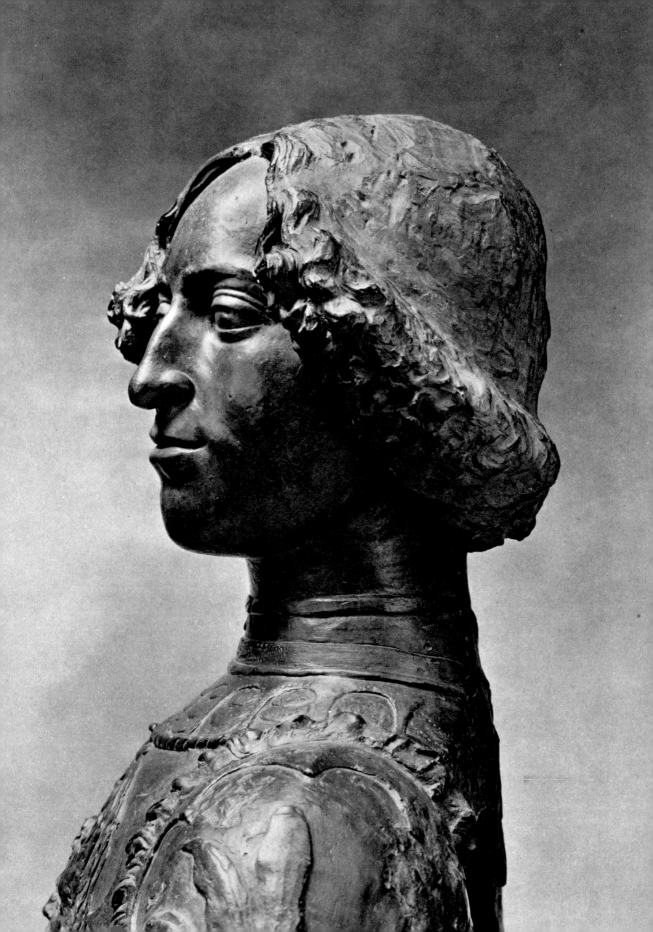

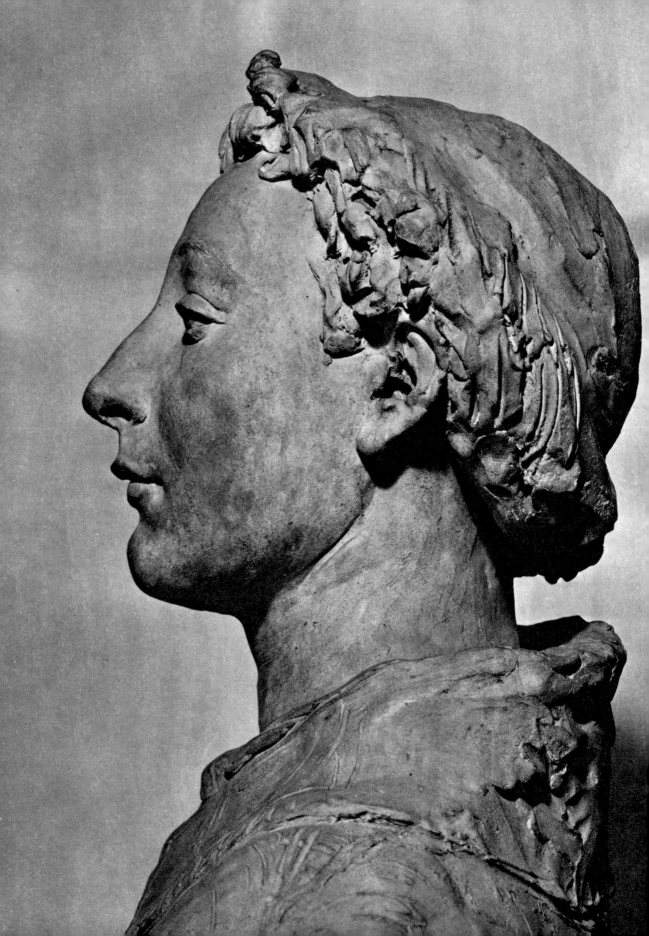

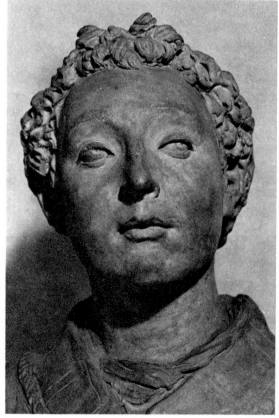

155. *Bust of a Deacon Saint.*
Detail, head, face on

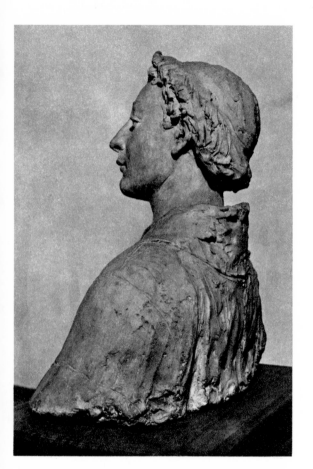

154. *Bust of a Deacon Saint, from back*

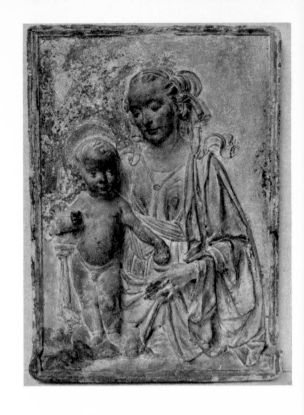

right: 156. Design attributed to
Verrocchio. Madonna and Child.
Allen Memorial Art Museum,
Oberlin, Ohio. Stucco

below: 157. After Verrocchio.
Madonna and Child.
Rijksmuseum, Amsterdam. Stucco

below right: 158. Detail of Fig. 156,
head of Madonna

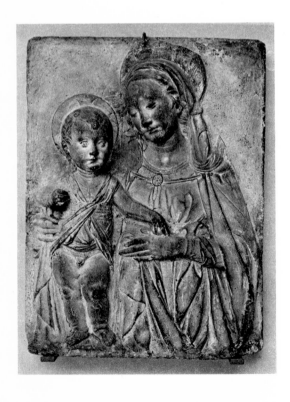

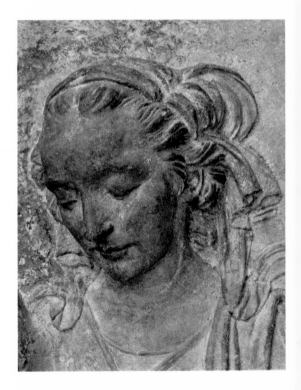

opposite page: 159. Attributed to Verrocchio. Madonna from S. Maria Nuova.
Museo Nazionale (Bargello), Florence. Terracotta, partially polychromed

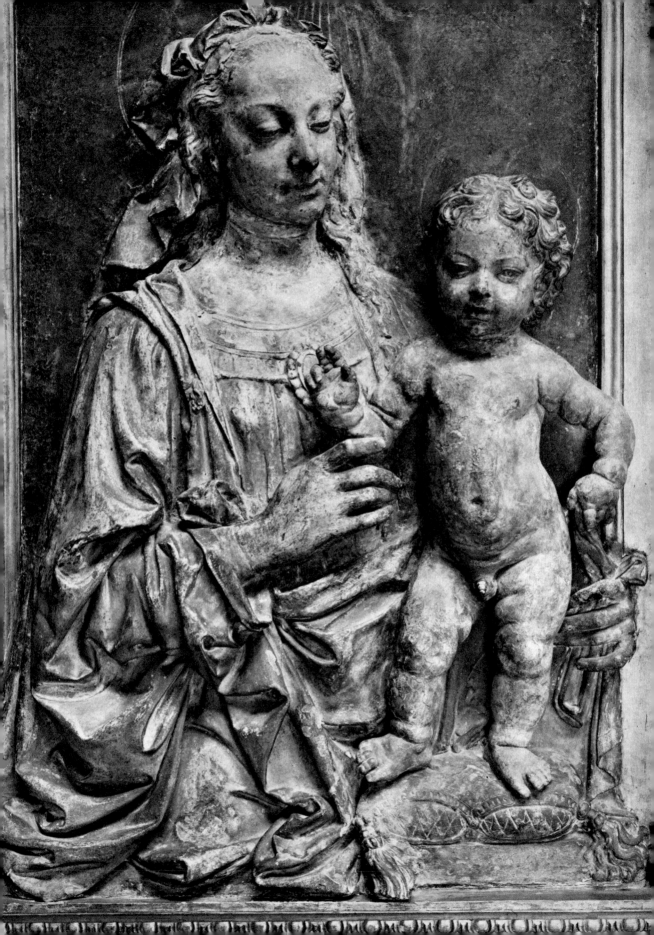

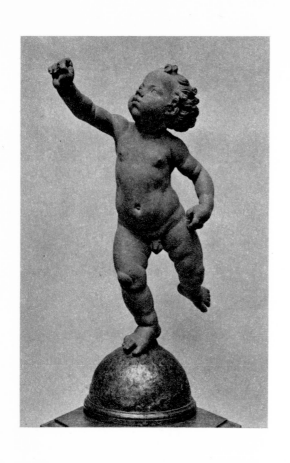
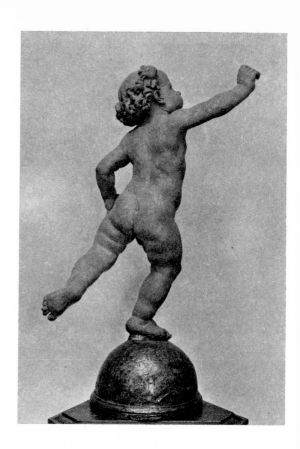
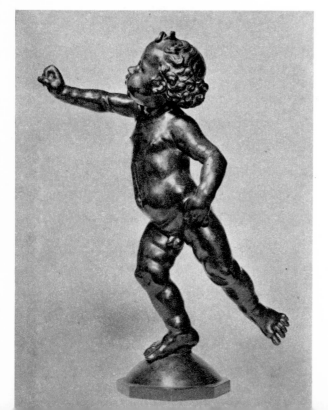
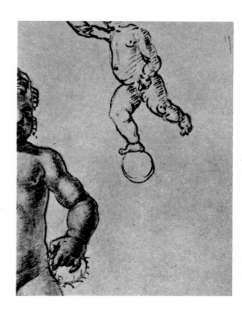

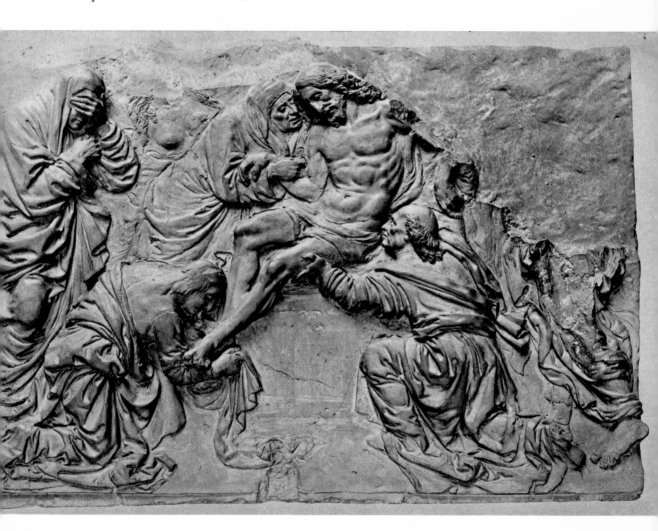

165. *Shop of Verrocchio.*
Relief from Monument of
Francesca Tornabuoni.
Detail, death of the mother.
Museo Nazionale (Bargello),
Florence. Marble

166. *Monument of Francesca*
Tornabuoni, detail, the dead child
shown to the father. Marble

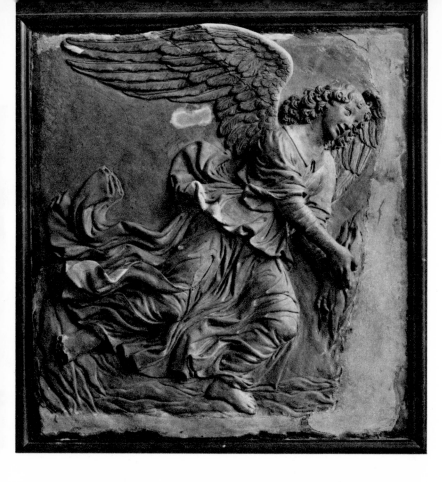

167. *Attributed to Verrocchio. Flying Angel. Louvre, Paris. Terracotta*

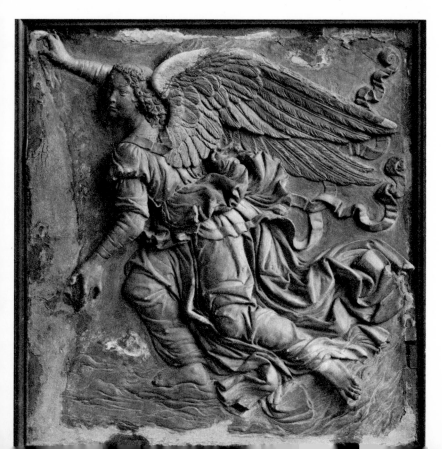

168. *Attributed to Verrocchio Shop. Companion Angel. Louvre, Paris. Terracotta*

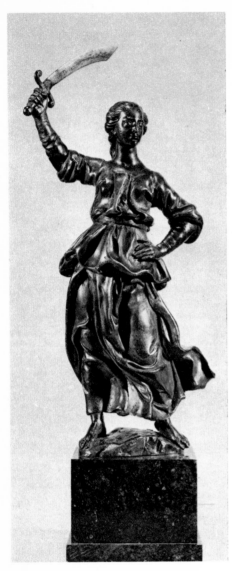

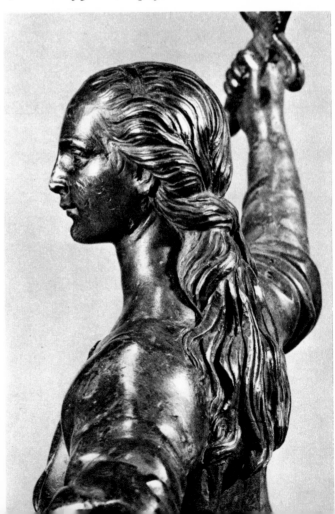

170. *Detail of Judith, in profile*

169. *Verrocchio(?). Judith.*
Detroit Institute of Arts, Detroit.
Bronze

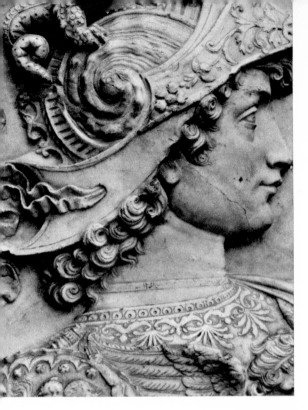

171. *Verrocchio Shop(?).*
Relief of "Alexander."
National Gallery of Art,
Washington, D.C. Marble

172. *After Verrocchio(?).*
Relief of Scipio.
Louvre, Paris. Marble

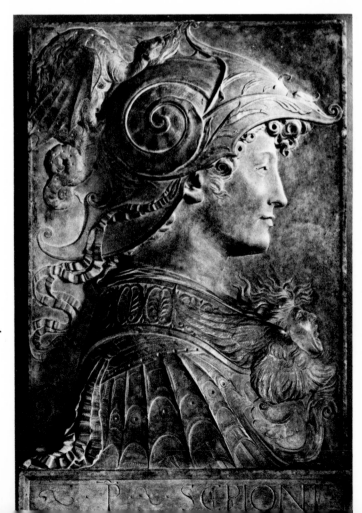

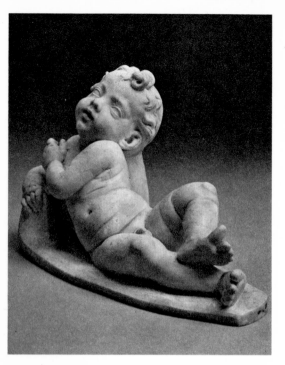

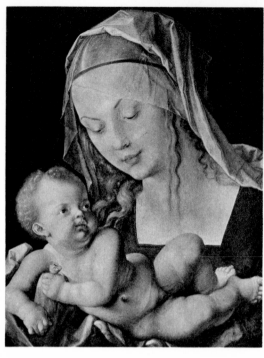

173. *Attributed to Verrocchio. Reclining Putto.*
De Young Museum, San Francisco. Marble

174. *Albrecht Dürer. Madonna and Child.*
Kunsthistorisches Museum, Vienna. Oil on panel

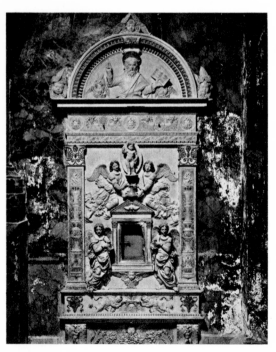

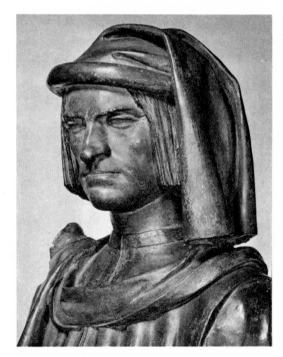

175. *Influence of Verrocchio, ca. 1490.*
Tabernacle. S. Maria, Monteluce. Marble

176. *After Verrocchio(?).*
Portrait bust of Lorenzo de' Medici, detail.
National Gallery of Art (Kress Collection),
Washington, D.C. Terracotta, polychromed

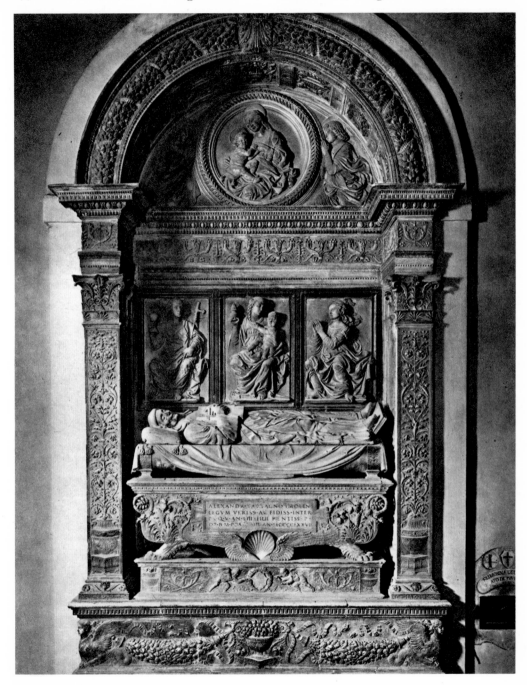

178. *Adaptation after Verrocchio.*
Bust of the Saviour. Museo Civico,
Pistoia. Terracotta, polychromed

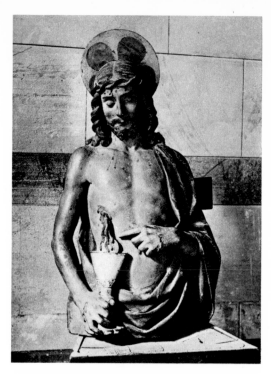

179. *Further adaptation after Verrocchio.*
Eucharistic Christ. S. Maria della Rose,
Lucca. Terracotta, polychromed

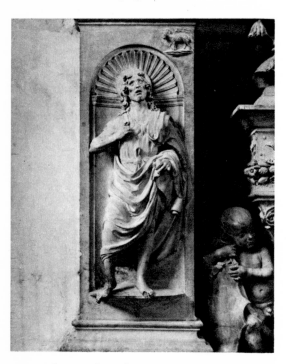

180. *Silvestro da Sulmona. Detail of*
Camponeschi Monument. S. Bernardino,
Aquila. Marble

181. *Unknown Master. Madonna Annunciate*
on Altar of the Sacrament. S. Maria del Soccorso,
Aquila. Stone, polychromed

NOTES ON PRINCIPAL PIECES
DISCUSSED IN THE TEXT

A. *Sculpture*

1. *TOMB-MARKER FOR COSIMO IL VECCHIO DE' MEDICI.* Florence, S. Lorenzo, set in pavement before the High Altar. Square, each side approx. 335 cm. Colored marbles and bronze (or brass?). Inscriptions: 1) COSMVS MEDICES/HIC SITVS EST/DECRETO PVBLICO/PATER PATRIAE. 2) VIXIT/ANNOS LXXV/MENSES III/DIES XX. *Fig. 30.*

The materials of this monumental memorial, in area close to 100 square feet, comprise white marble, green serpentine, and reddish porphyry, as well as dark gray *pietra serena*. At the corners are shields of polished light-colored bronze or brass inset with the six balls (or *palle*) of the coat of arms borne by the Medici in Cosimo's time; the *palle* are set into the shields in porphyry of reddish color, the equivalent of the heraldic gules. It has been said at various times that Cosimo's tombstone was destroyed in 1495, after the Medici were evicted from Florence. But recent careful re-examination (Passavant 1969) confirms that much of the original materials (as well as the total design) remains intact. Passavant suggests that the inscriptions were cut into the two white marble tablets which were originally covered by bronze plaques with the same letters cut out to allow the marble to show through. The work is documented as by Verrocchio by Tommaso's "List" (see DOCUMENTS AND SOURCES). The date of this tomb-marker falls between the spring of 1465 (when the decision concerning the type and placing of the tomb was taken) and October 22, 1467, when the body of Cosimo was transferred to its final resting place under the crossing of S. Lorenzo. Cosimo's burial-vault is immediately under the stone. The patron was Cosimo's oldest son, Piero de' Medici, called "Il Gottoso" (The Gouty).

2. *CANDELABRUM FOR THE CAPPELLA DELLA SALA DELL'UDIENZA IN THE PALAZZO DELLA SIGNORIA, FLORENCE.* Now in the Rijksmuseum, Amsterdam; earlier in the Berlin Schlossmuseum (up to about 1935). From private hands in Holland it was acquired in 1952 for the Rijksmuseum. Height 157 cm.; width at base 46 cm. Bronze. Inscription, on base: MAGGIO E GIUGNO MCCCCLXVIII. The three feet have been cut down; this affects the impression one should have of the thrusting height of the design. *Figs. 31-34.*

The history of this beautiful object can be traced back only to the Hohenzollerns in Berlin early in the nineteenth century (Passavant 1969). However, three records of payments to Verrocchio, in 1468, 1469, and 1480, document the piece securely (published in Gaye 1839, Cruttwell 1904, and Passavant 1959). It was W. R. Valentiner who identified the present candelabrum with that specified in the documents (Valentiner 1933). The "May and June" of the inscription can refer only to tenure of office of a member of the Signoria; that tenure was limited to two months. Whose tenure of 1468 is thus commemorated is not known, so the patron remains anonymous. The date may be taken as most probably 1468; if not, early 1469.

3. *MONUMENT OF PIERO AND GIOVANNI DE' MEDICI.* Florence, S. Lorenzo, Old Sacristy and former Chapel of the Sacrament (see below for explanation). Height of enclosing arch 450 cm.; width of plinth 241 cm.; depth of plinth 108 cm. Materials include: porphyry, marble, serpentine, *pietra serena*, and rich, darkly patinated bronze. Inscriptions: 1) in tondo on side away from Sacristy, PETRO/ ET IOHANNI DE/ MEDICIS COSMI P.P.F./H.M.H.N.S. 2) on tondo facing Sacristy, PET. VIX./AN. LIII.M.V.D.X. V./IOHAN. AN. XL II. M IIII./D.XXVIII.; 3) on all four sides of plinth, beginning at left on side facing away from

Sacristy, LAURENT ET IVL PETRI F/POSVER/ PATRI PATRVO QVE/MCCCCLXXII. *Figs. 35-45.*

The placing of this monument, as described in the text, *between* the Chapel of the Sacrament and the Sacristy is unusual, but could have been inspired by such double-faced arched tombs as that of the Strozzi in the Sacristy of S. Trinita, in Florence, or (as noted in Passavant 1969) that of a member of the Bardi family in S. Croce, also in Florence. It is quite possible that the Piero and Giovanni de' Medici monument was erected on the original site of the lavabo of the Sacristy. The main face, however, judging from the inscriptions, seems to have been the one that gave onto the Chapel of the Sacrament (today called the Chapel of the Madonna; see Paatz 1952), as suggested also to some extent by Vasari. The monument is documented by Tommaso's "List" of 1495-96, and judging by the inscription as well as from comments on its inception and progress by Lorenzo the Magnificent, must have been finished by 1472 at the latest. The patrons were Lorenzo de' Medici (the Magnificent) and his younger brother Giuliano, represented together in the nearby Entombment scene on one of the S. Lorenzo "pulpits," this one possibly designed in part by Donatello but executed evidently by a follower (Bertoldo? See Seymour 1966).

4. *EROS WITH A DOLPHIN.* Florence, Palazzo Vecchio, now in the smallish room called the Sala del Cancelliere Dettatori, to the left off the Sala dei Gigli. Height (of figure) 67 cm. Bronze, at present with very dark patina. Originally surmounted a fountain decorated in addition with bronze masks and four lion masks of marble supplied by the artist. See below and also text for a discussion of the original fountain base. *Figs. 46-49.*

This captivating bronze must be the *"banbino dj bronzo"* which appears as item No. 3 on Tommaso's "List." It is accordingly to be documented as by Verrocchio. The marginal note on the same document indicates that the piece was made for the Medici Villa at Carreggi. Vasari noted in his 1568 edition of Verrocchio's *Life* that the piece was transferred about the middle of the

sixteenth century from Careggi to Florence, to a new porphyry fountain set up in the center of the Palazzo Vecchio courtyard, on the spot where Donatello's bronze David had earlier stood. In 1959, the Verrocchio figure was removed for cleaning and replaced in the courtyard by a good copy. It is necessary now to mount several flights of stairs to view the original, but the long climb is amply repaid by the quality of the casting revealed by the cleaning done under the supervision of Commendatore Bearzi. The date of the Eros with a Dolphin remains a subject for discussion. Some critics (Dussler 1940, Middeldorf 1935, Seymour 1966) would date the sculpture in the 1460's, and fairly early in Verrocchio's career; others a trifle later, about 1470 (for example, Pope-Hennessy 1958); others later still (Passavant 1969: "end of the seventies"; Reymond 1906: "after 1476"; Planiscig 1941: "about 1480"). The question of patron, whether Piero de' Medici or Lorenzo, hinges on the dating. In the writer's view, the patron must have been Piero. According to a well-preserved inscription (see below) the little bronze figure was probably originally gilt. Professor Peter Meller in a lecture given at the Kunsthistorisches Institut of Florence in 1959 proposed that most of the original fountain base survives as part of the inactive fountain set at the head of the nineteenth-century entrance stairway of the Pitti in Florence. Considering the style and the references in the inscription, Meller's theory seems entirely acceptable. The inscription, an elegiac distych, is as follows: NE SIS PRAEDA TVIS ATHEON DEVS AVREVS VNDA/ IN VOLVCRES VERTIT VEL ADAMANTA VIROS. (Roughly translatable as: "Lest you fall a prey to your own [fellow citizens], the golden god of the pagans in the water changes men into birds or diamonds.") The falcon (*volvcres*) and the diamond (*adamanta*) of course, are Piero de Medici's heraldic symbols. The alternative proposed in Passavant 1969 is much weaker: the single basin of porphyry (now in the second court of the Palazzo Vecchio) that he suggests is Verrocchio's original appears to be a bit too late in style; and he makes no suggestion as to what figure originally surmounted the base now in the Pitti.

5. *BRONZE DAVID.* Florence, Museo Nazionale (Bargello). Height 125 cm. Bronze with heavy black lacquer patina; traces of gilding in the inscription on the edges of the costume. *Figs. 7, 55-61.*

All authorities are agreed that this David is the *"davitte e la testa dj ghulia"* of item No. 1 of Tommaso's "List." The head of Goliath is cast separately from the standing figure. For quite a long time a misunderstanding, or ambiguity, of a detail of the transcription of the manuscript persisted in the scholarly literature. It was thought that the marginal phrase "per a Charegj" applied to the David as well as to the succeeding two items, which in fact it does not. Thus the program for the David is not known. But in 1476 Lorenzo and Giuliano de' Medici did sell a David for 150 florins to the Florentine Signoria for placement at the head of the stairs at the entrance to the Sala del Orologio in the Palazzo della Signoria, where the "chains of the enemy" (*apud hostium catenae*) were exhibited, apparently as both a victory and freedom symbol (Gaye 1839, Cruttwell 1904 [with wrong interpretation of marginal note of document], Passavant 1969 [with correction of that interpretation]). That David sold in 1476 must be identified with the piece here discussed.

The fifteenth-century base for the statue survived in the Palazzo Vecchio after the statue was removed in the early years of the seventeenth century to the Guardaroba Ducale, and then in 1777 to the Uffizi. By 1898 the statue had been removed once again, this time to the Bargello, where it has been reunited with its original marble base (Passavant 1969: surprisingly, the base, according to him, is not to be attributed to Verrocchio or his shop). Although the *terminus ad quem* of 1476 is accepted, there is still disagreement about the date of the statue. Some historians hold to a dating shortly before the recorded sale: Dussler 1942 and Pope-Hennessy 1958 give 1473-75; others (such as Planiscig 1941) simply state "before 1476." It cannot be reasonably excluded that the statue was begun in the 1460's (Seymour 1966) and furthermore that it was first intended as a gift from Piero de' Medici (therefore

before 1469) to replace Donatello's David in the courtyard of the palace (Passavant 1969).

6. *CHRIST AND ST. THOMAS FOR THE MERCANZIA.* Florence, east façade of Or S. Michele. Height of Christ (to tip of uplifted fingers of right hand) 230 cm.; of St. Thomas, almost exactly 200 cm. Bronze, now weathered to greenish patina. Inscriptions (John 20:28-29): 1) on border of Christ's mantle, QVIA VIDISTI ME THOMA CREDIDISTI BEATI QVI NON VIDERVNT ET CREDI-DERVNT; 2) on border of Thomas's mantle, DOMINVS MEVS ET SALVATOR GENTIVM. *Figs. 5, 62-78.*

The group of two statues, as is well known, took the place of Donatello's St. Louis of Toulouse, done several decades earlier for the Parte Guelfa niche of Or S. Michele. By 1463 the Parte Guelfa niche was handed over to the Florentine Commercial Tribunal, the Mercanzia, and the St. Louis transferred to S. Croce. (It is currently being restored and will be returned to the museum attached to the church.) Verrocchio's role as sculptor is documented by records of the Mercanzia (Gaye 1839, Passavant 1959, Covi, "The Date of the Commission of Verrocchio's Christ and St. Thomas," *Burlington Magazine,* 110, 1968, p. 37). Covi has shown from documentary evidence that up to May 14, 1466, no sculptor had yet been chosen. Before his publication critics had been forced to use all-too-vague estimates for the beginning of work (unfortunately, Seymour 1966: "probably by 1465.") Pending Covi's expected publication of the now-available documents, some reserve with regard to the dating of the two statues is in order. Because of a misreading by Milanesi, it had been assumed that the Christ had been cast by 1476 and conceivably could have been modeled as much as several years before (Pope-Hennessy 1958, Bongiorno 1962, Seymour 1966). It is now thought that the *terminus ad quem* for the casting of the Christ could be as late as 1479 (Passavant 1969). The St. Thomas was evidently begun later than the Christ and was certainly finished by 1483, when it is known from contemporary testimony to have been seen in place. Payments to Verrocchio amounting to 800 florins

began in 1467 and apparently were still incomplete at the time of his death.

7. FORTEGUERRI CENOTAPH.

Pistoia, Duomo. Measurements in its present assemblage (mid-eighteenth century) not available. Marble. Inscription (on fifteenth-century tablet): NICOLAO FORTEGVERRAE/CARDINALI GRATA PATRIA/CIVI SVO DE SE OPTIME/MERITO POSVIT A.S.M./CCCCLXXIII. V.A. LIIII. *Figs. 81–89.*

The documentation for this commemorative monument (the cardinal was actually buried in Rome) is given by Bacci in Kennedy-Wilder-Bacci 1932, ably summarized and analyzed by Pope-Hennessy (1958) and Passavant (1969). Acting on the advice of Lorenzo de' Medici, the committee in charge of the commission entrusted it to Verrocchio in 1478. By November, 1483, only seven of the figures (the Christ, four angels, and two of the Virtues) had been brought to a nearly completed stage by Verrocchio and his three assistants. After Verrocchio's death, Lorenzo di Credi was commissioned to see to completing the sculpture for the monument; that contract called for nine figures in all (Covi 1967). Evidently Credi did not carry through; another contract was drawn up in 1514 with the Florentine sculptor Lorenzetto Lotti, with the better-known Giovanni Francesco Rustici, a sculptor in Verrocchio's direct tradition, as guarantor. The kneeling figure of the cardinal, probably by Rustici (see Middeldorf, in *Burlington Magazine*, XCVII (1935), p. 72), is now in the Museo Civico, Pistoia; it was replaced on the monument by an eighteenth-century bust. The Charity now on the monument is generally attributed to Lorenzetto, though some doubts may linger as to whether (as stated in Passavant 1969) the design was completely his. A small terracotta modello for the monument now in the Victoria and Albert Museum (No. 7599-1861) has not in the past been universally given to Verrocchio; however, the two most recent discussions of the modello (Pope-Hennessy-Lightbown 1964 and Passavant 1969) agree in giving it to the master himself.

The monument with its marble sculpture was originally intended to fit into a simple arched framing in *pietra serena;* the present Baroque framing and mingling of at least three period styles in the sculpture makes visual understanding of the monument difficult, to say the least. The stylistic analysis by Wilder of the "hands" evident in the various pieces that came from Verrocchio's own studio is, however, particularly helpful (see Kennedy-Wilder-Bacci 1932). The original patron was a committee composed of representatives of the "Pia Casa di Sapienza" (endowed by the Cardinal), of the Operai of the Duomo, and of City Council of Pistoia; funds to the sum of 300 florins were allocated, finally, by the City Council.

8. THE BEHEADING OF ST. JOHN THE BAPTIST.

Florence, Museo dell'Opera del Duomo. Height 31.5 cm.; width 42 cm. Silver relief, with figures cast separately and attached by dowels to the background. *Figs. 90–95.*

The relief appears as the lower panel in the right-hand side of the antependium of the Florentine Baptistry altar now preserved in the Opera del Duomo. The sides of the altar were commissioned in 1477. (The front portion of the antependium dates from the preceding century.) Verrocchio's part in the program is documented only for the Beheading relief (documents preserved in the archive of the Opera del Duomo; republished in Cruttwell 1904, Passavant 1959). Only the Beheading relief can be surely given to Andrea, although recently the figurines in niches at the summit of the side panel containing the Beheading relief have been also attributed to his design (Passavant 1969). In 1480, Andrea is recorded as "finishing" his scene (*storia del dossale d'ariento*), which is stated to weigh some thirty pounds and to have cost between 397 and 398 florins. The patron was the board of Consuls of the Calimala guild, itself the patron of the Baptistry.

9. THE COLLEONI MONUMENT.

Venice, Campo SS. Giovanni e Paolo (San Zanipolo). Height of horse and rider 395 cm. Bronze, originally in part gilt, now considerably weathered and streaked; greenish patina. Inscription on saddle girth of the horse: ALEXANDER LEOPARDVS

v.f. opvs. Inscription on the front face of the base: BARTHOLOMEO/COLLEONO/BIRGOMENSI/ OB MILITARE IMPERIVM/ OPTIME GESTVM/ s. c.; on back face: JOANNE MAURO/ ET MARINO/ VENERIO/ CVRATOR-IBVS/ ANN. SAL/ MCCCLXXXXV. Below is a modern inscription recording the restoration of 1831. *Figs. 9, 96–114.*

The chronology of this last and most famous of Verrocchio's works is established, in general terms only, through a succession of documents (in major part published in Cruttwell 1904 and Passavant 1969, supplemented by Covi 1968). The commission came to Andrea through a competition between him, Bellano, and Leopardi in 1483, some years after the announcement of the competition in 1479. In 1481, Andrea had sent his competition-model of the horse to Venice. He himself went to Venice to finish the monument either in 1483, or as now seems possible, somewhat later. Full-size models for casting of both horse and rider were evidently prepared before Andrea's death. But the casting and apparently the chasing and gilding of the group were carried out by Leopardi. The inscription appears to apply only to this last *post-mortem* part of Verrocchio's work, since thus far no work whose design can be safely attributed to Leopardi would support the attribution to him of the design of the Colleoni sculpture. At most one can assign to him the ornamental detail on the trappings of the horse and on the armor of the rider. It is believed that the horse and rider were both cast by 1492 (Passavant 1969). The monument, including the handsome base, was unveiled on March 21, 1496. The patron of the work was the Venetian Senate, acting with funds bequeathed by the condottiere for his own memorial, to be set up in front of the church of S. Marco; the monument was erected instead on the Campo SS. Giovanni e Paolo, in the vicinity of the Scuola di S. Marco.

10. *LAVABO.* Florence, S. Lorenzo, Sacristy. Height of basin plus shaft of fountain 167 cm.; of relief behind basin, 175 cm. Marble, with polished serpentine roundel insertion. Inscriptions: 1) on upper bowl of shaft, SEMPER; 2) on ribbon behind falcon of background relief, SEMPER. *Figs. 123–131.*

The falcon, the diamond ring he holds with one talon, and the motto SEMPER are emblematic of Piero de' Medici, who died in 1469. It is clear that the lavabo has undergone fairly severe alterations, though there is no obvious reason to believe that it originally served as anything else than a wall lavabo. (But for a differing theory of its original program see Passavant 1969.) The upper three sections of the white marble background relief are in marble of a different quality and are executed in a style slightly at variance with that of the lowest section; these differences are probably evidence of the remodeling, that took place when the lavabo was moved from an earlier emplacement to its present cramped position in the little room to the left of the altar of the Sacristy. The "plinth" is obviously a makeshift recutting of a block of polished serpentine pressed into service for the remodeling; its makeshift character is, however, far from obvious, since the shadow of the flaring basin, set very low, tends to obscure the "plinth." The quality of the carving, except for the upper sections of the arched background relief, is in the main unusually fine and vigorous, even for the best Florentine work of the 1450's and '60's. The lavabo is not documented as by Verrocchio, but it is known to have been in place as early as 1510 (see Albertini 1510), when it was believed to be by Antonio Rossellino. In Vasari's day it was called a joint work of Donatello and Verrocchio (an idea that continued into nineteenth-century criticism). From the evidence of style, the lavabo may be ascribed today to Verrocchio, with at least two assistants (one for parts of the basin and one for the weaker portions of the background relief inserted when the remodeling took place). From the heraldic evidence the original design must date between 1464 and 1469. The original patron must have been Piero de' Medici; the patrons for the remodeling, which presumably took place after Piero's death, would logically be Lorenzo and his brother Giuliano de' Medici, the joint patrons of Piero's tomb, set up by 1472 between the Sacristy and the Chapel of the Sacrament. As indicated in the text, the history of the remodeling of the lavabo is probably linked to the program of that tomb.

11. *LADY WITH FLOWERS*. Florence, Museo Nazionale (Bargello). Height 61 cm. Marble. *Figs. 133.*

This well-preserved portrait-bust, often called in the earlier literature "Lady with Primroses," is not documented, though it is believed to have come from the Medici collections; it was transferred from the Uffizi to the Bargello in the 1880's. Earlier theories that it represents either Lucrezia Donati (Lorenzo de' Medici's mistress) or Ginevra Benci (the well-known subject of the portrait by Leonardo now in the National Gallery of Art, Washington, which is closely related in facial features and pose) are currently to be discounted (Passavant 1969). The style of this piece is puzzling; it is noticeably weaker and more niggling in detail than the style believed to be Verrocchio's in the documented marble figures of the Forteguerri Cenotaph. In the past, and as late as 1954, it has been attributed to Leonardo da Vinci or to a collaboration between Leonardo and Andrea (see Venturi I-XI, 1901-40 [1935]). Dating varies considerably: 1472 (Bode 1909); later 1470's (Pope-Hennessy 1958); 1480 (Passavant 1969); 1480 (Planiscig 1941). A polychrome stucco replica, which appears to be late fifteenth-century and has been attributed to Leonardo, was fairly recently acquired at auction by the Metropolitan Museum of Art. The replica does not add much to the Leonardo oeuvre, but it does substantiate the distinction of the original marble from which it apparently derives.

12. *MADONNA AND CHILD FROM S. MARIA NUOVA*. Florence, Museo Nazionale (Bargello). Height 86 cm.; width 66 cm. Terracotta with traces of color. *Fig. 159.*

Not documented and not mentioned by Vasari. However, the vigorous, masterful style comes quite clearly within Andrea's immediate orbit and in fact may well represent autograph work by his hand alone. The piece was found in S. Maria Nuova in the nineteenth century and came to the Bargello in 1903. It could have been conceived as an *ex-voto* presentation to the hospital of S. Maria Nuova, though the date and circumstances escape us today. Vasari does not record Andrea's stay as a patient at the hospital, but mentions that of another, otherwise mysterious, sculptor he calls Nanni Grosso (*pace* Passavant 1969). The original color scheme would appear to have been a warm tone suggesting marble in the figures against a uniform blue ground. Dating has been spread by critics (see Cruttwell 1904, Pope-Hennessy 1958, Dussler 1940, Planiscig 1941) throughout the 1470's. The drapery style recalls, albeit in a gentler mode, that of the Christ of Or S. Michele.

13. *DIBLEE-OBERLIN MADONNA TYPE*. See particularly the example in the Allen Memorial Museum, Oberlin, Ohio. Height: 84.5 cm.; Stucco. *Figs. 156, 158.*

The Oberlin relief, which comes from the New York dealer Tozzi, and the cognate stucco formerly owned by G. B. Diblee (sold at Christie's, London, June 2, 1964) together seem to reproduce a lost marble of unusual quality. Judging from those two Renaissance stucco reproductions and at least one marble and one glazed terracotta derivation (Bargello and S. Croce, Florence), we should accord the lost original a prominent place in Florentine Quattrocento art. The compositional type occurs quite frequently in painting—and always in a Verrocchiesque context. At one time the former Diblee Collection relief was unsuccessfully attributed to Leonardo. The Oberlin relief has recently been given—too modestly, I think—to an unknown Verrocchio follower (Bongiorno 1962); more recently that notion has been elaborated by the much less convincing suggestion that the follower may have been Benedetto da Majano (Passavant 1969). One may take as Benedetto's version of the theme the very differently conceived and executed Madonna and Standing Child, formerly in the Liechenstein Collection and now in the National Gallery of Art. For the Diblee-Oberlin Madonna type, then, the available visual evidence would seem to point away from Benedetto and toward a more central stylistic source, with respect both to sculpture and painting in Florence. That double source must surely have been Verrocchio. Judging from the Desideresque physical type of the Child and the fluid drapery style of the surviving stucco replica,

the lost marble relief must have come from Verrocchio's early period, before 1470 rather than after (see Seymour 1966).

14. THE RESURRECTION. Florence, Museo Nazionale (Bargello). Height 135 cm.; width 150 cm. Terracotta, with traces of color and gilt. Modeled and fired in nine sections. *Figs. 145, 147-151.*

The relief came to the Bargello from the Medici villa at Careggi where it was discovered unassembled toward the end of the nineteenth century. It was at first reassembled and installed in a wall of an inner courtyard at Careggi. Then, in 1930, it was brought to the Bargello after sale to the state. Evidently the piece has suffered a good deal in its checkered history. There are also problems of dating, and latterly of attribution. A particularly wide span of critical opinion is encountered here. For example, some writers term the relief a rather late work (Cruttwell 1904, Pope-Hennessy 1958), others an early work (Gamba 1904 [revised, however, in Gamba 1931 to after 1478]; Planiscig 1941; and Seymour 1966); others believe it reflects a collaboration with Leonardo (see Valentiner 1930 and Dussler 1942), and recently one writer denied it entirely to Verrocchio (Passavant 1969). Continued study of the original, in this writer's view, only confirms Verrocchio's authorship. The quality is indeed high, and there are strikingly original passages which differ from the program's evident model, Luca della Robbia's Resurrection over the North Sacristy door of the Florentine Duomo. Relationship between the types of the Careggi Christ and the Christ of the Mercanzia niche brought up by Passavant are explained if we assume that Andrea executed the Careggi relief at the time he was working on sketches which resulted in the Or S. Michele Christ as we see it today. A dating of 1466-70 under these circumstances is difficult to contradict flatly; admittedly most opinion today would more readily accept a date closer to 1475. It has been suggested several times in the literature, not unreasonably, that the Careggi relief may correspond to item No. 5 of Tommaso's "List": *una storia di rilievo chom più fighure*. This writer would like to be recorded as in favor of that suggestion.

15. PORTRAIT OF GIULIANO DE' MEDICI. National Gallery of Art, Washington, D.C. Height 61 cm. Terracotta, evidently much restored in the lower portions. *Fig. 152.*

Undocumented; does not appear in any source; but on the basis of the bold style and execution of the head the bust is today quite generally accepted as by Andrea. It first appeared in the mid-nineteenth century when it was bought, in Italy, by Eugène Piot in 1846. Thereafter it entered the Timbal Collection in Paris and subsequently the Dreyfus and Mellon Collections (passing between the last two through the House of Duveen). The striking Medusa head of the armor has been attributed to Leonardo (R. S. Stites, in *Critica d'Arte* X, 1963, p. 1 ff.); however, the question of the condition of the piece as a whole, and particularly of the lower portions, still needs further elucidation. First published as by Verrocchio in Bode 1892-95.

16. RUNNING PUTTO ON A GLOBE. National Gallery of Art, Washington, D.C. Height 75 cm. Terracotta, lightly fired; painted. *Figs. 160-161.*

Entered the Dreyfus Collection in Paris from the Timbal Collection in the mid-nineteenth century. Its origin is not documented, and the condition of the surface is clotted by a quite un-Renaissance coating of modern grayish color. Despite doubts, this is very possibly that ultimate rarity: an original Renaissance full-size modello-figure in the round. For what program? Surely not for the mechanical bronze figure that Vasari asserted Verrocchio made to strike the hours on the clock of the marketplace of Florence. Surely not for a trumpet-blowing figure either. Perhaps, as seems more likely, the little boy should be understood as blowing on a kind of toy windmill or "butterfly." A well-known early sixteenth-century bronze attributed to Rustici was intended to set such a toy in motion by a stream of water. This Putto may have been the original for the idea. A running putto with a similar function is recorded on a Verrocchio studio drawing sheet (Louvre), and one is depicted in a late fifteenth-century painting of an Ideal City (Walters Art Gallery, Baltimore),

in which it is shown surmounting a sizable public fountain. Perhaps that painting shows the way to the Washington Putto's original function. It may in turn be connected with the fountain known to have been commissioned of Verrocchio by Matthias Corvinus of Hungary shortly before the artist's death (marble documented as purchased in 1488); the fountain was to be presented to the city of Florence by the King. There has been of late some opposition to Verrocchio's authorship of the Washington Putto; for example, Passavant (1969) gave it to Benedetto da Majano, and the reviewer of his book in the *Times Literary Supplement* (late fall, 1969) stated it derives from a post-Renaissance bronze (mentioned below). These negative views are hard to understand, except for the fact that the present painted surface of the sculpture may obscure the details of modeling. A bronze after-cast with some differences in detail does indeed exist, as of this writing, on the Paris art market; the bronze is late (judging from a necessarily superficial examination I made of it in the spring of 1970), of the nineteenth century.

17. *DEACON-SAINT*. Florence, S. Lorenzo, Sacristy. Height 50 cm. Terracotta. *Figs. 153-155.*

The earliest mention of this piece is in Richa's guidebook on the churches of Florence, published in 1757. It was then set in a tabernacle niche over a door in S. Lorenzo. Later, in the nineteenth century, it was noted in the same place, and remnants of some type of stucco or paint coating on the surface were also remarked. The bust has since been cleaned and placed in the "Old" Sacristy; it reveals striking resemblances to Verrocchio's known style. For a long time it was attributed to Donatello. Janson, however—to my mind quite correctly—refused it for Donatello's oeuvre (*The Sculpture of Donatello*, Princeton, 1957, II, pp. 236-37). He proposed Desiderio as the sculptor; but it is hard to follow this suggestion today, though it is interesting in view of Verrocchio's dependence as a young man on Desiderio's example. It has been suggested that the bust represents St. Leonard, in whose honor a chapel in S. Lorenzo was dedicated; it could also, of course, represent St. Lawrence, to whom the church itself

was dedicated and who had particular meaning for the Medici family. The style of the piece indicates that it is a modello that for some reason was not carried out in marble or metal but was instead painted more or less naturalistically to stand as a work of art on its own merits (which are indeed extraordinarily high).

18. *REMNANTS OF THE TORNABUONI MONUMENT*. 1) The Death and Bewailing of Francesca Tornabuoni and her Child. Florence, Museo Nazionale (Bargello). Height 45 cm.; width 169 cm. Marble. 2) Sketches for Angels. Paris, Louvre. Height 38 cm.; width 35 cm. Terracotta. *Figs. 165-168.*

In 1477, Francesca Pitti, the wife of Giovanni Tornabuoni and a first cousin of Lorenzo de' Medici, died in childbirth in Rome. She was buried there in the Florentines' church of S. Maria sopra Minerva. The Tornabuoni had a family chapel in the church decorated with frescos by Domenico Ghirlandaio. In that chapel Francesca and her child, who died with her, were laid to rest in a tomb ascribed by Vasari to Verrocchio. A drawing by Heemskerck representing the sarcophagus with the unusual double effigy of mother and child survives. The tomb does not. (Nor does the Tornabuoni chapel, though scattered sculpture from it may be seen today in the church). We do not know precisely what the tomb of Francesca Tornabuoni looked like. However, a long, narrow marble relief with scenes of birth travail and death and including an unmistakable portrait, in little, of Francesca Tornabuoni exists in the Bargello, to which it came from Medici possession (mentioned in Medici inventories as early as 1666). This relief has been for some time connected with the Francesca Tornabuoni tomb in Rome. Perhaps because of the family connection with the Medici, the relief was brought back to Florence when the monument was broken up. Perhaps the relief was carved in Florence and never was sent to Rome. One cannot be sure. In any event, the design and modello of the marble relief appear to be by Verrocchio, though the carving must be attributed to a hand, or hands, of the bottega (Francesco di Simone?).

Two sketches, or modelli, of angels in the Louvre, depicted as supporting the edge of a mandorla, have usually been connected with the Forteguerri Cenotaph in the literature. However, these two angels are posed perpendicularly, as if they were running on a flat cloud base—they do not at all fit the definitely floating angelic choir of the Forteguerri monument. Instead they may be imagined as more stable—foot on cloud—supporters of a mandorla containing the image of the Madonna and Child (a motif frequent in tombs designed for Rome, for example those from Mino da Fiesole's Roman workshop). It is in this kind of context that these angels should probably be considered. Much restored today, they could be Verrocchio's own work in part, or shop work. They are by two different hands, at least partly. The author of the one facing left can hardly be Leonardo (despite Passavant 1969).

19. *FLOOR-TOMB OF FRA GIULIANO DEL VERROCCHIO.* Florence, S. Croce. Marble. Length 250 cm.; width 122 cm. Much worn. The inscription under the feet, recut, follows with only minor variations that recorded in the seventeenth century: F. JVLIANVS VERROCCHIVS THEOLOGVS INSIGNIS HIC SEPVL/ TVS EST F. ANTONIVS DE MEDICIS EIVSDEM ORDINIS THEOL./ ET ETRVRIAE PROVINCIAE MINISTER NE IACERET INCVLTVS/ QVIA AETATIS SVAE FVERAT DECOR HOC MONVMENTVM/ DONAVIT. VIX.A.XXXXII MEN. VI DIES X OBIIT AD MCCCCXXXXII. Around the edge in Gothic lettering an inscription from the Book of Psalms, with a date of 1413, shows that stones already inscribed were used for the border. *Fig. 29.*

The figure is so worn down that its style is virtually impossible to judge except as to composition and a few elements of the drapery. These are, however, so suggestive of Verrocchio's art that the attribution, first made by Covi (1968), seems entirely justified. He makes the plausible suggestion that the tomb was ordered from Verrocchio by Fra Antonio de' Medici (*ca.* 1425-1485) and that it was executed between 1465 and 1470. The patron was a pupil of the subject and a distinguished member of the Franciscan Order. He was held in high esteem by Pope Sixtus IV, who had been at one time head of the Franciscan Order; at the end of his life he was appointed a bishop.

20. *PORTRAIT-BUST OF A LADY (SIMONETTA VESPUCCI?).* National Gallery of Art, Washington, D.C. (Kress Collection). Height 53 cm. Marble. *Fig. 135.*

Currently attributed to Desiderio da Settignano by the National Gallery of Art. It was also attributed, by Suida, to the hand of Leonardo. Suida's identification of the subject as Simonetta Vespucci, on the basis of a strong resemblance to a profile in the Vespucci family fresco by Ghirlandaio in Ognissanti, Florence, has a good deal more to offer. Stylistically, the piece fits into what is known of Verrocchio's marble style of the 1470's. The brocade decoration of the bodice and sleeves relates to similar decoration in the painting of the Madonna and Child, Berlin 104A (see p. 171). There is no history of the bust before the nineteenth century (see Seymour 1949). But the quality is extraordinarily high, despite evidence of severe cleaning (nineteenth or early twentieth century).

21. *PORTRAIT-BUST OF A LADY ("MARIETTA STROZZI").* National Gallery of Art, Washington, D.C. (Widener Collection). Height 56 cm. Marble. Unfinished; modern repair to nose and hair. *Fig. 136.*

Attributed by the National Gallery of Art to Desiderio (see Seymour 1949). However, the forms are extremely close to the style of the Faith (Verrocchio's own style) of the Forteguerri Cenotaph. Relationships with Verrocchio's method of sensing form sculpturally in his drawing (see below) can also be established. According to Bode (1921), the piece came from the Strozzi palace in Florence; he claimed it as the "lost" portrait of Marietta Strozzi mentioned by Vasari as the work of Desiderio. Neither the identification nor Vasari's attribution can be sustained in considering this portrait. The recorded history of this piece is meager; after its supposed discovery in the Strozzi palace it is said to have passed to private hands in Città di Castello, and thence, via the dealers Grassi and Duveen, to the Widener Collection.

22. *PORTRAIT-BUST OF A LADY ("ISOTTA DA RIMINI")*. Louvre, Don Donaldson. Height 55 cm. Marble. *Fig. 134*.

Attributed simply to the "Ecole italienne" in the Louvre catalogue (Musée National du Louvre, *Catalogue des Sculptures du moyen age, de la Renaissance, et des temps modernes*, I, Paris, 1922, p. 76). The early identification as Isotta da Rimini never has been taken seriously, least of all by the Louvre staff, who catalogued the piece in 1922 as only a "supposed" likeness of that famous lady. Clarence Kennedy, who used to call the bust "The Ugly Lady," at one time thought of her in the context of Desiderio. The style, however, recalls far more strongly Verrocchio's known work in marble. The history provided by the Louvre states simply that the piece was given by Sir George Donaldson in 1892.

23. *PORTRAIT-BUST OF A BOY*. National Gallery of Art, Washington, D.C. (Mellon Collection). Height 26 cm. Marble. *Figs. 139-141*.

Attributed by the National Gallery of Art to Desiderio (see Seymour 1949). The attribution to Desiderio can be sustained, but only with increasing difficulty if the style is compared to Desiderio's Bargello Lady or Vanchetoni *Christ Child* (Kress Collection, National Gallery of Art). The piece now appears on the borderline between the late style of Desiderio (as in the S. Lorenzo Altar of the Sacrament) and what one may suppose to be the early style of Verrocchio, which seems to appear in the Altar of the Sacrament as assistant's work. The Mellon Collection Boy is very well known, and rightly so, as a remarkable study of the psychology as well as the forms of childhood. An attribution, at least in part, to Verrocchio is not impossible. The recorded history of the piece goes back to 1848 when it was acquired by Eugène Piot in Italy. Via the Timbal and Dreyfus collections in Paris, it came (through Duveen) to the Andrew W. Mellon Collection in 1937 and was transferred with the Mellon Collection to the National Gallery of Art.

24. *PORTRAIT-BUST OF LORENZO DE' MEDICI*. National Gallery of Art (Kress Collection), Washington, D.C. Height: 67 cm. Polychrome terracotta. Part of headdress at subject's right broken and missing. *Figs. 176*.

Attributed to Verrocchio by the National Gallery of Art. This seems to be one of several versions or variants of the bust of Lorenzo by Verrocchio that is known from a sketch by Leonardo (Windsor 1244R) to have been in Verrocchio's shop—evidently after 1478, the date of the Medici's successful suppression of the Pazzi Rebellion and of Lorenzo's bold trip to Naples to re-establish a balance of power to preserve Florentine independence (see Seymour 1949). This example does not appear to be the original; it could well date from about 1513, when the Medici were once more (following their expulsion in 1495) restored to power. Recently the bust has been classified as by an imitator of Verrocchio and the death mask now preserved in Florence has been invoked as a source for the features; the drawing in Windsor of a bust of this type is not mentioned, however (Passavant 1969). To call the originator of this powerful sculptural image simply an "imitator of Verrocchio" seems insufficient.

25. *ALEXANDER RELIEF*. National Gallery of Art, Washington, D.C. Height 58 cm.; width 38 cm. Marble. Some breakage in the decorative dragon motif of the helmet and the winged mark of the breastplate. *Fig. 171*.

The relief cannot be traced further back than 1922, when it is said to have appeared on the Vienna market, supposedly from a Hungarian noble source. In 1927, it was with Jacques Seligmann in Paris. It was later acquired by Herbert N. Straus of New York; from the Straus Collection it went as a gift to the National Gallery of Art. When the relief first appeared it was enthusiastically greeted as the lost "Alexander" by Verrocchio mentioned by Vasari (as in metal, however) that was sent with a pendant of Darius to the King of Hungary, Matthias Corvinus, by Lorenzo de' Medici (see Valentiner 1950, preceded by Planiscig 1933 and 1941). Up to 1960 the relief was more or less generally accepted as Verrocchio's in this context (Pope-Hennessy 1958). Latterly doubts about its

authenticity have been expressed (Passavant 1969). Verrocchio's own hand is in my view extremely difficult, perhaps impossible, to establish here; but to imply that the relief is not Renaissance work must be too strong an indictment. The Straus-National Gallery of Art "Alexander" (to give it the title by which it is still generally known) appears to be in somewhat the same category as the marble Scipio relief in the Louvre (catalogued in 1922 as early sixteenth century; Don Rattier 1903, No. 668; heitht 68 cm.). For a time the Louvre relief was cited as the "lost" Verrocchio Corvinus gift; like the Straus relief it was also attributed at one time to Leonardo; and rather like the Straus relief, which now also seems to be slipping out of the fifteenth century, it has been catalogued as a sixteenth-century version of an earlier Florentine design, now lost. The Louvre piece is bolstered by a Renaissance stucco squeeze from it in the Victoria and Albert Museum (see Pope-Hennessy 1964; there it is classified as "after Francesco di Simone": Inv. A59-1921). There is no record of a Renaissance version, variant, or copy of the "Alexander" now in Washington. One would like to know more about it before either condemning it or accepting it as a work of Verrocchio's time; the present situation enjoins caution.

B. *Some Painting and Drawings*

NOTE: The brief section given below is intended to help the reader who is interested primarily in Verrocchio as a sculptor rather than as a painter. In no way does it purport to "cover" the full activity of Verrocchio as a sculptor, painter or draughtsman. For a recent accounting, see Passavant 1959 and 1969. Omitted from Passavant's catalogue, however, are both the beautiful "Ruskin Madonna," now in Sheffield (given by Berenson to Verrocchio), and the ruinous but evidently remarkable Madonna recently discovered by Sheldon Grossman, which seems likely to be by the master. For the reference, see Bibliography.

1. *THE BAPTISM*, with Leonardo da Vinci. Florence, Uffizi. Height 117 cm.; width 151 cm. Tempera and oil on panel. *Fig. 13.*

According to Vasari, Leonardo painted the left-hand kneeling angel. Examination of the panel, including radiography, has confirmed that statement. But even more of the picture should be credited to Leonardo's hand: certainly the background of river and mountains (Lord Clark). Some critics have held that the overpainting of the face and figure of the Christ are also by Leonardo (see Passavant 1959 and 1969); but there is no unanimity on this point. Nor, strangely, on the attribution to Verrocchio of the composition and basic preliminary painting (Ragghianti 1954: Botticelli rather than Verrocchio). It is generally understood today that Verrocchio began the picture and carried the execution, in tempera, of the figures and much of the background to the point represented by the painting of the St. John; then Leonardo came in, using an oil technique and altering fairly freely the design of the parts he overpainted. Passavant, for not very convincing iconographic reasons, does not think that the picture was intended for a patron in Florence. But there is evidence that very early in the sixteenth century it was to be seen in the monastery of S. Salvi just outside the city walls (Albertini 1510), and Vasari understood at mid-century that the painting was done for the monks of S. Salvi. This is a case where Vasari's use of tradition may well be correct. In 1730 the Baptism was moved from S. Salvi to S. Verdiana; in 1810 it was moved again, to the Accademia delle Belle Arti; it went in 1919 to the Uffizi. A date of about 1475 is usually given the picture, but its chronology, especially the precise dating of Leonardo's part in it, is uncertain.

2. *MADONNA AND CHILD*. Berlin, Staatliche Museen, 104A. Tempera on panel. Height 72 cm.; width 53 cm. Edges are evidently not original; the panel seems to have been cut down. (*Fig. 15 reproduces a version in Washington, which is believed to be the original format.*)

The Berlin painting was recorded in the collection of Jerome Bonaparte, who for a time before he

came to Baltimore lived in the Palazzo Serristori on the south bank of the Arno in Florence. The painting is thought to have been acquired by him in Florence; it was bought for the Berlin museum in 1873. The picture has not always been attributed to Verrocchio, but today critics consider it surely his (see Passavant 1969). An old version, most probably a copy of the original in its original dimensions and state, and probably closely contemporaneous with the Berlin painting, is in the National Gallery of Art, Washington (Kress Collection). The date of the Berlin picture is not known but is generally placed earlier than that of the S. Salvi Baptism, in the neighborhood of 1470. The National Gallery of Art version is unfortunately much repainted, but it might well have come from the Verrocchio bottega and be at least partly by the master; it certainly deserves more study.

3. MADONNA ENTHRONED BETWEEN STS. JOHN THE BAPTIST AND DONATUS. Pistoia, Duomo. Height 189 cm.; width 191 cm. Tempera (?) and oil on panel. *Fig. 14.*

This is the only documented painting by Verrocchio, and ironically most modern critics (following Vasari to some extent) have attributed it at one time or another to Lorenzo di Credi. Analysis of the probable roles of both Verrocchio and of Credi is carefully outlined in Passavant 1959 and 1969. The altarpiece must be considered as a bottega job, though a fine one. The predella panels are now scattered: one by Perugino, in Liverpool, and two by Credi, in the Louvre and in the Worcester Museum in Massachusetts. It is thought that the commission for the painting, destined for the Oratory of the Virgin (Cappella della Piazza) that was built onto the east end of the Pistoia Cathedral and endowed by Bishop Donato de' Medici, was no later than 1478. The painting was mentioned in a document of 1485 as being purportedly "finished or nearly so" (*si dice essere facto o mancarvi poco*). Credi must have completed it after 1485 when Verrocchio was in Venice or after his death there (Passavant 1959 and 1969). The bishop, not a close relative of Cosimo or Piero de' Medici, died in 1474. He was buried in

the Oratory (since opened up to become the Chapel of the Sacrament of the Cathedral), where his marble portrait memorial, dated 1475, and an extremely fine tombstone (design conceivably by Verrocchio) are preserved today along with the panel of the Madonna with Saints.

4. SKETCH FOR A STANDARD. Florence, Gabinetto di Disegni e Stampe, Uffizi, 212E. Height 15 cm.; width 26 cm. (in triangular shape). Silverpoint and bistre on yellowish tinted paper mounted so as to be rectangular. Berenson 674A (former 2788). *Fig. 21.*

A sleeping nymph about to be surprised by Cupid is the subject. The triangular shape can best be explained by considering the sketch a preliminary design for a tournament standard—most probably that made by Verrocchio for the Giostra of Giuliano de' Medici in 1476. Over the years the critics have tended to see Verrocchio's hand here, or that of a member of his school (particularly Credi), more rarely Leonardo (there is a drawing of rushes similar to those in this drawing on a sheet in Windsor, No. 12428). The last Berenson verdict is "ascribed to Verrocchio" (Berenson 1961). It is considered autograph by Passavant (Passavant 1959 and 1969). I think Passavant is right.

5. HEADS OF WOMEN. London, British Museum, 1895-9-15-785; Malcolm 338. Height 32.5 cm.; width 27.3 cm. Black chalk and bistre heightened with white on pale brown paper. Berenson 2782. *Figs. 22, 23.*

The drawing on the verso is a preliminary blocking in of the head that is carried to a higher degree of finish on the recto. The hair-do of the recto head indicates that it surely cannot be for a Madonna. Passavant, however, is correct in linking the verso to the reclining nymph with right hand supporting her head, Uffizi 212E (see above). Both London drawings therefore are interpreted most easily as elaborations at actual size in preparation for the standard, presumably of 1476. Both drawings are universally given to Verrocchio.

6. *SKETCH OF AN INFANT.* Florence, Gabinetto di Disegni e Stampe, Uffizi, 212F verso. Height 28 cm.; width 20 cm. Black chalk on pale buff prepared paper. Berenson 2798. *Fig. 19.*

Possibly for the Christ Child of the Pistoia Altarpiece (Passavant 1959 and 1969). Middeldorf at one time considered the drawing as possibly by Desiderio or Antonio Rossellino (in any event by a sculptor). Generally given today to Verrocchio. The drawing in silverpoint on the recto of the sheet is by a different hand.

7. *STUDY SHEET OF NAKED PUTTI.* Paris, Louvre, Cabinet des Dessins, No. 2R.F. Height 14.5 cm.; width 20 cm. Pen and bistre on white paper. Berenson 2783. *Figs. 17, 18.*

The sheet, which was acquired for the Louvre in 1871, has always been given to Verrocchio, if only because of the dedicatory verses (for an epitaph?) on the verso, which have been transcribed as follows:

> Viderunt equum mirandaque arte confectum
> Quem nobiles Veneti tibi dedere facturum
> Florentiae decus crasse mihi crede, Varochie,
> Qui te plus oculis amant diliguntque
> Atque cum Jupiter animas infuderit ipsi [*sic*]
> Hoc tibi Dominus rogat Salmonicus idem.
> Vale et bene qui legis.

> They have seen the horse[1] wrought with wondrous skill
> Which the noble Venetians[2] gave to you to make
> A glory to Florence,[3] believe me,
> stout[4] Verrocchio
> Who more than their eyes[5] regard and esteem you.
> And this same regard our Lord of Justice[6]
> asks for you
> When Jove himself has poured out[7] the souls.[8]
> Fare you well who read this.

[1] Doubtless refers to the whole finished equestrian statue of Colleoni.

[2] Alternatively: Venetian nobles.

[3] Alternatively: The glory of Florence.

[4] Alternatively: Fat Verrocchio (but probably not "dull Verrocchio").

[5] A pun on Verrocchio's name [*occhio* meaning "eye"].

[6] Literally: Lord [as wise] as Solomon. Since in Venice, Solomon was used as a symbol of justice, perhaps the idea of justice is preferable. Could refer to the Doge of Venice.

[7] Used of molten metal.

[8] Possibly pun on "soul" as used to define the solid core in hollow metal-casting.

8. *SKETCH FOR A TOMB.* London, Victoria and Albert Museum. Inv. 2314. Height 27 cm.; width 19.5 cm. Black lead gone over with pen and ink by a later hand, on paper. Berenson 699B. *Fig. 24.*

This drawing for a console-tomb was given by Berenson to Credi, but there can be no question that the superior power of concept and quality of execution in the original parts point to Verrocchio himself. The ink overlay should be discounted. The sketchy lion of St. Mark on the sarcophagus identifies the tomb as Venetian, and as one for a doge. The drawing is to be identified with that which Vasari mentions as belonging to Vincenzo Borghini: *"un disegno di sepultura, da lui fatto in Vinegia per un doge"* (see Möller 1935 and Passavant 1969). It must have been done shortly before Verrocchio's death, while he was residing in Venice. The heraldic evidence suggests that the design was for the monument of Andrea Vendramin, carried out after Verrocchio's death by Tullio Lombardi; it was originally in the Servi and was removed in the nineteenth century to the choir of SS. Giovanni e Paolo. A poorer version (after a lost Verrocchio?), by the same inferior hand that was responsible for the inking on the Victoria and Albert sheet, is in the Louvre Cabinet des Dessins; it has been in the past ascribed to Credi—one would think wrongly.

APPENDIX I

SELECTED DOCUMENTS AND SOURCES

A. *Guide to the More Easily*
Available Published Documents
and Sources

The most recently published compendium of documents on Verrocchio and his art is to be found in Passavant 1959, pp. 214-231. This collection, while still valuable for an over-all view, appears to have been based to considerable extent on earlier transcriptions, which in a few cases are not free from errors or ambiguities. A new collection by Professor Dario Covi, based on a review of all available archival material, is expected. Meanwhile, for newly discovered material, see Covi 1966 (four texts which throw light particularly on Verrocchio's later period and Lorenzo di Credi's views about Verrocchio's life). Documents on the Or S. Michele group that Milanesi had used in the nineteenth century and were believed to have been lost have since been found by Professor Covi and, it is understood, will be published in full by him. One hitherto overlooked document which helps in a more accurate dating of the Or S. Michele group has already been published by Covi in *Burlington Magazine*, 110, 1967, p. 37. Peleo Bacci, authoritative archivist of the early part of the twentieth century, reviewed the Forteguerri Cenotaph documents (see Kennedy, Wilder, and Bacci 1932). Material, mainly from the declarations to the Catasto, is found in Mather 1958, pp. 29-31. An older compendium, subject to caution pending Covi's expected publication, is given in Cruttwell 1904, pp. 234-56 (previously published in *L'Arte* 1904). For sources: See Albertini and Felix Faber in the Bibliography; but the major source, of course, is Giorgio Vasari—even though a rather late one. The authoritative *Vita* of Verrocchio by Vasari is in the edition with notes of Gaetano Milanesi (see Vasari-Milanesi, III, pp. 357-82); obviously Milanesi's notes are

considerably dated, and a new annotated edition by Paola Barocchi is anticipated. There are a large number of English translations of the Vasari *Lives*, varying in quality and vivacity; a standard translation is given almost *in toto* on pp. 000.

B. *Selected Texts*

1. TOMMASO'S "MEDICI COMMISSION LIST"

Copy of a list of works of art purported by the artist's brother Tommaso to have been done by Verrocchio for the Medici and still, as of 1495, not fully paid for.

Dj Tommaso Verrochhj. + adj 27 dj gennaio 1495. Rede dj Lorenzo de Medicj deon dare per questo lavoro fatto qui appie cioc.

1. Per uno davitte e la testa dj ghulia fj-
2. Per lo gnudo rosso . fj-

Per a Charegj

3. Per el banbino dj bronzo chon 3 teste dj bronzo e 4 bocche dj lione dj marmo fj-
4. Per una fighura dj marmo che gietta acqua fj-
5. Per una storia dj rilievo chom piu fighure . . fj-
6. Per achonciatura dj tutte le teste chotalie che sono sopra a gli uscj del chortile in Firenze . fj-
7. Per uno quadro dj legname drentovj la fighura della testa della Luchrezia de Donatj . . fj-
8. Per lo stendardo per la giostra dj Lorenzo . . fj-
9. Per una dama dj rilievo ch'è posta in sul elmo . fj-
10. Per dipintura duno stendardo ch 1° spiritello per la giostra dj Giuliano fj-

11. Per la sepoltura dj Chosimo appie del altare
magiore in san Lorenzo...............fj-

12. Per la sepoltura dj Piero e Giovannj de
Medicifj-

13. Per intagliatura dj 80 lettere intagliate in su
el serpentino in due tondj in detta sepoltura fj-

14. Per ventj maschere rittatte al naturale....fj-

15. Per lo adornamento e aparato del ducha
Ghaleazofj-

Bibl. degli Uffizi Miscellanee Manoscritte P.I.,
No. 3. Cruttwell 1904, p. 243 (with wrong
archive reference); Passavant 1959 (with same
archive reference and ambiguous printing of
marginal note); Passavant 1969, p. 174, corrected.

TRANSLATION

By Tommaso del Verrocchio. The twenty-
seventh day of January, 1495 (1496 our style). The
heirs of Lorenzo de' Medici owe the following
sums for work that appears below.

1. For a David with the head of Goliath..florins*

2. For the red nude.................florins*

For Careggi

3. For the bronze baby with three heads
of bronze and four lion's masks of
marbleflorins*

4. For a marble fountain figure........florins*

5. For a historiated relief with several
figuresflorins*

6. For the attachment of all the heads
that are [set] above the exits from the
courtyard in [the palace in] Florence..florins*

7. For a [painted] panel of the head of
Lucrezia Donati.................florins*

8. For the standard [made] for the Tour-
nament of Lorenzo...............florins*

9. For [the figure of] a lady in relief [sic]
that was placed on [his] helmet......florins*

10. For the painting of a standard with a
figure of a young spirit [sic] for the
Tournament of Giuliano.........florins*

11. For the tomb of Cosimo at the foot of
the High Altar of S. Lorenzo.......florins*

12. For the tomb of Piero and Giovanni
de' Mediciflorins*

13. For the cutting of 80 letters inscribed
in the serpentine [marble] of two
roundels in the said tomb.........florins*

14. For 20 masks taken from nature......florins*

15. For the ceremonial [armor?] of the
Duke Galeazzo [Sforza]...........florins*

2. PORTION OF LETTER TO LORENZO DE' MEDICI

Portion of letter dated March 11, 1477-8 from
the authorities of the Sapienza in Pistoia to
Lorenzo de' Medici, asking for his advice in
judging between designs submitted by Andrea
del Verrocchio and Piero del Pollaiuolo for the
Forteguerri Monument, finally erected in the
Duomo, Pistoia in the eighteenth century.

... per nri. Consigli fu obtenuto per sua Sepoltura
et memoria si dovesse spendere lire mille cento. e
commisse a noi Ciptadini che facessimo fare
modelli, et quelli facti si presentassero al consiglio,
et quello il consiglio elegiesse, si dovesse prehen-
dere. Il perchè al consiglio fu presentati cinque
modelli, fra quali nenera uno dandrea del
varrocchio, il quale piaceva più che altro; et il
consiglio dè commessione a noi, dovessimo
praticare di pregio con dco. Andrea. Ilchè facemo,
et lui ci chiese ducati trecento cinquanta. et inteso
noi la chiesta sua li demo licentia, et nulla saldamo
seco: perchè con avevamo commessione spendere
più che lire mille cento. Et di poi desiderandosi per
noi che dca. opera avesse effecto, ricorrimo al
consiglio, dicendo che bisognava magior quantità
di denari a questa opera che lire mille cento,
volendo una cosa degnia. Il consiglio inteso il vero
nuovamente diliberò, et diecci auctorità potessimo
spendere quella quantità di denari ci paresse per
dca. opera, parchè fusse bella, et potessimo allo-

*No sums are carried by the copy of the document
which is the only record of the nonextant original.

garla a dco. andrea et a ogni altro che ci paresse. Il perchè noi intendendo essere qui piero del pollaiuolo fumo seco, et preghamolo ci dovesse fare modello di tale opera; il che ci promesse fare, et per questo abbiamo diferito ad alogare dca. opera. Ora è seguito che enostri M. Commissari, per fare che dca. opera avesse effecto, lanno allogata al dco. andrea per dco. pregio et modo; et noi, come figliuoli dubidientia, a questa et a ogni altara cosa che loro facessino et diliberasseno, semper staremo contenti et ubidienti: et così alloro nabbiamo scripto. Ora piero del pollaiuolo à facto il modello che per noi li fu imposto; il quale ci pare più bello et più dengnio darte et più piace a contento di mess. piero fratello di dco. Monsignore et di tucta la sua famiglia, et simul di noi et di tucti e ciptadini della nra. ciptà, che lanno veduto, che non fa quello dandrea o dalchuno altro, et per questo abbiamo preghato decti commissari, che se paga loro usare alchuna cortesia a dco. andrea. et pigliare quello di dco. piero, ciò ne farebbeno contento et piacere assai. . . .

(Arch. Medicea Famiglia privata lettere; Filza 35. Gaye 1889, I, p. 256; Cruttwell 1904, pp. 252-53; Bacci in Kennedy, Wilder, and Bacci 1932. p. 78; Passavant 1959, p. 227).

TRANSLATION

. [Permission] was obtained from the consuls [of Pistoia] to spend eleven hundred lire for the tomb and memorial [of Niccolò Forteguerri] and for the citizens to have models made, which, when finished, should be presented to the Council, which should [then] select the one to be retained. Therefore there were presented to the Council five models, among them one by Andrea del Verrocchio which was more pleasing than any of the others. And the Council commissioned us to discuss the price with the said Andrea. This we did and he asked of us a price of three hundred fifty ducats [florins*]; and we intended to request permission [for this], but made no agreement with

*Somewhat more than 1100 lire, the exact amount depending on which of two rates of conversion ot lorins was used for computation.

him, because we had permission to spend no more than eleven hundred lire. Then, desirous of obtaining that work, we went back to the Council, saying that a larger amount of money than eleven hundred lire was required if a worthy [work] was wished for. The Council understood the true [nature of the problem] and gave us permission to spend whatever amount of money would be needed to make the work beautiful and also [permission] to commission the said Andrea or any other who might appear to us [worthy]. Therefore, when we heard that Piero del Pollaiuolo was to be amongst us, we asked him to make a model for the said work. This he promised to do and for that reason we have put off commissioning the said work. Now it appears that the *Commissari* [of the Sapienza[, in order to get the said work done, have let it out to the said Andrea for the above-mentioned price; we in turn, like obedient sons remain content with, and obedient to, whatever they do or decide, and we shall always remain so, and so have written them. Now Piero del Pollaiuolo has made the model that we ordered from him; this model appears to us more beautiful and more worthy as art, and more pleasing to Piero, brother of Monsignore [Niccolò Forteguerri] and all his family, and likewise to us all the citizens of our city who have seen it, which is not the case for that of Andrea or those of the others, and for this reason we have entreated the said *Commissari* that they excuse courteously the said Andrea and that they take [the model] of the said Piero [Pollaiuolo] and in this we would be very happy and pleased . . . [The letter goes on to invite Lorenzo de' Medici to help them make a decision between Andrea and Piero as sculptor of the proposed monument. This Lorenzo appears to have done and is thanked in a letter of the same month, March 1477-8.]

3. VASARI'S LIFE OF VERROCCHIO, IN TRANSLATION

Portions of the biography of Andrea by Giorgio Vasari in the 1568 (2nd) edition of the *Vite de' piu eccellenti pittori scultori ed architettori*. From the standard DeVere translation, III, London, 1912, pp. 267-76.

LIFE OF ANDREA VERROCCHIO
PAINTER, SCULPTOR, AND
ARCHITECT OF FLORENCE

Andrea del Verrocchio, a Florentine, was in his day a goldsmith, a master of perspective, a sculptor, a wood-carver, a painter, and a musician; but in the arts of sculpture and painting, to tell the truth, he had a manner somewhat hard and crude, as one who acquired it rather by infinite study than by the facility of a natural gift. Even if he had been as poor in this facility as he was rich in the study and diligence that exalted him, he would have been most excellent in those arts, which, for their highest perfection, require a union of study and natural power. If either of these is wanting, a man rarely attains to the first rank; but study will do a great deal, and thus Andrea, who had it in greater abundance than any other craftsman whatsoever, is counted among the rare and excellent masters of our arts.

In his youth he applied himself to the sciences, particularly to geometry. Among many other things that he made while working at the goldsmith's art were certain buttons* for copes, which are in S. Maria del Fiore at Florence; and he also made larger works, particularly a cup, full of animals, foliage, and other bizarre fancies, which is known to all goldsmiths, and casts are taken of it; and likewise another, on which there is a very beautiful dance of little children. Having given a proof of his powers in these two works, he was commissioned by the Guild of Merchants** to make two scenes in silver for the ends of the altar of S. Giovanni, from which, when put into execution, he acquired very great praise and fame.

There were wanting at this time in Rome some of those large figures of the Apostles which generally stood on the altar of the Chapel of the Pope, as well as certain other works in silver that had been destroyed; wherefore Pope Sixtus sent for Andrea and with great favor commissioned him to do all that was necessary in this matter, and he brought the whole to perfection with much diligence and

judgment*. Meanwhile, perceiving that the many antique statues and other things that were being found in Rome were held in very great esteem, insomuch that the famous bronze horse was set up by the Pope at S. Giovanni Laterano, and that even the fragments—not to speak of complete works—which were being discovered every day, were prized, Andrea determined to devote himself to sculpture. And so, completely abandoning the goldsmith's art, he set himself to cast some little figures in bronze, which were greatly extolled. Thereupon, growing in courage, he began to work in marble. Now in those days the wife of Francesco Tornabuoni** had died in childbirth, and her husband, who had loved her much, and wished to honor her in death to the utmost of his power, entrusted the making of a tomb for her to Andrea, who carved on a slab over a sarcophagus of marble the lady herself, her delivery, and her passing to the other life; and beside this he made three figures of Virtues, which were held very beautiful, for the first work that he had executed in marble; and this tomb was set up in the Minerva.

Having then returned to Florence with money, fame, and honor, he was commissioned to make a David of bronze, two braccia and a half in height, which, when finished, was placed in the Palace, with great credit to himself, at the head of the staircase, where the Catena was. The while that he was executing the said statue, he also made that Madonna of marble which is over the tomb of Messer Lionardo Bruni of Arezzo in S. Croce; this he wrought, when still quite young, for Bernardo Rossellino, architect and sculptor, who executed the whole of that work in marble, as has been said. The same Andrea made a half-length Madonna, in half-relief, with the Child in her arms, in a marble panel, which was formerly in the house of the Medici, and is now placed, as a very beautiful thing, over a door in the apartment of the Duchess of Florence. He also made two heads of metal, likewise in half-relief; one of Alexander the Great, in profile, and the other a fanciful portrait of Darius; each being a separate work by itself, with variety in the crests, armor,

*Morses (C.S.).
**The Calimala (C.S.).

*Vasari is evidently in error here (C.S.)
**Giovanni Tornabuoni (C.S.).

and everything else. Both these heads were sent to Hungary by the elder Lorenzo de' Medici, the Magnificent, to King Matthias Corvinus, together with many other things, as will be told in the proper place.

Having acquired the name of an excellent master by means of these works, above all through many works in metal, in which he took much delight, he made a tomb of bronze in S. Lorenzo, wholly in the round, for Giovanni and Pietro di Cosimo de' Medici, with a sarcophagus of porphyry supported by four corner-pieces of bronze, with twisted foliage very well wrought and finished with the greatest diligence. This tomb stands between the Chapel of the Sacrament and the Sacristy, and no work could be better done, whether wrought in bronze or cast; above all since at the same time he showed therein his talent in architecture, for he placed the said tomb within the embrasure of a window which is about five braccia in breadth and ten in height, and set it on a base that divides the said Chapel of the Sacrament from the old Sacristy. And over the sarcophagus, to fill the embrasure right up to the vaulting, he made a grating of bronze ropes in a pattern of *mandorle*, most natural, and adorned in certain places with festoons and other beautiful things of fancy, all remarkable and executed with much mastery, judgment, and invention.

Now Donatello had made for the Tribunal of Six of the Mercanzia that marble shrine which is now opposite to S. Michael, in the Oratory of Orsanmichele, and for this there was to have been made a S. Thomas in bronze, feeling for the wound in the side of Christ; but at that time nothing more was done, for some of the men who had the charge of this wished to have it made by Donatello, and others favored Lorenzo Ghiberti. Matters stood thus as long as Donatello and Ghiberti were alive; but finally the said two statues were entrusted to Andrea, who, having made the models and molds, cast them; and they came out so solid, complete, and well made, that it was a most beautiful casting. Thereupon, setting himself to polish and finish them, he brought them to that perfection which is seen at the present day, which could not be greater than it is, for in

S. Thomas we see incredulity and a too great anxiety to assure himself of the truth, and at the same time the love that makes him lay his hand in a most beautiful manner on the side of Christ; and in Christ Himself, who is raising one arm and opening His raiment with a most spontaneous gesture, and dispelling the doubts of His incredulous disciple, there are all the grace and divinity, so to speak, that art can give to any figure. Andrea clothed both these figures in most beautiful and well-arranged draperies, which give us to know that he understood that art no less than did Donato, Lorenzo,* and the others who had lived before him; wherefore this work well deserved to be set up in a shrine made by Donatello, and to be ever afterwards held in the greatest price and esteem.

Now the fame of Andrea could not go further or grow greater in that profession, and he, as a man who was not content with being excellent in one thing only, but desired to become the same in others as well by means of study, turned his mind to painting, and so made the cartoons for a battle of nude figures, very well drawn with the pen, to be afterwards painted in colors on a wall. He also made the cartoons for some historical pictures, and afterwards began to put them into execution in colors; but for some reason, whatever it may have been, they remained unfinished. There are some drawings by his hand in our book, made with much patience and very great judgment, among which are certain heads of women, beautiful in expression and in the adornment of the hair, which Leonardo da Vinci was ever imitating for their beauty. In our book, also, are two horses with the due measures and protractors for reproducing them on a larger scale from a smaller, so that there may be no errors in their proportions; and there is in my possession a horse's head of terracotta in relief, copied from the antique, which is a rare work. The Very Reverend Don Vincenzio Borghini has some of his drawings in his book, of which we have spoken above; among others, a design for a tomb made by him in Venice for a Doge, a scene of the Adoration of Christ by

*Donatello and Ghiberti (C.S.).

the Magi, and the head of a woman painted on paper with the utmost delicacy. He also made for Lorenzo de' Medici, for the fountain of his Villa at Careggi, a boy of bronze squeezing a fish, which the Lord Duke Cosimo has caused to be placed, as may be seen at the present day, on the fountain that is in the courtyard of his Palace; which boy is truly marvelous.

Afterwards, the building of the Cupola of S. Maria del Fiore having been finished, it was resolved, after much discussion, that there should be made the bronze ball [*palla*] which, according to the instructions left by Filippo Brunelleschi, was to be placed on the summit of that edifice. Whereupon the task was given to Andrea, who made the ball four braccia high, and, placing it on a knob, secured it in such a manner that afterwards the cross could be safely erected upon it; and the whole work, when finished, was put into position with very great rejoicing and delight among the people. Truly great were the ingenuity and diligence that had to be used in making it, to the end that it might be possible, as it is, to enter it from below, and also in securing it with good fastenings, lest the winds might do it damage.

Andrea was never at rest, but was ever laboring at some work either in painting or in sculpture; and sometimes he would change from one to another, in order to avoid growing weary of working always at the same thing, as many do. Wherefore, although he did not put the aforesaid cartoons into execution, yet he did paint certain pictures; among others, a panel for the Nuns of S. Domenico in Florence, wherein it appeared to him that he had acquitted himself very well; whence, no long time after, he painted another in S. Salvi for the Monks of Vallombrosa, containing the Baptism of Christ by S. John. In this work he was assisted by Leonardo da Vinci, his disciple, then quite young, who painted therein an angel with his own hand, which was much better than the other parts of the work; and for that reason Andrea resolved never again to touch a brush, since Leonardo, young as he was, had acquitted himself in that art much better than he had done.

Now Cosimo de' Medici, having received many antiquities from Rome, had caused to be set up within the door of his garden, or rather, courtyard, which opens on the Via de' Ginori, a very beautiful Marsyas of white marble, bound to a tree trunk and ready to be flayed; and his grandson Lorenzo, into whose hands there had come the torso and head of another Marsyas, made of red stone, very ancient, and much more beautiful than the first, wished to set it beside the other, but could not, because it was so imperfect. Thereupon he gave it to Andrea to be restored and completed, and he made the legs, thighs, and arms that were lacking in this figure out of pieces of red marble, so well that Lorenzo was highly satisfied and had it placed opposite to the other, on the other side of the door. This ancient torso, made to represent a flayed Marsyas, was wrought with such care and judgment that certain delicate white veins, which were in the red stone, were carved by the craftsman exactly in the right places, so as to appear to be little nerves, such as are seen in real bodies when they have been flayed; which must have given to that work, when it had its original finish, a most lifelike appearance.*

The Venetians, meanwhile, wishing to honor the great valor of Bartolommeo da Bergamo,** thanks to whom they had gained many victories, in order to encourage others, and having heard the fame of Andrea, summoned him to Venice, where he was commissioned to make an equestrian statue of that captain in bronze, to be placed on the Piazza di SS. Giovanni e Paolo. Andrea, then, having made the model of the horse, had already begun to get it ready for casting in bronze, when, thanks to the favor of certain gentlemen, it was determined that Bellano da Padova should make the figure and Andrea the horse. Having heard this, Andrea broke the legs and head of his model and returned in great disdain to Florence, without saying a word. The Signoria, receiving news of this, gave him to understand that he should never be bold enough to return to Venice, for they would cut his head off; to which he wrote in answer that he would take good care not to,

*Identified by W. R. Valentiner with a restored Antique Marsyas in the Uffizi (C.S.).
**Bartolommeo Colleoni (C.S.)

because, once they had cut a man's head off, it was not in their power to put it on again, and certainly not one like his own, whereas he could have replaced the head that he had knocked off his horse with one even more beautiful. After this answer, which did not displease those Signori, his payment was doubled and he was persuaded to return to Venice, where he restored his first model and cast it in bronze; but even then he did not finish it entirely, for he caught a chill by over-heating himself during the casting and died in that city within a few days; leaving unfinished not only that work (although there was only a little polish-ing to be done), which was set up in the place for which it was destined, but also another which he was making in Pistoia, that is, the tomb of Cardinal Forteguerra, with the three Theological Virtues, and a God the Father above; which work was afterwards finished by Lorenzetto, a sculptor of Florence.

Andrea was fifty-six years of age when he died. His death caused infinite grief to his friends and to his disciples, who were not few; above all to the sculptor Nanni Grosso, a most eccentric person both in his art and in his life.* This man, it is said, would not have worked outside his shop, particu-larly for monks or friars, if he had not had free access to the door of the vault, or rather, wine cellar, so that he might go and drink whenever he pleased, without having to ask leave. It is also told of him that once, having returned from S. Maria Nuova completely cured of some sickness, I know not what, he was visited by his friends, who asked him how it went with him. "Ill," he answered. "But thou art cured," they replied. "That is why it goes ill with me," said he, "for I would dearly love a little fever, so that I might lie there in the hospital, well attended and at my ease." As he lay dying, again in the hospital, there was placed before him a wooden Crucifix, very rude and clumsily wrought; whereupon he prayed them to take it out of his sight and to bring him one by the hand of Donato, declaring that if they did not take it away he would die in misery, so greatly did he detest badly wrought works in his own art.

Disciples of the same Andrea were Pietro Perugino and Leonardo da Vinci, of whom we will speak in the proper place, and Francesco di Simone of Florence, who made a tomb of marble in the Church of S. Domenico in Bologna, with many little figures, which appear from the manner to be by the hand of Andrea, for Messer Alessandro Tartaglia,* a doctor of Imola, and another in S. Pancrazio at Florence, facing the sacristy and one of the chapels of the church, for the Cavaliere Messer Pietro Minerbetti. Another pupil of Andrea was Agnolo di Polo, who worked with great mastery in clay, filling the city with works by his hand; and if he had deigned to apply him-self properly to his art, he would have made very beautiful things. But the one whom he loved more than all the others was Lorenzo di Credi, who brought his remains from Venice and laid them in the Church of S. Ambrogio, in the tomb of Ser Michele di Cione, on the stone of which there are carved the following words:

SER MICHAELIS DE CIONIS, ET SUORUM.

And beside them:

HIC OSSA JACENT ANDREAE VERROCHII, QUI OBIIT VENETIIS, MCCCCLXXXVIII.**

Andrea took much delight in casting in a kind of plaster which would set hard—that is, the kind that is made of a soft stone which is quarried in the districts of Volterra and of Siena and in many other parts of Italy. This stone, when burnt in the fire, and then pounded and mixed with tepid water, becomes so soft that men can make what-ever they please with it; but afterwards it solidifies and becomes so hard that it can be used for molds for casting whole figures. Andrea, then, was wont to cast in molds of this material such natural objects as hands, feet, knees, legs, arms, and torsi, in order to have them before him and imitate them with greater convenience. Afterwards, in his time, men began to cast the heads of those who

*Not otherwise known; perhaps apocryphal for the sake of anecdote (C.S.).

* Tartagni (C.S.)

**No longer extant. However, a small marker in the floor of the left aisle purports to show the location of Andrea's burial place (C.S.).

died—a cheap method; wherefore there are seen in every house in Florence, over the chimney-pieces, doors, windows, and cornices, infinite numbers of such portraits, so well made and so natural that they appear alive. And from that time up to the present the said custom has been continued, and it still continues, with great convenience to ourselves, for it has given us portraits of many who have been included in the stories in the Palace of Duke Cosimo. And for this we should certainly acknowledge a very great obligation to the talent of Andrea, who was one of the first to begin to bring the custom into use.

From this men came to make more perfect images, not only in Florence, but in all the places in which there is devoutness, and to which people flock to offer votive images, or, as they are called, "miracoli," in return for some favor received. For whereas they were previously made small and of silver, or only in the form of little panels, or rather of wax, and very clumsy, in the time of Andrea they began to be made in a much better manner, since Andrea, having a very strait friendship with Orsino, a Florentine worker in wax, who had no little judgment in that art, began to show him how he could become excellent therein. Now the due occasion arrived in the form of the death of Giuliano de' Medici and the danger incurred by his brother Lorenzo, who was wounded in S. Maria del Fiore,* when it was ordained by the friends and relatives of Lorenzo that images of him should be set up in many places, to render thanks to God for his deliverance. Wherefore Orsino, among others that he made, executed three life-size figures of wax with the aid and direction of Andrea, making the skeleton within of wood, after the method described elsewhere, interwoven with split reeds, which were then covered with waxed cloths folded and arranged so beautifully that nothing better or more true to nature could be seen. Then he made the heads, hands, and feet with wax of greater thickness, but hollow within, portrayed from life, and painted in oils with all the ornaments of hair and everything else that was necessary, so lifelike and so well wrought that they

*In the Pazzi Conspiracy of 1478 (C.S.).

seemed no mere images of wax, but actual living men, as may be seen in each of the said three, one of which is in the Church of the Nuns of Chiarito in the Via di S. Gallo, opposite to the Crucifix that works miracles. This figure is clothed exactly as Lorenzo was, when, with his wounded throat bandaged, he showed himself at the window of his house before the eyes of the people, who had flocked thither to see whether he were alive, as they hoped, or to avenge him if he were dead. The second figure of the same man is in the *lucco*, the gown peculiar to the citizens of Florence; and it stands in the Servite Church of the Nunziata, over the lesser door, which is beside the counter where candles are sold. The third was sent to S. Maria degli Angeli at Assisi, and set up before the Madonna of that place, where the same Lorenzo de' Medici, as has been already related, caused the road to be paved with bricks all the way from S. Maria to that gate of Assisi which leads to S. Francesco, besides restoring the fountains that his grandfather Cosimo had caused to be made in that place. But to return to the images of wax: all those in the said Servite Church are by the hand of Orsino, which have a large O in the base as a mark, with an R within it and a cross above; and they are all so beautiful that there are few since his day who have equaled him. This art, although it has remained alive up to our own time, is nevertheless rather on the decline than otherwise, either because men's devoutness has diminished, or for some other reason, whatever it may be.

And to return to Verrocchio; besides the aforesaid works, he made Crucifixes of wood, with certain things of clay, in which he was excellent, as may be seen from the models for the scenes that he executed for the altar of S. Giovanni, from certain very beautiful boys, and from a head of S. Jerome, which is held to be marvelous. By the hand of the same man is the boy on the clock of the Mercato Nuovo, who has his arms working free, in such a manner that he can raise them to strike the hour with a hammer that he holds in his hands; which was held in those times to be something very beautiful and fanciful. And let this be the end of the Life of that most excellent sculptor, Andrea Verrocchio . . .

APPENDIX II

Note on the Proportions of the Base of the Colleoni Monument

BY WENDY STEDMAN SHEARD

Analysis of the proportions of the Colleoni base reveals a simple but extremely beautiful scheme which helps to explain the impression of harmony experienced by the beholder. That scheme is highly compressed and united, relating every dimension organically to the height of the bronze horse and rider and their plinth.

Here is a reconstruction of how the proportional scheme of the base seems to have been developed:

(1) The height of the horse, rider and plinth is given as a starting point. This is Line 1—2 on the diagram.

(2) It was evidently decided that the entire base, *including* the horse's plinth, should measure twice the height of the group itself. This is Line 3—4 on the diagram.

(3) On an imaginary base line, a line was drawn equal to Line 1—2, the height of the bronze group and plinth. This is the line BC on the diagram.

(4) A golden-section rectangle was constructed on line BC (rectangle ABCD on the diagram). This provided the architect with the dimensions of the base, up to the top of the columns. The square constructed on the short side of this golden-section rectangle (AEFD) automatically leaves a golden rectangle EBCF as its remainder, which defines the area occupied by the monument's dado and base.

(5) It was then apparently decided that the length of the columns should also equal Line 1—2, the height of the bronze group and its plinth. The width of the monument where the column bases meet the top of the dado is just a little shorter than Line 1—2, and the greatest projection of molding, just below these column bases, is a little longer than Line 1—2.

(6) The other principal dimensions are determined by a technique identical to what I found on the Vendramin monument by Tullio Lombardi (now in SS. Giovanni Paolo). This system takes the long side of the golden-section rectangle (AB) and divides it. In the Colleoni monument there are two modules, not very different in length, each deriving from AB. Thus the arithmetic and geometrical proportions are interrelated; the former derives from the latter (as in the Vendramin monument).

(a) One module results from the division of the longer side of the golden-rectangle (AB) into 10. This module (Aa, for example) is used for the height of the dado, excluding all moldings (bc), and for the width of the spaces between the sections of the dado lying directly beneath the columns, measured between their widest points (de). One half this module (or AB divided by 20) is used for the height of the molded cornice above the upper frieze and below the plinth under the horse (fg); for the height of the capital core (hi), and that of the two risers of the molded base below the dado (jk, jjkk).

(b) The other module results from dividing the longer side of the golden rectangle (AB) into 14. This is startling, as 14 is the divisor for the same line in the Vendramin monument, but is not evident in the proportions of any other Venetian Quattrocento tomb. It is to be noted that Vitruvius had recommended the division of a column into 14 parts to find a module. Possibly the architect combined Vitruvius' arithmetical recommendations with his decision to employ golden-mean proportions. The module resulting from the division by 14 is used for the height of the frieze over the capitals (lm), for the height of the capitals

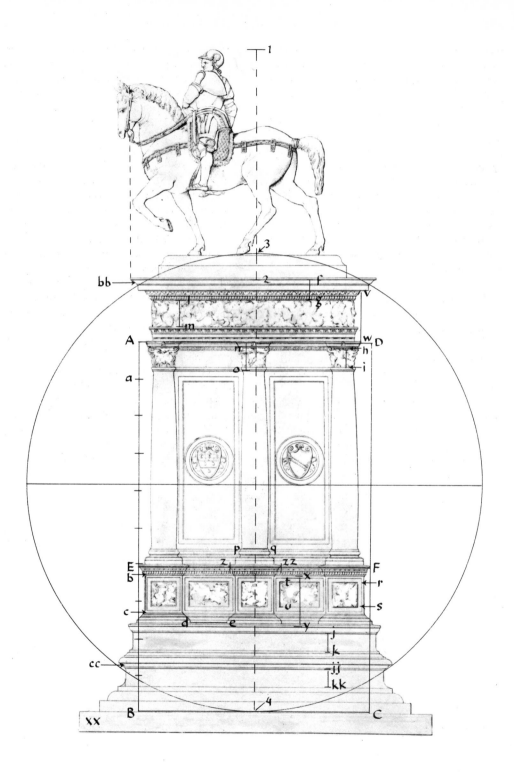

themselves (no), the diameter of the columns just over the torus (pg), the height and width of the square reliefs under the columns (rs), and the height of the rectangular friezes between the smaller dado sections (tu).

The doubling of this second module (AB divided by 7), which is extremely close to the procedure of quadrupling the minor module used in the Vendramin tomb, gives the length employed for the height of the entablature, excluding the two uppermost projecting moldings of the cornice (vw), for the height of the dado from the row of denticulation down to the top of the double base below it (xy), and to determine the greatest width of the sections of the dado beneath the columns (z-zz).

(7) When a circle is drawn with the radius equal to Line 1—2, its circumference can be seen to determine certain widths of the projecting cornices; if the circle is horizontally bisected, the medallions with reliefs of arms are securely anchored on the diameter.

It should be added that the intervals of the horizontal sections gradually decrease as the monument ascends in order to create an impression of rising. The exception to this is the uppermost cornice, whose interval (bb) almost equals that of the molding which separates the dado from the base beneath it (cc). No doubt this was intended to provide a psychological-visual sense of security about the support of the very heavy bronze group. When a line is drawn perpendicular to the left edge of this upper cornice, it runs through the middle of the horse's head. If the interval of this cornice just beneath the plinth were any narrower, the beholder might feel that the horse was about to walk off the base entirely.

This analysis thus sheds light on the strong impression of forward motion that beholders have always had of this equestrian monument. It can be seen immediately that two-thirds of the horse lies to the left of the central line bisecting the monument. Visually this arrangement counteracts the sublime stability imparted to the marble base by the square, circle, and golden rectangle which underlie its proportions. Yet at the same time the horse is subtly anchored to the design of the base by the fact that his left rear hoof is tangent to the circle which inscribes the base. Two other hoofs also fall close to the circle's circumference. The horse and its base are inextricably bound together by the derivation of all the proportions of the latter from the height of the former.

The measured drawing used for the analysis is from Cicognara, *Le Fabbriche più cospicue di Venezia*, 1838-40, Plate 160. (The platform marked xx does not exist in the actual monument and is not part of the proportional scheme.)

Albertini, Memoriale, 1510 – *Memoriale di molte statue e pitture della citta di Firenze fatto da Francesco Albertini Prete.* Florence (Antonio Tubini), 1510. Edition by Milanesi and Guasti. Florence, 1863.

Baldinucci I – Baldinucci, Filippo. *Notizie de' professori del disegno da Cimabve in qva.* Vol. I. Florence, 1681.

Balogh 1962 – Balogh, Jolàn. "Un Capolavoro sconosciuto di Verrocchio." *Acta Artium Academicae Scientiarum Hungaricae*, Vol. VIII (1962), pp. 55-98.

Berenson 1896 – Berenson, Bernard. *The Florentine Painters of the Renaissance.* London, 1896.

Berenson 1903 – Berenson, Bernard. *The Drawings of Florentine Painters.* London, 1903.

Berenson 1933-34 – Berenson, Bernard, "Verrocchio e Leonardo, Leonardo e Credi." *Bollettino d'arte*, Vol. XXVII (1933-34), pp. 193 ff. and pp. 241 ff.

Berenson 1938 – Berenson, Bernard. *The Drawings of the Florentine Painters.* Enlarged edition, 3 vols. Chicago, 1938.

Berenson 1961 – Berenson, Bernard. *I designi dei pittori fiorentini.* Revised and enlarged edition, 3 vols. Milan, 1961.

Berenson 1963 – Berenson, Bernard. *Italian Pictures of the Renaissance, Florentine School.* London, 1963.

Bertini 1935 – Bertini, Aldo "L'arte del Verrocchio." *L'Arte*, Vol. XXXVIII, (1935), pp. 433 ff.

Bertini 1967 – Bertini, Aldo. "Verrocchio." *Encyclopedia of World Art.* 1967. Vol. XIV, cols. 757-766.

Bode 1882 – Bode, Wilhelm. "Die italienischen Sculpturen der Renaissance in den Königlichen Museen. II. Bildwerke des Andrea del Verrocchio." *Jahrbuch der Königlich Preussischen Kunstsammlungen*, Vol. III (1882), pp. 91 ff. and pp. 235 ff.

Bode 1887 – Bode, Wilhelm. *Italienische Bildhauer der Renaissance.* Berlin, 1887.

Bode 1892-1905 – Bode, Wilhelm. *Denkmäler der Renaissance-Sculptur Toscanas.* Munich, 1892-1905. Vols. I-XI, plates; Vol. XII, text.

Bode 1904 – Bode, Wilhelm. "Leonardo als Bildhauer." *Jahrbuch der Königlich Preussischen Kunstsammlungen*, Vol. XXV (1904), pp. 125 ff.

Bongiorno 1962 – Bongiorno, Laurine Mack. "A Fifteenth-Century Stucco and the Style of Verrocchio." *Allen Memorial Art Museum Bulletin* (Oberlin), Vol. XIX (1962), pp. 115 ff.

Borghini (ed. Bottari) – Borghini, Raffaello. *Il Riposo, in cui della pittura e della scultura si favella* (Firenze, 1584). Second annotated edition by Bottari, Giovanni. Florence, 1730.

Burckhardt 1855 – Burckhardt, Jacob. *Der Cicerone.* Basel, 1855.

Bürger 1904 – Bürger, Fritz. *Geschichte des florentinischen Grabmals von den ältesten Zeiten bis Michelangelo.* Strassburg, 1904.

Chiappelli and Chiti 1899 – Chiappelli, Alessandro and Chiti, Alfredo. "Andrea del Verrocchio in Pistoia." *Bollettino storico Pistoiese*, Vol. I (1899), pp. 41 ff.

Cicognara 1823 – Cicognara, Conte Leopoldo. *Storia della scultura dal suo resorgimento in Italia fino al secolo di Canova.* Second emended and enlarged edition, Prato, 1823. Vol. IV.

Clark 1935 – Clark, Kenneth. *A Catalogue of the Drawings of Leonardo da Vinci in the Collection of His Majesty the King at Windsor Castle.* London, 1935.

Covi 1966 – Covi, Dario A. "Four new Documents Concerning Andrea del Verrocchio." *The Art Bulletin*, Vol. XLVIII (1966), pp. 97 ff.

Covi 1967 – Covi, Dario. "An Unnoticed Verrocchio?" *Burlington Magazine*, Vol. CX (1967), pp. 4-9.

Cruttwell 1904 – Cruttwell, Maud. *Verrocchio*. London and New York, 1904.

Dalli Regoli 1966 – Dalli Regoli, Cigetta. *Lorenzo di Credi*. Milan, 1966.

Degenhart 1932 – Degenhart, Bernhard. "Di alcuni problemi di sviluppo della pittura nella bottega del Verrocchio, di Leonardo e di Lorenzo di Credi." *Rivista d'arte*, Vol. XIV (1932), pp. 263 ff. and pp. 403 ff.

Degenhart 1933 – Degenhart, Bernhard. "Das Forteguerri-Monument—zur Publikation von Clarence Kennedy." *Pantheon*, Vol. XI (1933), pp. 179 ff.

Dussler 1940 – Dussler, Luitpold. "Andrea del Verrocchio." U. Thieme und F. Becker, *Allgemeines Lexikon der bildenden Kunstler von der Antike bis zur Gegenwart*, Vol. XXXIV, 1940, pp. 292 ff.

Faber 1892-97 – Faber, Felix. *The Wanderings of Felix Fabri*, Vol. VII-X. Trans. by A. Stewart. Palestine Pilgrims' Text Society. London, 1892-97.

Fabriczy 1895 – Fabriczy, Cornelius von. "Andrea del Verrocchio ai servizi de' Medici." *Archivio storico dell'arte*, Vol. I (1895), pp. 163 ff.

Fabriczy 1909 – Fabriczy, Cornelius von. "Kritisches Verzeichnis toskanischer Holz-und Tonstatuen bis zum Beginn des Cinquecento." *Jahrbuch der Königlich Preussischen Kunstsammlungen*, Vol. XXX (1909), Supplement.

Galassi 1949 – Galassi, Giuseppe. *La Scultura fiorentina del Quattrocento*. Milan, 1949.

Gamba 1904 – Gamba, Carlo. "Una Terracotta del Verrocchio a Careggi." *L'Arte*, Vol. VII (1904), pp. 59 ff.

Gamba 1931 – Gamba, Carlo. "La Resurrezione di Andrea Verrocchio al Bargello." *Bolletino d'Arte*, Vol. XXV (1931-32), pp. 193 ff.

Gaye 1839 – Gaye, Giovanni. *Carteggio inedito d'artisti dei secoli XIV, XV, XVI*. Vol. I. Florence, 1839.

Grossman 1968 – Grossman, Sheldon. "Madonna with a Pomegranate and some new paintings from the circle of Verrocchio." *National Gallery of Art, Report and Studies in Art History*, 1968.

Heil 1969 – Heil, Walter. "A marble Putto by Verrocchio," *Pantheon*, Vol. XXVII (1969), pp. 3-15.

Kennedy, Wilder, and Bacci 1932 – *The unfinished Monument by Andrea del Verrocchio to the Cardinal Niccolò Forteguerri at Pistoia*. Studies in the History and Criticism of Sculpture, Vol. 7. Photographs by Clarence Kennedy, Text by Elizabeth Wilder, Appendix of Documents by Peleo Bacci. Smith College, Northampton, Mass., 1932.

Kennedy 1968 – Kennedy, Clarence. "A Clue to a Lost Work by Verrocchio." *Festschrift Ulrich Middeldorf*. Ed. by A. Kosegarten and P. Tigler. Berlin, 1968, pp. 158-60.

Landucci (ed. Del Badia) – Landucci, Luca. *Diario fiorentino dal 1450 al 1516*. Published by Iodoco del Badia. Florence, 1883.

Mackowsky 1896 – Mackowsky, Hans. "Das Lavabo in San Lorenzo zu Florenz." *Jahrbuch der Königlich Preussischen Kunstsammlungen*, Vol. XVII (1896), pp. 239 ff.

Mackowsky 1901 – Mackowsky, Hans. *Verrocchio*. Berlin and Bielefeld, 1901.

Maclagan and Longhurst 1932 – London, Victoria and Albert Museum. *Catalogue of Italian Sculpture*. Sir E. R. D. Maclagan and M. H. Longhurst. 2 vols. London, 1932.

van Marle, XI, 1929 – Marle, Raimond van. *The Development of the Italian Schools of Painting*. Vol. XI. The Hague, 1929.

Mather 1948 – Mather, Rufus G. "Documents mostly new relating to Florentine painters and sculptors of the fifteenth century." *Art Bulletin*, XXX (1948), pp. 29-31.

Middeldorf 1934 – Middeldorf, Ulrich. Review of Cl. Kennedy, E. Wilder and P. Bacci, *The unfinished Monument by Andrea del Verrocchio to the Cardinal Niccolò Forteguerri at Pistoia*,

Northampton (Mass.), 1932, in *Zeitschrift für Kunstgeschichte*, Vol. III (1934), pp. 54 ff.

Middeldorf 1935 – Middeldorf, Ulrich. "Frühwerke des Andrea del Verrocchio" (Résumé of lecture), Report on the 51st Session on 29th May 1935, in *Mitteilungen des Kunsthistorischen Instituts in Florenz*, Vol. V (1937-40), p. 209.

Möller 1930-34 – Möller, Emil. "Leonardo e il Verrocchio: quattro relievi di capitani antichi lavorati per Re Mattia Corvino." *Raccòlta Vinciana*, Vol. XIV (1930-34), pp. 4-22.

Möller 1935 – Möller, Emil. "Verrocchio's last drawing." *Burlington Magazine*, Vol. LXVI (1935), pp. 103 ff.

Müntz 1888 – Müntz, Eugène. *Les Collections des Medicis au XVe siècle*. Paris, 1888.

Paatz, II, 1941 – Paatz, Walter and Paatz, Elisabeth. *Die Kirchen von Florenz—ein kunstgeschichtliches Handbuch*. Vol. II, D-L. Frankfurt, 1941.

Paatz, IV, 1952 – Paatz, Walter and Paatz, Elisabeth. *Die Kirchen von Florenz—ein kunstgeschichtliches Handbuch*. Vol. IV: SS. Maccabei—S. Maria Novella. Frankfurt, 1952.

Passavant 1959 – Passavant, Günter. *Andrea del Verrocchio als Maler*. Düsseldorf, 1959.

Passavant 1960 – Passavant, Günter. "Beobachtungen am Verkündigungsbild aus Monte Oliveto." *Mitteilungen des Kunsthistorischen Instituts in Florenz*, Vol. IX (1960), pp. 71 ff.

Passavant 1966 – Passavant, Günter. "Beobachtungen am Silberaltar des Florentiner Baptisteriums." *Pantheon*, Vol. XXIV (1966), pp. 10 ff.

Passavant 1969 – Passavant, Günter. *Verrocchio. Sculpture, Paintings and Drawings*. London, 1969.

Perkins 1864 – Perkins, Charles C. *Tuscan Sculptors; their Lives, Works, and Times*, Vol. I. London, 1864.

Planiscig 1933 – Planiscig, Leo. "Andrea del Verrocchios Alexander-Relief." *Jahrbuch der Kunsthistorischen Sammlungen in Wien* (new series), VII (1933), pp. 89 ff.

Planiscig 1941 – Planiscig, Leo. *Andrea del Verrocchio*. Vienna, 1941.

Pope-Hennessy 1958 – Pope-Hennessy, John. *An Introduction to Italian Sculpture*. Vol. II: *Italian Renaissance Sculpture*. London, 1958.

Pope-Hennessy 1964 – Pope-Hennessy, John (with the assistance of Ronald Lightbown). *Catalogue of Italian Sculpture in the Victoria and Albert Museum*. Vol. I, Text: Eighth to fifteenth century. London, 1964.

Popham and Pouncey 1950 – Popham, A. E. and Pouncey, P. *Italian Drawings in the Department of Prints and Drawings in the British Museum*. 2 vols. London, 1950.

Ragghianti 1935 – Ragghianti, Carlo Ludovico. "La giovanezza e lo svolgimento artistico di Domenico Ghirlandaio." *L'Arte*, XXXVIII (1935), pp. 167 ff. and pp. 341 ff.

Ragghianti 1954 – Ragghianti, Carlo Ludovico. "Inizio di Leonardo." *Critica d'arte*, 1954, pp. 102 ff. and pp. 302 ff.

Reymond, III, 1899 – Reymond, Marcel. *La Sculpture florentine*. Vol. III: *Seconde moitié du XVe siècle*. Florence, 1899.

Reymond 1906 – Reymond, Marcel. *Verrocchio*. Paris, 1906.

Richa, I, 1754 – Richa, Giuseppe. *Notizie istoriche delle chiese fiorentine divise ne' suoi quartieri*. Vol. I: *Del quartiere di Santa Croce*. Florence, 1754.

Richa, V, 1757 – Richa, Giuseppe. *Notizie istoriche delle chiese fiorentine divise ne' suoi quartieri*. Vol. V: *Del quartiere di S. Giovanni*. Florence, 1757.

Schottmüller 1933 – Berlin, Staatliche Museen zu Berlin. *Bildwerke des Kaiser-Friedrich-Museums. Die italienischen und spanischen Bildwerke der Renaissance und des Barock*. Vol. I: *Die Bildwerke in Stein, Holz, Ton und Wachs*. Second edition, revised by Frida Schottmüller. Berlin and Leipzig, 1933.

Schubring 1915 – Schubring, Paul. *Das italienische Grabmal*. Berlin, 1904.

Semper 1875 – Semper, Hans. *Donatello, seine Zeit und Schule. Quellenschriften für Kunstgeschichte*, Vol. IX. Vienna, 1875.

Semper 1877 – Semper, Hans. *Andrea del Verrocchio. Kunst und Künstler des Mittelalters und der Neuzeit*, No. 49. Leipzig, 1877.

Seymour 1949 – Seymour, Charles, Jr. *Masterpieces of Sculpture from the National Gallery of Art.* New York, 1949.

Seymour 1966 – Seymour, Charles, Jr. *Sculpture in Italy 1400-1500* (Pelican History of Art). Harmondsworth, 1966.

Steingräber 1955 – Steingräber, Erich. "Studien zur Florentiner Goldschmiedekunst." I. *Mitteilungen des Kunsthistorischen Instituts in Florenz*, Vol. VII (1955), pp. 87 ff.

Stites 1963 – Stites, Raymond S. "Leonardo scultore e il busto di Giuliano de' Medici del Verrocchio." I, 2. *Critica d'arte*, Vol. X (1963), Nos. 57-58, pp. 1 ff; Nos 59-60, pp. 25 ff.

Swarzenski 1943 – Swarzenski, Georg. "Some Aspects of Italian Quattrocento Sculpture in the National Gallery. II." *Gazette des Beaux-Arts*, Vol. XXIV (1943), pp. 283 ff.

Valentiner 1930 – Valentiner, W. R. "Leonardo as Verrocchio's Co-worker." *The Art Bulletin*, Vol. XII (1930), pp. 43 ff.

Valentiner 1933 – Valentiner, W. R. "Verrocchio's Lost Candlestick." *The Burlington Magazine*, Vol. LXII (1933), pp. 228 ff.

Valentiner 1941 – Valentiner, W. R. "On Leonardo's Relation to Verrocchio." *The Art Quarterly*, Vol. IV (1941), pp. 3 ff.

Valentiner 1944 – Valentiner, W. R. "Two Terracotta Reliefs by Leonardo." *The Art Quarterly*, Vol. VII (1944), pp. 3 ff.

Valentiner 1950 – Valentiner, W. R. *Studies of Italian Renaissance Sculpture.* London, 1950.

Van Marle: see under M.

Vasari-Milanesi – Vasari, Giorgio. *Le vite de' più eccellenti pittori scultori ed architettori scritte da Giorgio Vasari pittore aretino.* With notes and commentary edited by Gaetano Milanesi. 9 vols. Florence, 1878-85.

Venturi, I-XI, 1901-40 – Venturi, Adolfo. *Storia dell'arte italiana.* 11 vols. in 25. Milan, 1901-40.

Vitry 1907 – Vitry, Paul. "La Collection de M. Gustave Dreyfus. I : La sculpture." *Les Arts*, No. 72 (December 1907), pp. 2 ff.

Wackernagel 1938 – Wackernagel, Martin. *Der Lebensraum des Künstlers in der florentinischen Renaissance.* Leipzig, 1938.

Wilder: see Kennedy.

Wiles 1933 – Wiles, Bertha Harris. *The Fountains of Florentine Sculptors and Their Followers from Donatello to Bernini.* Cambridge, Mass., 1933.

PHOTOGRAPHIC SOURCES

Alinari-Brogi (I.D.E.A.), Florence: 1-4, 7-8, 10, 13, 16, 26, 28, 37, 39-42, 47, 49, 55-61, 63, 79, 81, 83-100, 110, 120-121, 125-126, 130, 133, 138, 146-151, 175, 177-181. Alinari-Seymour: 45-7, 123. Allen Memorial Museum, Oberlin: 156, 158. Anderson, Rome: 5, 9, 96-98, 101, 106, 107, 109, 111. Archives Photographiques, Paris: 17, 18, 163. Böhm, Venice: 96-107, 112, 114. British Museum, London: 22, 23. Detroit Institute of Fine Arts: 169-170. De Young Museum, San Francisco: 173. The Frick Collection, New York (Courtesy of): 137. Gabinetto Fotografico, Soprintendenza alle Gallerie, Florence: 6, 14, 19-21, 29-30, 35, 36, 38, 43, 44, 62, 64-67, 83, 85-95, 115-119, 123-124, 129-131, 132, 142, 145, 147-151, 153-155, 159, 165-166, 179. Giraudon, Paris: 134, 143, 167, 168, 172. W. Heil (Courtesy of): 162. C. Kennedy (Courtesy of): 55, 84. Kunsthistorisches Museum, Vienna: 174. Musée du Louvre, Paris: 25. National Gallery of Art, Washington, D.C.: 15, 135, 136, 139-141, 144, 152, 160-161, 171, 176. Rijksmuseum, Amsterdam: 31-34, 157. W. S. Sheard (Courtesy of): 113. Soprintendenza ai Monumenti, Florence: 51-54. Staatliche Museen, Berlin-Dahlem: 164. Victoria and Albert Museum, London: 24, 48, 82. Walters Art Gallery, Baltimore: 11.

INDEX OF NAMES, PLACES, SUBJECTS

Verrocchio abbreviated as V. Numbers in italics refer to the illustrations.